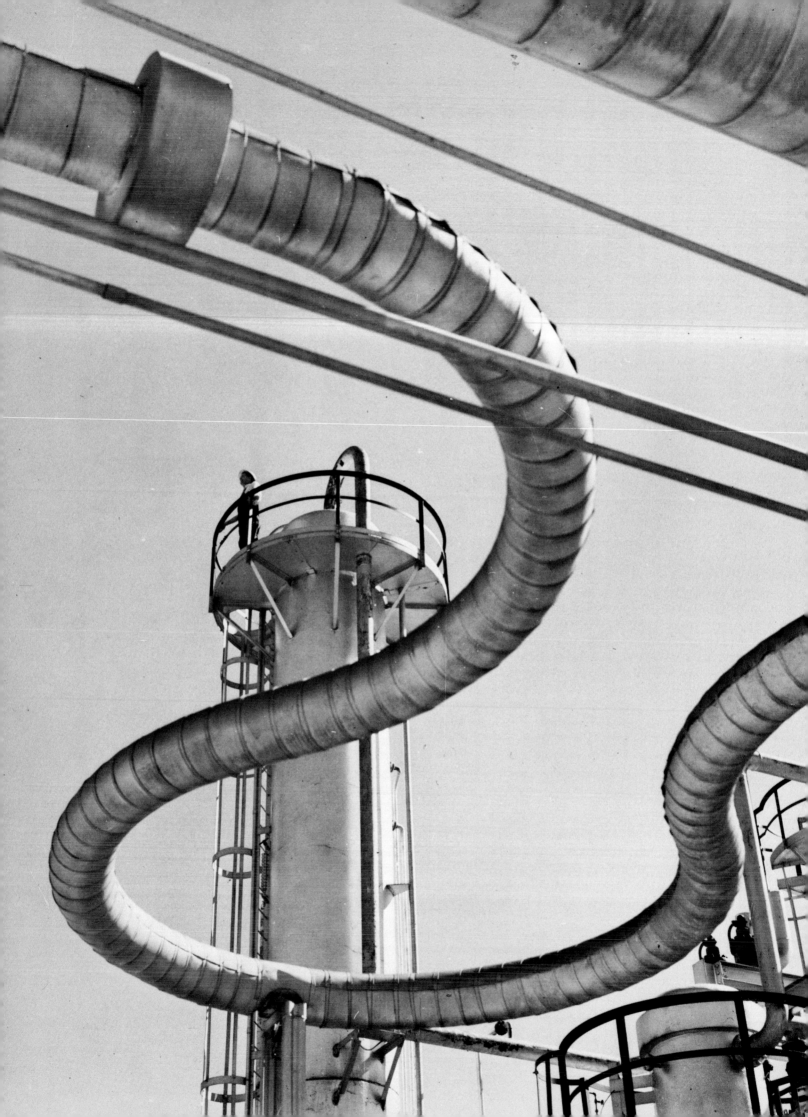

INDUSTRY
AND THE
PHOTOGRAPHIC IMAGE

153 Great Prints from 1850 to the Present

edited by

F. Jack Hurley

Department of History, Memphis State University
Memphis, Tennessee

George Eastman House, Rochester
in association with
DOVER PUBLICATIONS, INC.
NEW YORK

Frontispiece: Tomball gasoline plant, Tomball, Texas, June 1945; photo by Esther Bubley.

Published in Canada by General Publishing Company, Ltd., 30 Lesmill Road, Don Mills, Toronto, Ontario.
Published in the United Kingdom by Constable and Company, Ltd., 10 Orange Street, London WC2H 7EG.

Industry and the Photographic Image: 153 Great Prints from 1850 to the Present is a new work, first published in 1980 by Dover Publications, Inc., New York, and George Eastman House (International Museum of Photography), Rochester.
Thanks are due to all picture lenders, who are listed individually in the Picture Credits section.

Book design by Carol Belanger Grafton

International Standard Book Number: 0-486-23980-2
Library of Congress Catalog Card Number: 79-56505

Manufactured in the United States of America
Dover Publications, Inc.
180 Varick Street
New York, N.Y. 10014

V.S.W.
9-29-81

PREFACE

This study initially came about through the efforts of Robert Doherty, then Director of the George Eastman House (International Museum of Photography) in Rochester, New York. It was thanks to him that a Bicentennial Grant was sought and received from the National Endowment for the Arts, and it was he who interested me in the subject of industrial photography. To both Bob Doherty and the N.E.A. I offer my gratitude and acknowledge my debt.

The N.E.A. grant bought me a year's work at the International Museum of Photography (sheer delight to any photographic historian) and visits to nearly thirty other public and private archives with industrial holdings. The work yielded an exhibition of nearly three hundred photographs, which opened in New York City at the Kodak Gallery in March of 1976 and which later that year was on display for three and a half months at the International Museum of Photography.

The initial work on the exhibit revealed that this was a vast and virtually unstudied subject for photographic historians. American photographers have taken literally millions of photographs of industrial subjects and, over the 135 years that they have been active, have developed an identifiable visual rhetoric. They have learned to make the camera say what they—or their employers—mean for it to say. How did this come about? What forces have shaped and changed the symbols and metaphors of industry in this most technologically oriented country?

A short study of this sort, aimed at the general reader, can only suggest a framework, a way of approaching the large and fascinating subject of industrial photography. I hope this first glimpse will lead others to more detailed studies, and I look forward to other work in the field.

F. Jack Hurley

Memphis
1979

CONTENTS

CLUMSY CAMERAS
AND INFANT INDUSTRIES

From the very beginning, photography in the United States has been deeply interconnected with the process of national industrialization. The camera arrived on the scene just as American industry began to emerge in its modern form and has thus been in a unique position as participant and beneficiary as well as observer of industrial progress. It is significant to note, for example, that the first man to make a permanent photographic image in this country, using the then-new daguerreotype process, was Samuel F. B. Morse, who is usually remembered for devising the Morse code. It was Morse's system of dots and dashes that later enabled huge railway systems and equally large-scale businesses to correlate their activities over tremendous distances, and it was Morse's first love, the camera, that recorded the process of national industrial growth.

When Morse succeeded in making his first daguerreotype in 1839, the United States was poised on the brink of what economist W. W. Rostow has called its industrial "take-off" period. Most of the necessary factors for a modern industrial nation were present. Capital wealth had accumulated in enough hands that fairly high levels of investment could be sustained. A good potential labor force existed and the country possessed vast markets and vast supplies of raw materials. What was necessary was the devising of a network of transportation and communication in order to bring together all these elements. By the early 1840s that was exactly what was happening in this country.

In 1840, the United States had a canal system some three thousand miles long, mostly in the northeast and the midwest, and an infant railway system of about the same extent. Much of its interior commercial traffic still clung to the natural waterways of the Mississippi and Ohio river valleys, where hundreds of barges and steamboats attempted to keep up with the country's growing needs. During the next decade the railroad, which most economic historians see as the key to industrialization in this country, tripled its length to nine thousand miles and from 1850 to 1860 it more than tripled again, reaching roughly thirty thousand miles by the outbreak of the Civil War. The effect of all this growth was to open to commerce immense areas of the nation's interior (although the growth was still east of the Mississippi River at this point) and to provide industry with a way to bring raw materials, manufacturing and markets together.

During the decade of the 1840s, according to Rostow, the economy of the United States moved permanently from its original agricultural base and modern industrial activity "took off." As the new transportation and communication technology annihilated distance, everything fell into place. In the more urbanized northeast and in the growing industrial towns of the Midwest, businesses developed which in their scale and in their activities bore greater resemblance to the industrial corporations of today than to their own small predecessors. The Civil War brought a brief hiatus in the growth of heavy industry but afterward the process moved forward inexorably. The railroads became a truly national rapid-transportation system. Factories became very large in order to take advantage of the tremendous national markets that were now available. Cities developed as workers and managerial talents were attracted to the wage-paying industries. Something very important was happening in this country and, in time, photographers would learn to record and even interpret the process.

During the nineteenth century, most photographers seem to have reacted to industrialization on a fairly expository level. That is, they generally appear to have been satisfied to record the railroad locomotive, the steamboat or the factory (usually the exterior) in a straightforward manner without feeling the necessity to search for symbols or metaphors. Visual flights of poetic fancy were usually reserved for pastoral scenes, portraits or morally didactic scenes borrowed from the academic painters of Europe.

Relatively few photographs of industry have survived from the very earliest, pre-Civil War, period. Exteriors of buildings where manufacturing is known to have gone on are fairly common but these do not tell us much about the work that went on inside or the people who did it. The small ambrotype of the interior of a spinning mill from the George Eastman House collection is a very rare exception. Exterior views of buildings, boats and trains had the clear advantages that the objects could be made to hold still and the light levels were high. These were important considerations in the early days.

In its technical infancy, photography was an almost incredibly difficult process. It involved exposing a plate of polished metal (usually silver) to iodine vapor, exposing the plate in a camera for several minutes and developing in hot mercury vapor. Once this fairly dangerous step had been completed, the plate was "fixed," so that it would not fade, in a solution of "hypo" that was not much different from the chemical used today. Cameras were expensive and relatively bulky. All this undoubtedly explains why so few of the very early industrial images have survived. Amateurs took their cameras out into the countryside to search for pastoral images, while professionals could

seldom afford the time and logistical difficulties of moving their cameras out of their studios. By the time of the Civil War, however, all this was changing.

By the 1850s photography was in the throes of a major technical change that would give photographers much more flexibility. The slow daguerreotype process was giving way to the far more light-sensitive wet-plate process. In terms of the process itself, wet-plate photography was, if anything, more complicated than the daguerreotype. A thick mixture of ether and gun cotton called collodion was floated onto a glass plate, then a solution of silver nitrate was added. The plate was exposed in the camera and developed while still wet. The manipulations were tricky and, again, some of the chemicals used would hardly be considered safe today, but the advantages were real. With the new process, exposure times were lowered to a few seconds and, best of all, an infinite number of prints could be made from the glass negative. The metal plate of the daguerreotype had been a single item which had not been easily reproducible.

Given the clear advantages, professional photographers were using wet-plate processes extensively by 1860. In fact it was the speed and sensitivity of this process that allowed Mathew Brady's photographers to capture their fine documents of the terror and tragedy of the Civil War. In the small studios specializing in cheap portraits "while you wait," a form of the earlier daguerreotype hung on until nearly the end of the century, but this "tintype" was seldom used to record the image of industry. The wet-plate process dominated photography from the 1850s until the late 1880s and was the medium used to document this country's economic "drive to maturity" (the phrase, again, is Rostow's). Since technical change is often related to stylistic change in photography, it seems useful to discuss some of the physical characteristics of wet-plate photography and to see how these characteristics affected the relationships between photographers and their subjects.

The introduction of glass negatives made by the wet-plate method set off a craze for larger and larger cameras in this country. Enlargements were very difficult to make, but large images could be obtained if one had a very large camera and could contact-print. C. E. Watkins, for example, made scenic views of the Yosemite Area in 1860 using glass negatives that were 18 by 22 inches! Other photographers followed suit and soon cameras producing negatives 11 by 14 inches and larger were quite common. The weight and logistical difficulty of these cameras tended to discourage amateurs. This becomes even more obvious when one considers that the wet-plate process required that some sort of portable darkroom accompany photographers wherever they went. A studio darkroom could be well arranged and reasonably commodious but traveling darkrooms tended to be small, cramped and dangerous. When William Henry Jackson packed his equipment for the long trip to the Yellowstone River area, he had somehow to carry safely one and a half pounds of potassium cyanide! In short, the wet-plate process was simply not a medium that lent itself very well to dilettantism.

Because of the difficulties involved in "securing a good negative," professional photographers in the wet-plate era chose their subjects with particular care. If a photographer in the 1860s or 1870s thought highly enough of a subject to photograph it, we may take it as evidence that he and his contemporaries thought it was pretty important. Amateur photographers, whose clubs continued to flourish in some of the larger East Coast cities, occasionally focused on industrial subjects during this period but their work usually involved nostalgic views or attempts to capture a vanishing past. Professional photographers, on the other hand, tended to seek their subjects within the most active areas of industry.

The railroads were surely a "leading sector" of the late nineteenth century and photographers loved to photograph them. Mechanized agriculture, lumbering and mining were all favorite subjects. These were usually photographed by traveling professionals who expected to sell their work either to the subjects photographed or to the owners of industrial operations. Consequently, professional photographers closely mirrored the values and presuppositions of their day. They were not reformers, nor were they poets. They were generally in the business of making and selling photographs.

Interestingly enough, these logistical and commercial considerations created a certain honesty in the photographic results. The pictures taken by those pioneer industrial photographers were posed, they were stylized, but they were never glib. Given the dual facts that cameras were heavy and subjects were often potential customers, the tendency was to pick the camera's angle, plant it firmly on its tripod and more or less let the subjects pose themselves. In these situations, certain patterns emerged from which we can learn a great deal. Because the very act of "having one's picture taken" was still a new and extraordinary experience, people tended to take it seriously. The camera was both a challenge and a perfect audience and it forced its subjects to give some thought as to how they were to be preserved for posterity. The self-conscious poses which people adopted reveal many of their fundamental assumptions about themselves and their world.

Consider the wonderful photographs that old John Mather took in the first oil fields near Titusville, Pennsylvania in the 1860s and '70s. With his custom-built buggy-darkroom-on-wheels he would strike out into the back country until he came to a suitable scene of oil-field shanties and ramshackle derricks. The local entrepreneur of the well (for most wells were individually owned in those days) would be invited to become a photographic subject and few seem to have refused the honor. With hired help, wives, children and dogs, they clambered into the center of the utter physical devastation they had created. There amidst the denuded hills, the savaged land and the wasted oil, they assumed the most heroic poses they could think of while Mather, well satisfied, fixed forever these Napoleons of western Pennsylvania.

The same thing happened in the 1870s and '80s in the lumber camps. When faced with the challenge of the camera, men who were clear-cutting the forests and stripping the timber wealth from millions of acres of prime northern woodlands climbed up onto huge loads of logs or stood in front of their camps holding the tools of their trade like conquering troops, heroes, proud of their work and utterly oblivious to the destruction surrounding them.

This heroic theme persists throughout the posed industrial photographs of the late nineteenth century and

continues well into the twentieth. In New York City the engineers in charge of building the Brooklyn Bridge climbed out on the flimsy, incomplete structure, unconsciously placing themselves in the dominant position: above their creation. Farmers in the Midwest, proud of the new machinery that allowed them to open vast new areas of the plains, stood on or in front of, sat on, and put their feet up on this valued equipment. In all cases the men, either collectively or individually, were putting their foot on their work in much the same way a big game hunter, in more naïve times than today, used to put his foot on his trophy to indicate for the camera, "I am the master of this."

In short, the very act of posing (often self-posing) is a key to understanding some of the attitudes of the period. Whether the individual pictured was the employer of tens of thousands, or a humble factory worker perched atop his machine, men shared a common heroic image of themselves. They were taming, dominating, bending to their wills (all words which we today associate with rape) the vast virginity of a rich continent. They frankly gloried in it. This may be a natural human response to the unfolding of a tremendously rich land mass or it may be a perfect example of the hubris that lies at the beginning of all classic tragedies. Whatever it is, it is there in the photographs. No other documents of the period show the hero-rapist mentality of nineteenth-century Americans as clearly as the photographs.

The image of the nature-dominating hero may be repugnant to us today but it was endorsed by the entire nineteenth- and early twentieth-century system of values. It was considered axiomatic that man was destined to control nature and make whatever use of natural resources seemed good to him. The so-called "Protestant work ethic" (which was invented by the Biblical Jews and is a part of nearly every major religious system) demanded that men work, and designated the unchecked exploitation of the continent as honorable. Political and economic or-thodoxies in this country were oriented to maximum production and profit. These people were doing exactly what they were supposed to be doing and they were proud of it. If it made them feel masculine, so much the better, for industrial America in the late nineteenth century was very much a man's world.

Professional photographers in the late nineteenth century understood that pictures showing recognizable people often resulted in sales, but they also understood the American love of hyperbole. Americans have always loved pictures of anything that was "biggest" or "first" or "newest" or even "most terrible" (as in disasters). Although newspapers could not yet reproduce photographs, illustrated magazines such as *Leslie's* and *Harper's* did buy photographs for their wood engravers to work from. Good views of a particularly tall building or a particularly grisly train wreck might be sold to one of the magazines, or might interest other Americans enough to wring a few cents from their pockets for a print or "stereo view." These market realities served to broaden the scope of the nineteenth-century photographic record, assuring the creation of a fine legacy of historically important pictures relating to the triumphs and tragedies of American industrialization.

It was only in the decade of the 1890s that any significant groups of Americans began to question the system and call for reforms. The national consensus concerning the unalloyed benefits of industrialization was breaking down. Photographers, along with everyone else, were being forced to make up their minds concerning the deeper meanings of American industrialization. Moreover, the camera itself was becoming far less complicated to operate, which meant that a far less technically oriented person could use it. The result of all this was the exploitation of the interpretive uses of images and the enrichment of that developing visual language which would come to be known as industrial photography.

ABOUT THE PHOTOGRAPHS

I. Early Industrial Mills and Shops (Photos 1–4)

Early industrial activities, such as weaving, shoemaking and the manufacture of simple items of wood or iron, were usually done in small shops during the first half of the nineteenth century. Prior to the Civil War the small, independent shop, owned by one or two master craftsmen and employing a few journeymen and apprentices, dominated the industrial life of the country. After the war the small shop continued for a time in the more rural areas, preserving the early image of industry for later photographers.

II. Early Oil-Field Photographs (Photos 5–7)

John Mather's wet-plate photographs of the early oil fields of western Pennsylvania constitute one of the most valuable visual resources available to the historian interested in nineteenth-century business methods and working patterns. The collection is large enough to be considered fairly comprehensive and quite consistent in style and approach.

III. Early Mechanized Agriculture (Photos 8–11)

The mechanization of agriculture was one of the more important aspects of nineteenth-century industrialization and one which continually fascinated photographers. The introduction of increasingly complex and productive machines into large-scale farming, particularly in the plains states, released many agricultural workers for work in the new mills and manufacturing complexes of the cities.

IV. Early Lumbering (Photos 12–16)

Since colonial days lumbering has been an important activity in this country. The introduction of modern balloon-frame construction with standardized lumber dimensions (2 x 4, 2 x 6, etc.) in the 1830s made it possible for the lumber industry to operate on a much larger scale than it had in the past. After the Civil War the rail network extended into the great northern forests, and trees by the hundreds of thousands were cut up to feed the needs of the growing cities for cheap construction materials.

V. Transportation: Canals (Photos 17–20)

The first great attempt to link together the nation's markets and raw materials involved the use of canals, and the greatest of all American canals was the Erie. The sheer statistics of the project are amazing. The Erie was 364 miles long and covered a ground rise of over 650 feet. The original "big ditch" was dug in just eight years, from 1817 to 1825, using basic hand tools, men and mules. The technology for building and operating locks had to be worked out on the spot, for at the time the Erie project was begun there was not a single canal lock operative in the country! The project succeeded brilliantly, funneling the produce of the upper Midwest across upstate New York and down the Hudson to New York City. Other cities, anxious to cash in on a similar bonanza, began canal-building projects of their own, and within fifteen years the northern and eastern states were crisscrossed with over three thousand miles of canals.

VI. Other Water Transportation (Photos 21–24)

Nineteenth-century canals were generally built to tie together other avenues of water transportation. Oceans were linked with rivers or lakes. Until the railroads became fast, efficient and ubiquitous, most businesses had to ship by water. On the Western rivers, the steamboat answered the needs of the period best, while ocean-going traffic continued to rely on wind in canvas until very late in the century.

VII. Transportation: Railroads (Photos 25–28)

More than any other single factor, the growth and development of the American railway system tied together the elements of industrial production and distribution in the nineteenth century. Photographers were drawn instinctively to record this exciting new technical marvel. Every major new development in railroading, every accident, every violent strike, practically anything that had to do with railroading, seemed to fascinate photographers and their customers.

VIII. Making Steel (Photos 29–34)

The material that became the physical base for modern American industrialization was steel. Strong, resilient and ductile, steel made it possible to carry far heavier loads on rails; steel made the modern skyscraper possible. Evolving from the early iron industry, steel was a necessity to national growth by 1900. Like other "leading sectors" of the economy, steel attracted its share of photographers, and thus we are left with an important visual record of the industry's growth.

IX. The Urban Landscape (Photos 35–39)

Photographers in the late nineteenth century were delighted with the burgeoning growth of the modern industrial city. Everything seemed to be happening on a heroic scale. The buildings were taller, the bridges were longer and almost anything seemed to be possible. The photographs are filled with infectious enthusiasm for the bustling urban landscape.

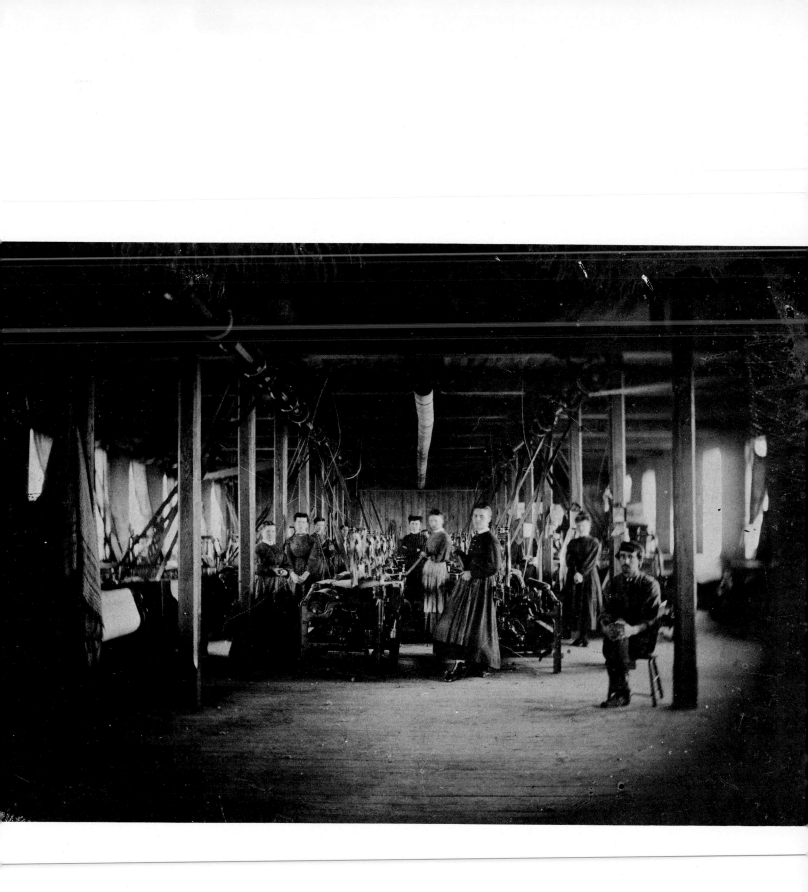

1. Early interior of a spinning mill, probably in New England, ca. 1850; photographer unknown.

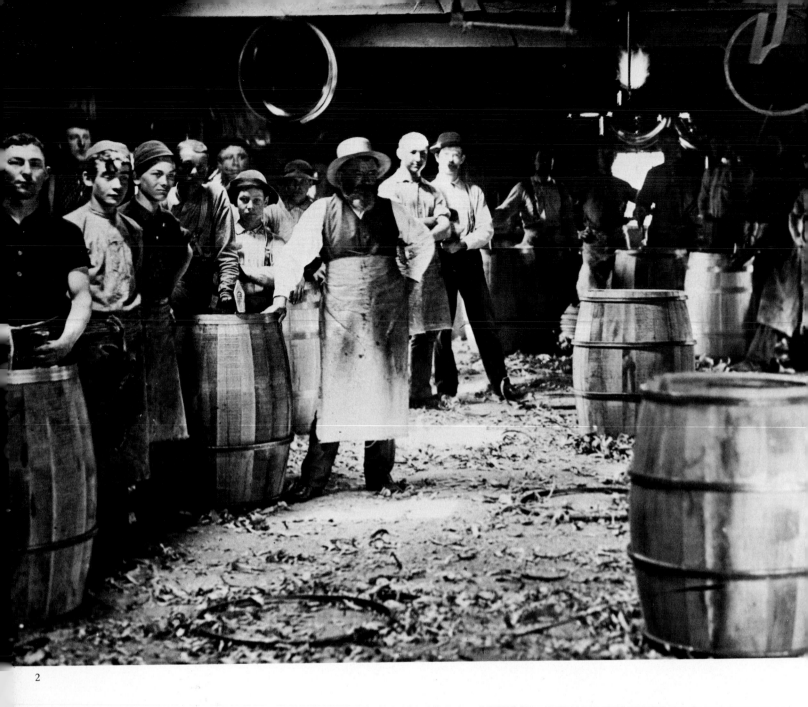

2

2. Cooper shop interior, in or near Titusville, Pennsylvania, ca. 1865; photo by John Mather.
3. Broom factory, Carlisle County, Kentucky, ca. 1900; photo by J. T. Golden. 4. Bean Brothers carriage shop, Winchester, Kentucky, ca. 1900; photo by A. J. Earp.

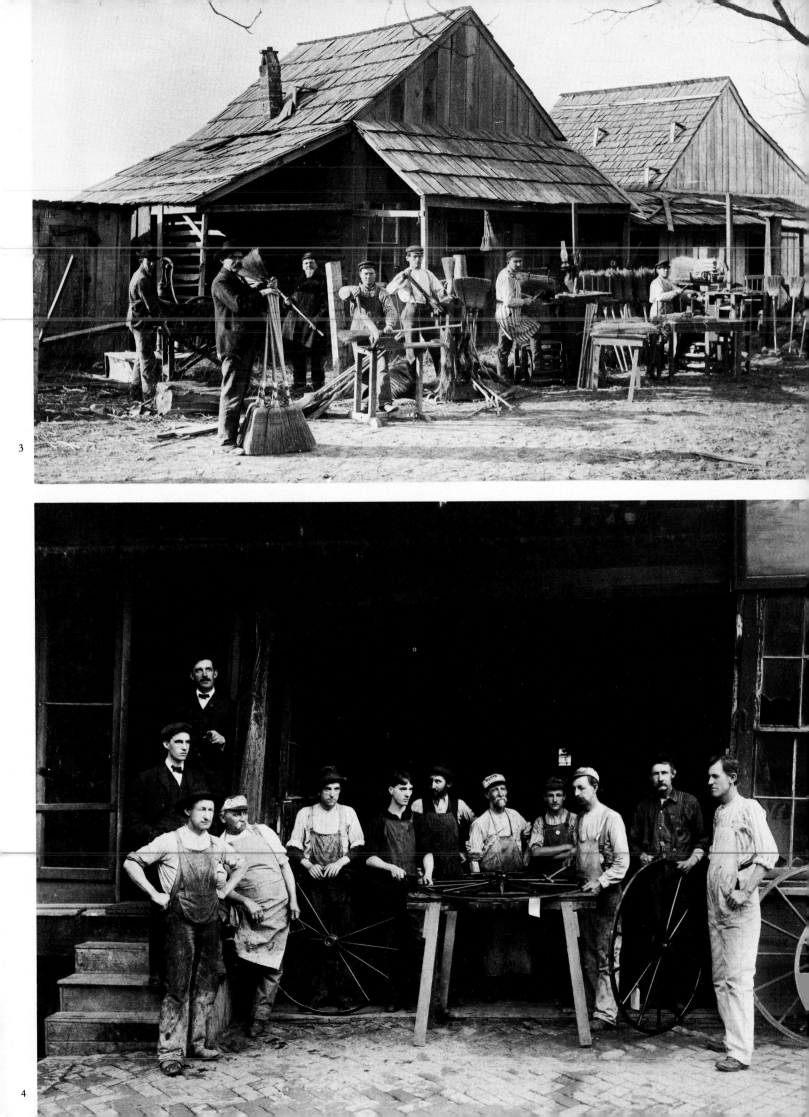

3

4

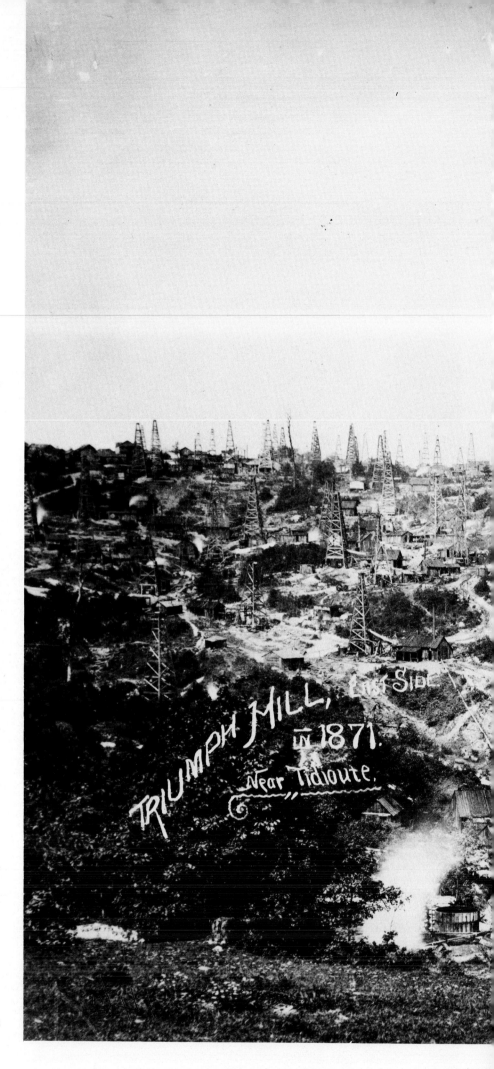

5. Triumph Mill, east side, 1871; photo by John Mather.

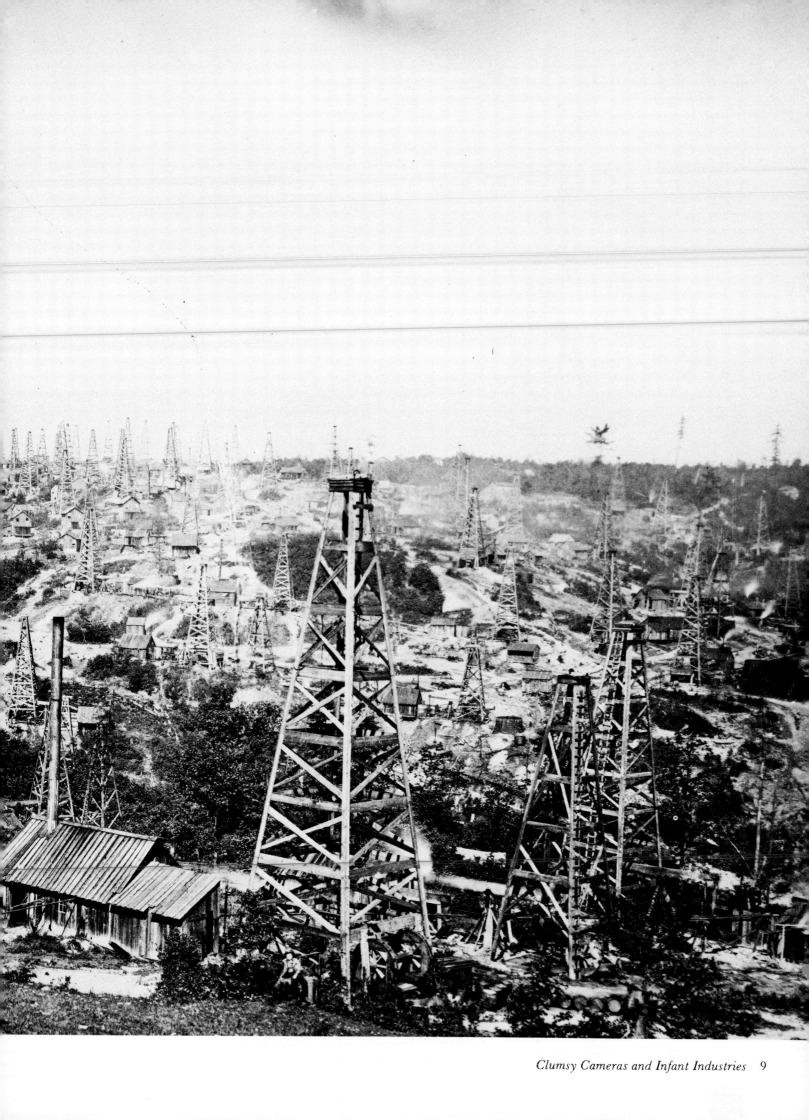

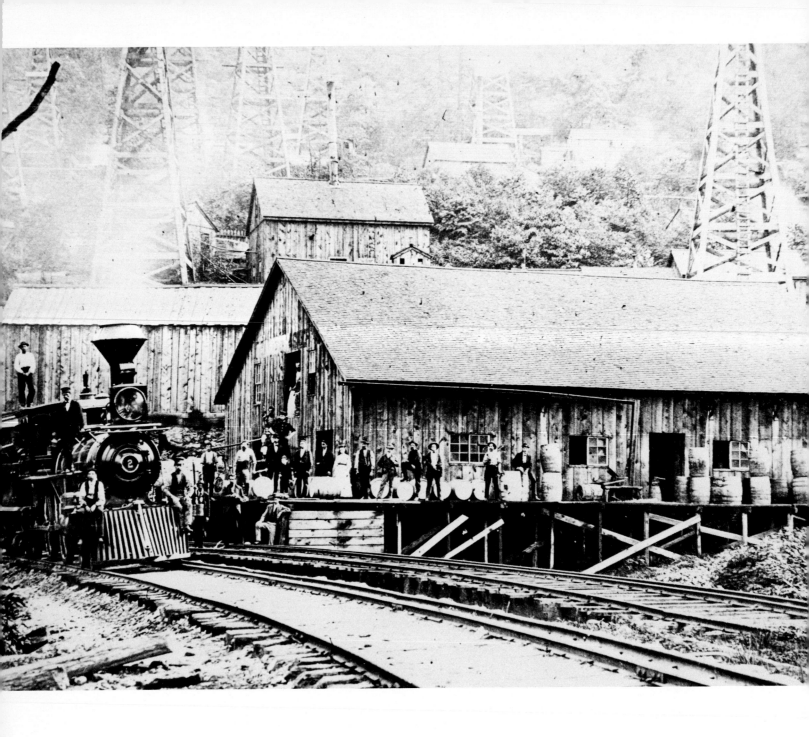

6. Railroad freight loading dock; no date; photo by John Mather.

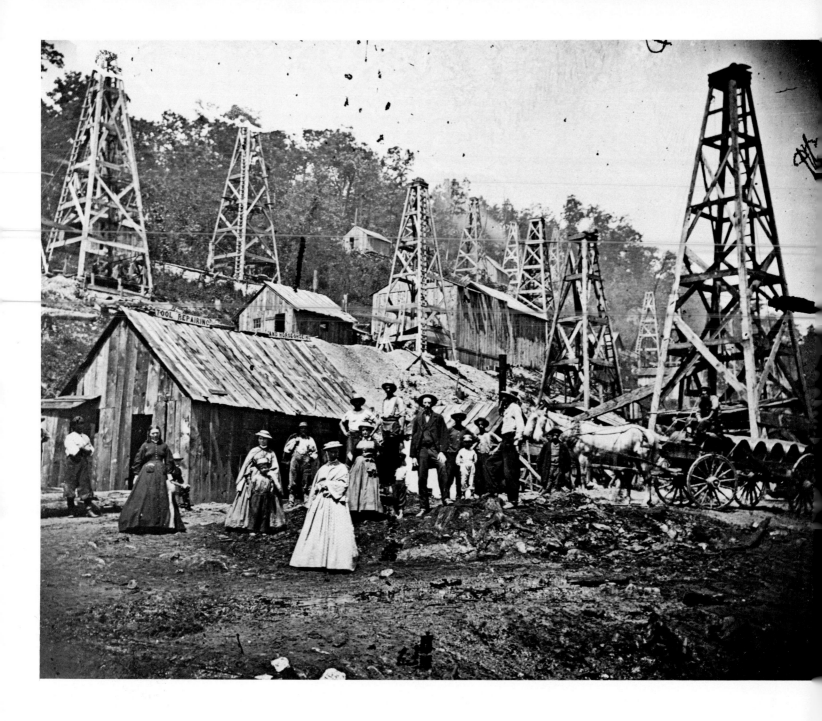

7. Oil wells and people near Titusville, Pennsylvania, ca. 1865; photo by John Mather.

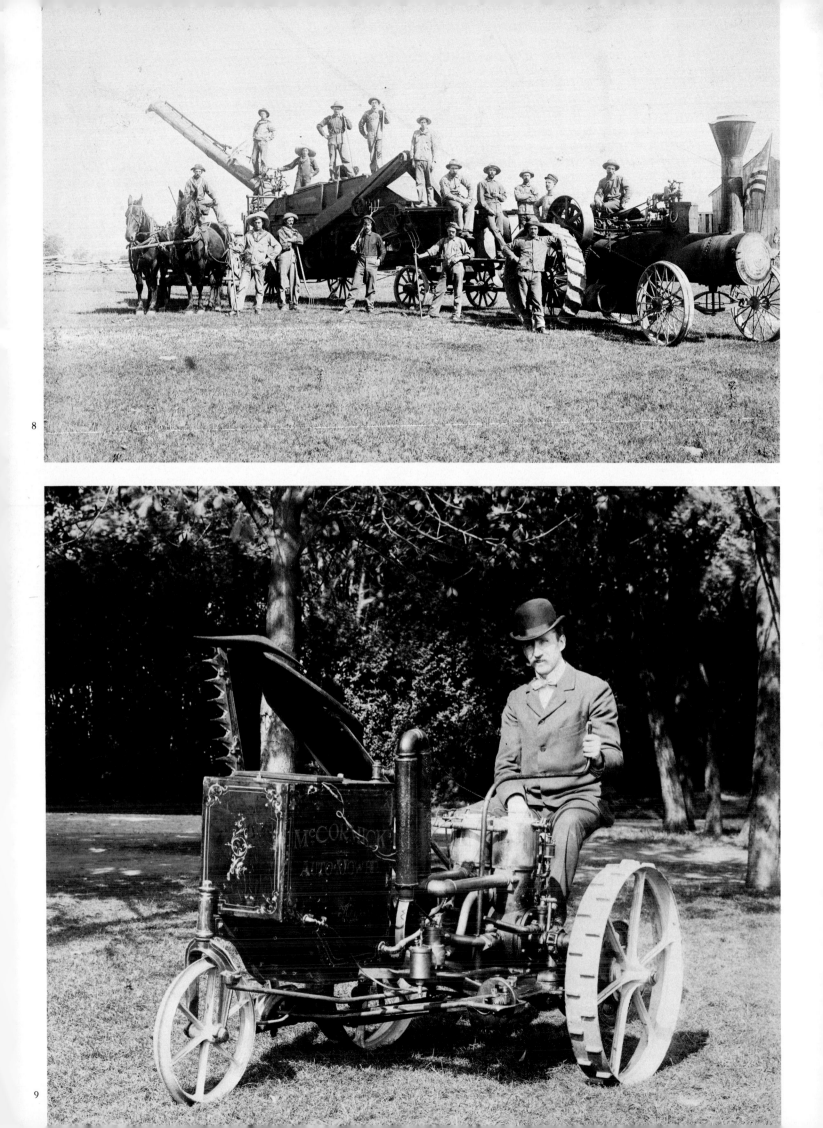

8

9

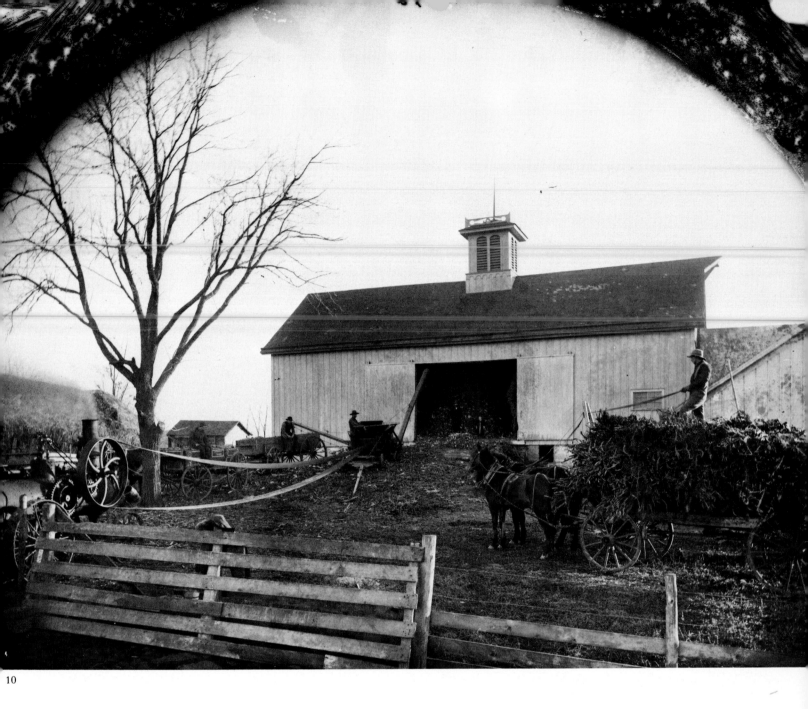

10

8. Threshing crew, Sheboygan County, Wisconsin, 1895; photographer unknown. **9.** Dapper gentleman with a McCormick Auto Mower, Paris Exposition, 1900; photo by Fernique & Fils, Paris. **10.** Early McCormick threshing machine; no date; photographer unknown.

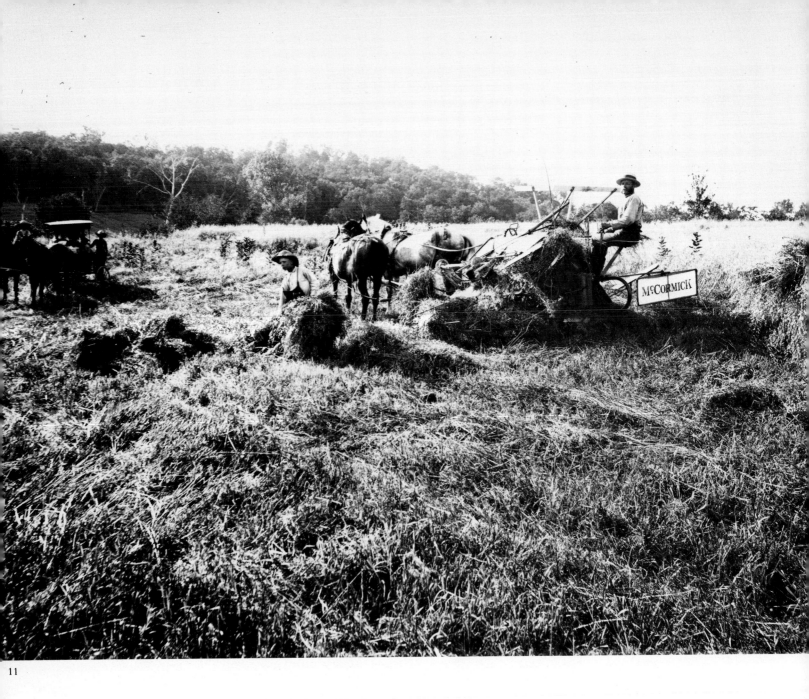

11

11. Harvesters in the field; no date; photographer unknown. 12. Logging scene at Hermansville, Michigan, 1884; photographer unknown. 13. Log jam at Taylor's Falls, Minnesota, on the St. Croix River, 1884; photographer unknown.

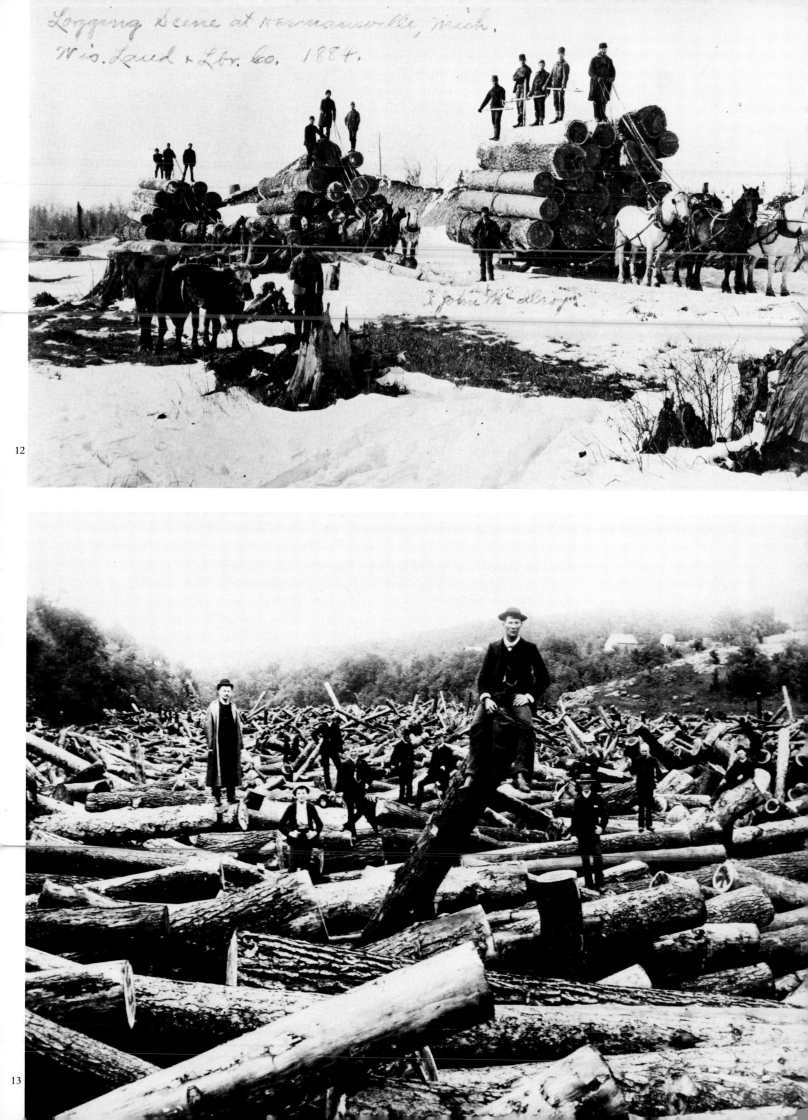

Logging Scene at Hermansville, Mich.
Wis. Land & Lbr. Co. 1884.

12

13

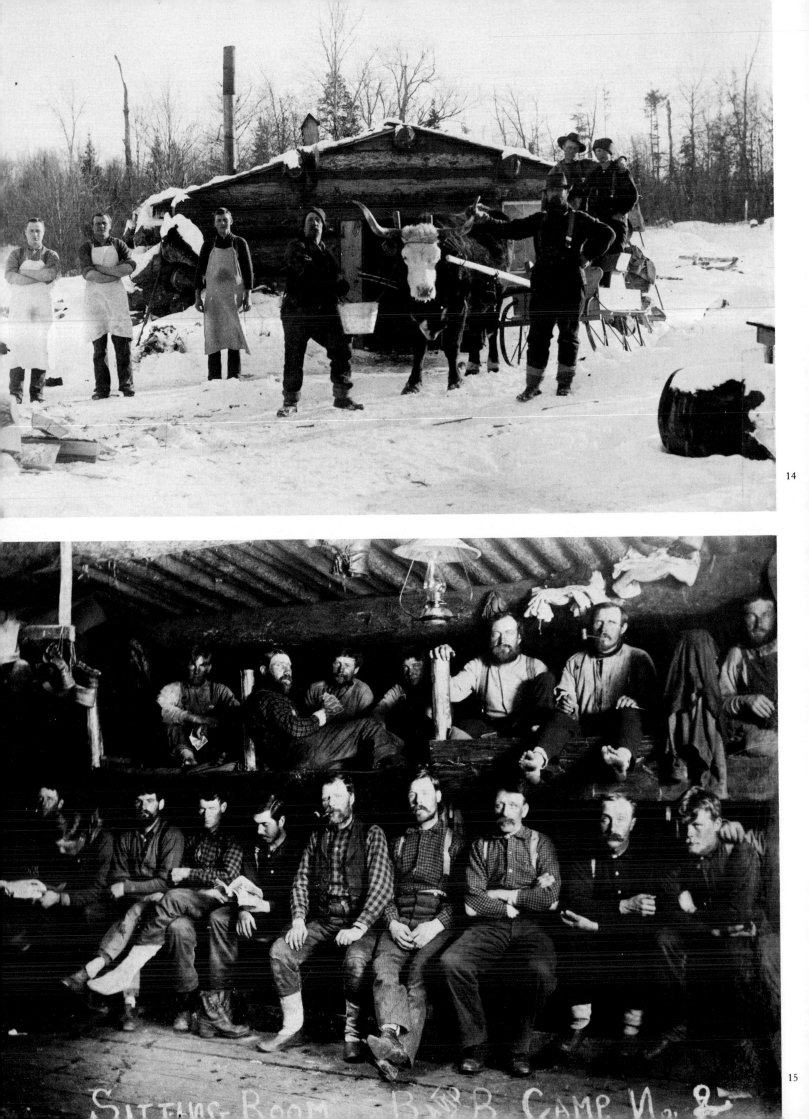

14

15

SITTING-ROOM — B&B CAMP N. 8

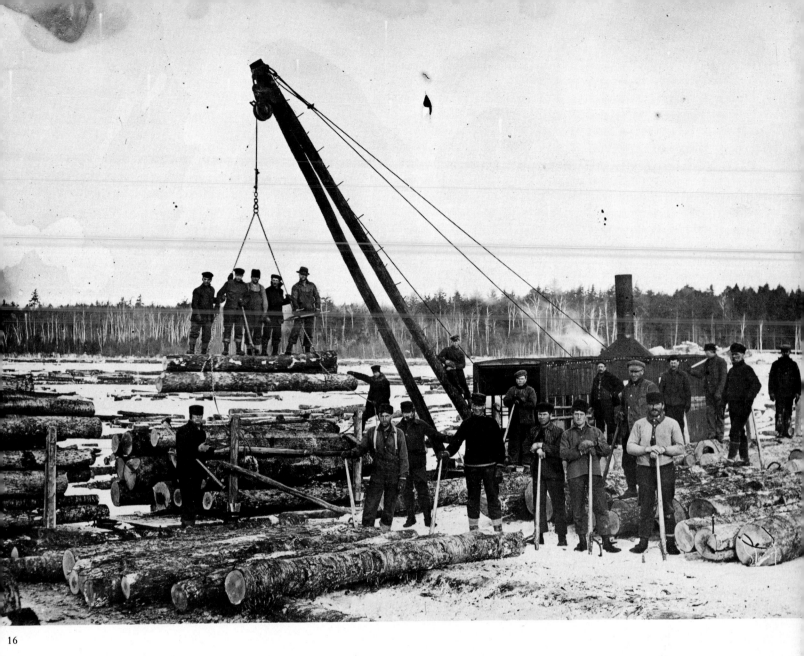

16

14. Lumber camp, Two Harbors, Minnesota, ca. 1895; photographer unknown. 15. "Sitting room," B and B Camp No. 2, north of Grand Rapids, Michigan, ca. 1900; photographer unknown. 16. Rice Lake lumber camp, Barron County, Wisconsin, 1906; photographer unknown.

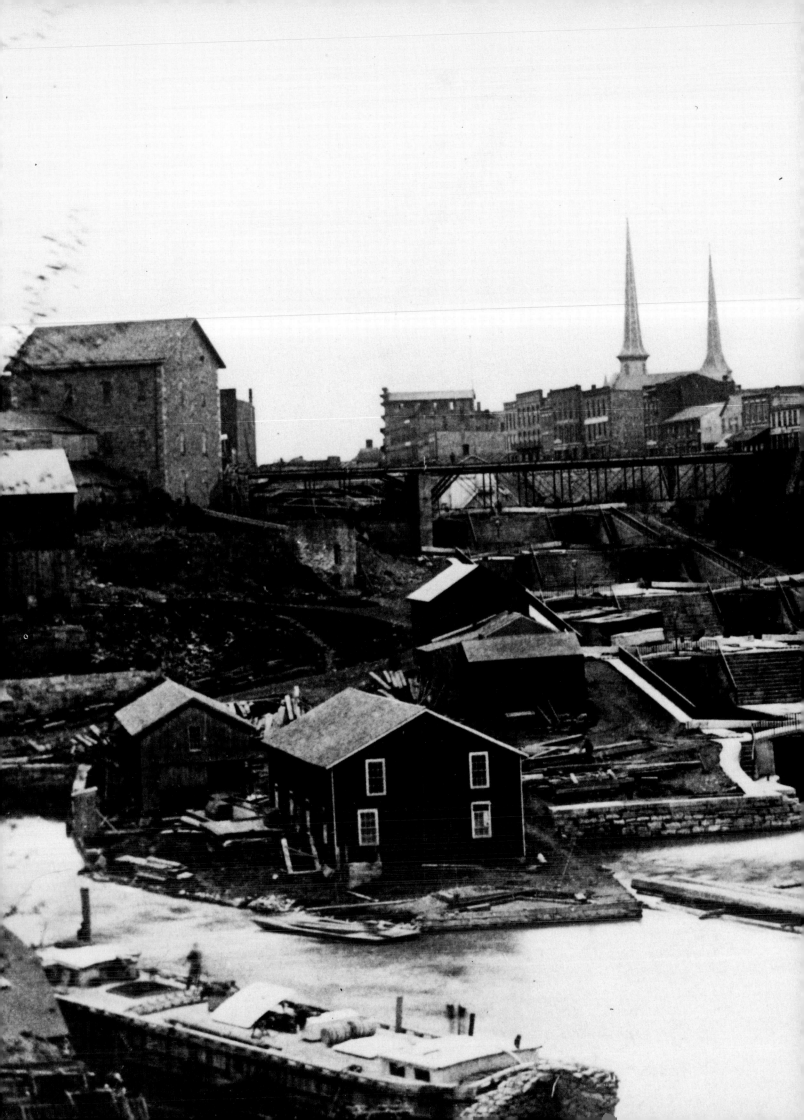

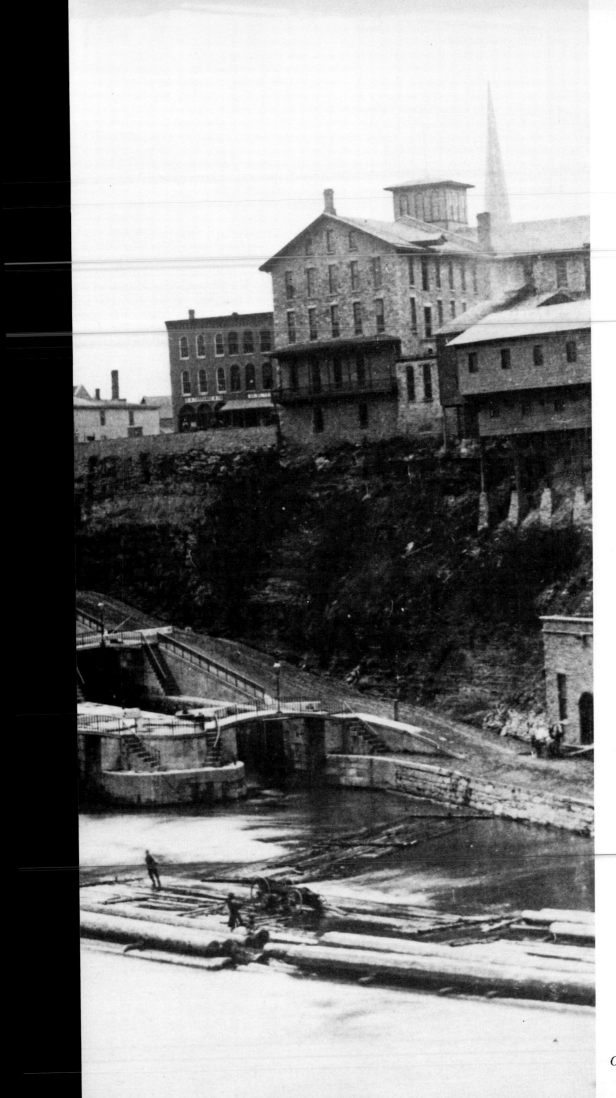

17. The Lockport (New York) flight; no date; photographer unknown.

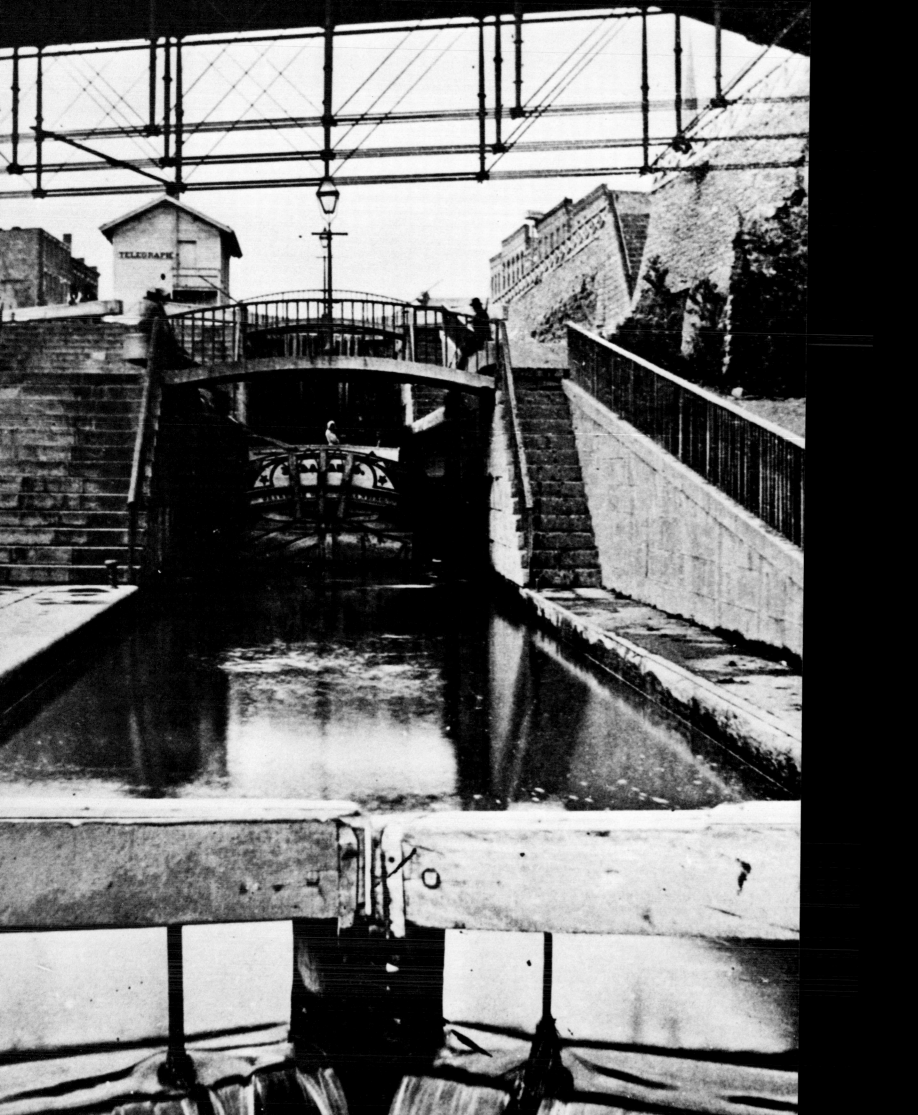

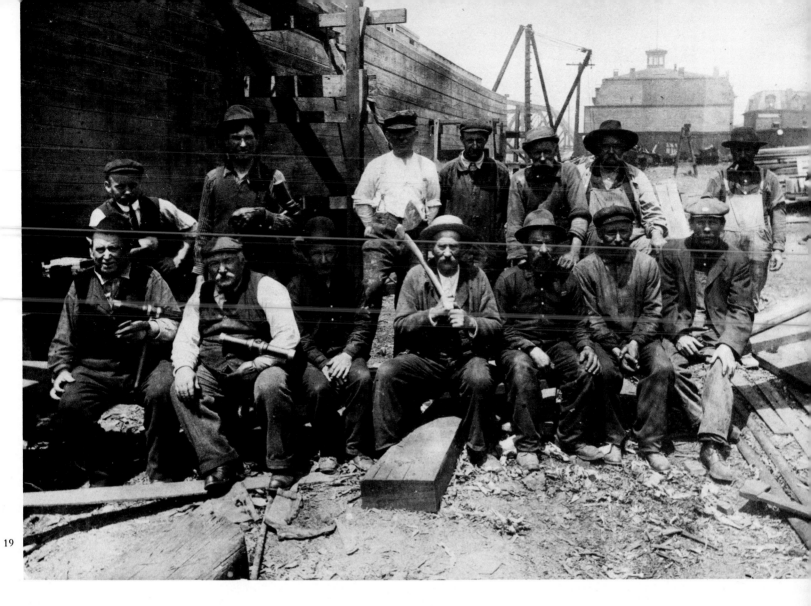

18. Locks on the Erie Canal, ca. 1870; photographer unknown. **19.** Boats and boat builders; no date; photographer unknown.

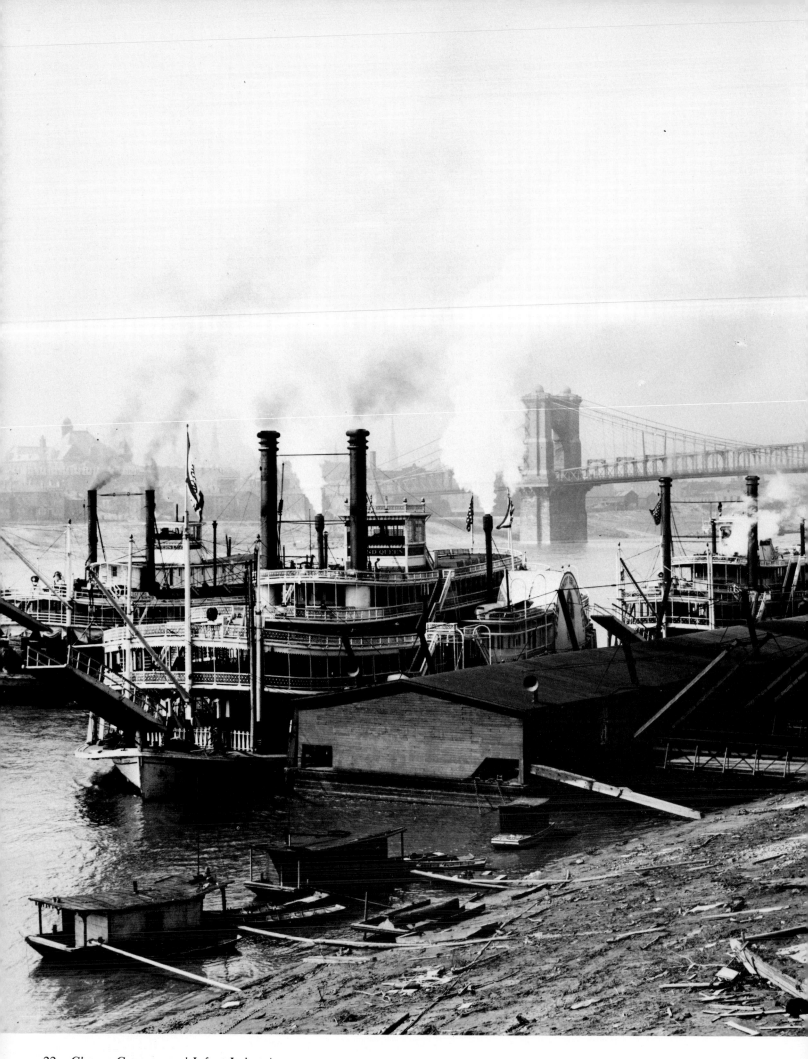

20

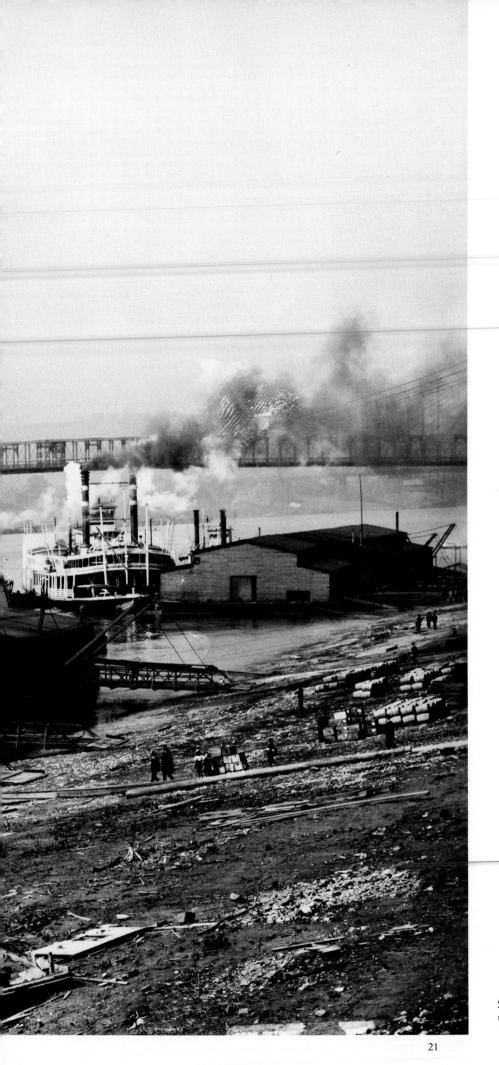

20. Canal boat in dry dock; no date; photographer unknown. 21. Along the levee, Cincinnati, Ohio, ca. 1907; photo by the Detroit Photographic Co.

21

Clumsy Cameras and Infant Industries 23

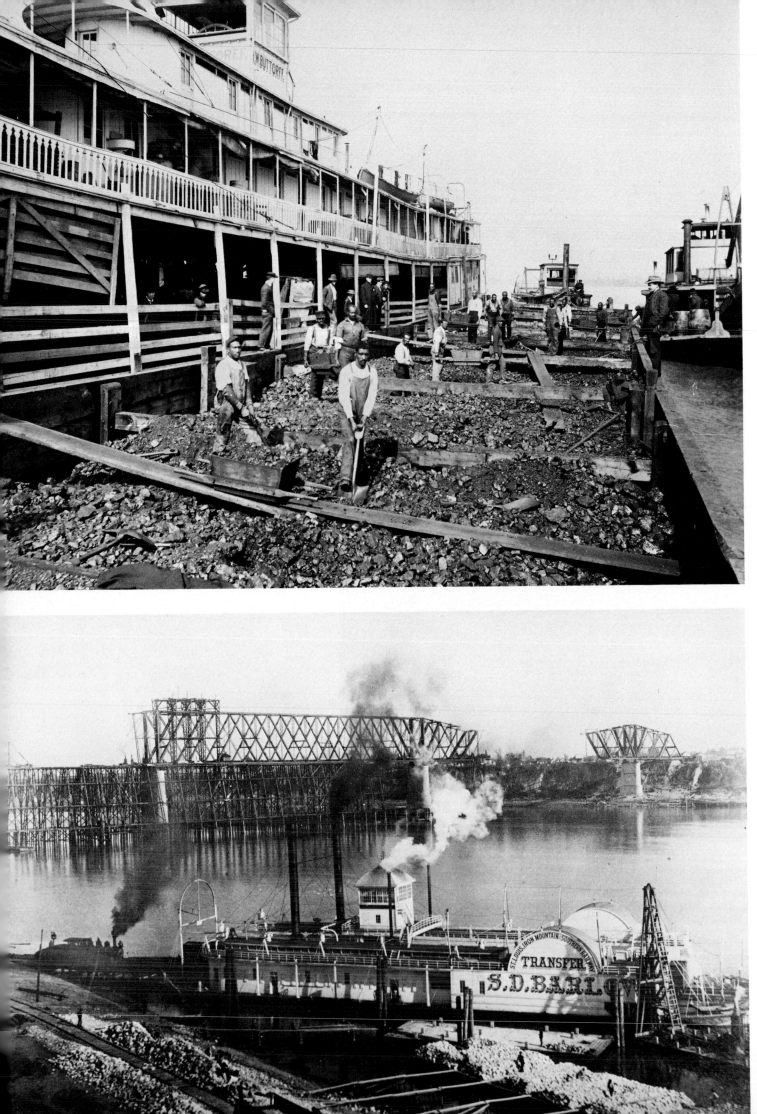

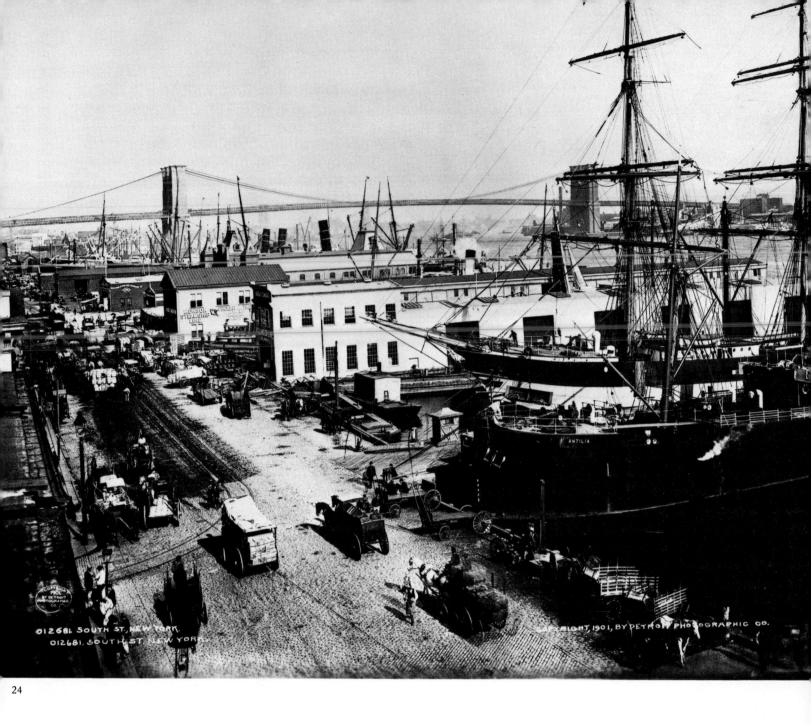

24

22. Placing coal in steamboat bunkers, Paducah, Kentucky, ca. 1910; photo by F. A. Muntzer of Evansville, Indiana. 23. Memphis Bridge under construction, Memphis, Tennessee, November 12, 1891; photo by Walter E. Angier. Note the small switch engine used for moving rail cars on board the transfer boat. 24. South Street, New York City, ca. 1901; photo by the Detroit Photographic Co.

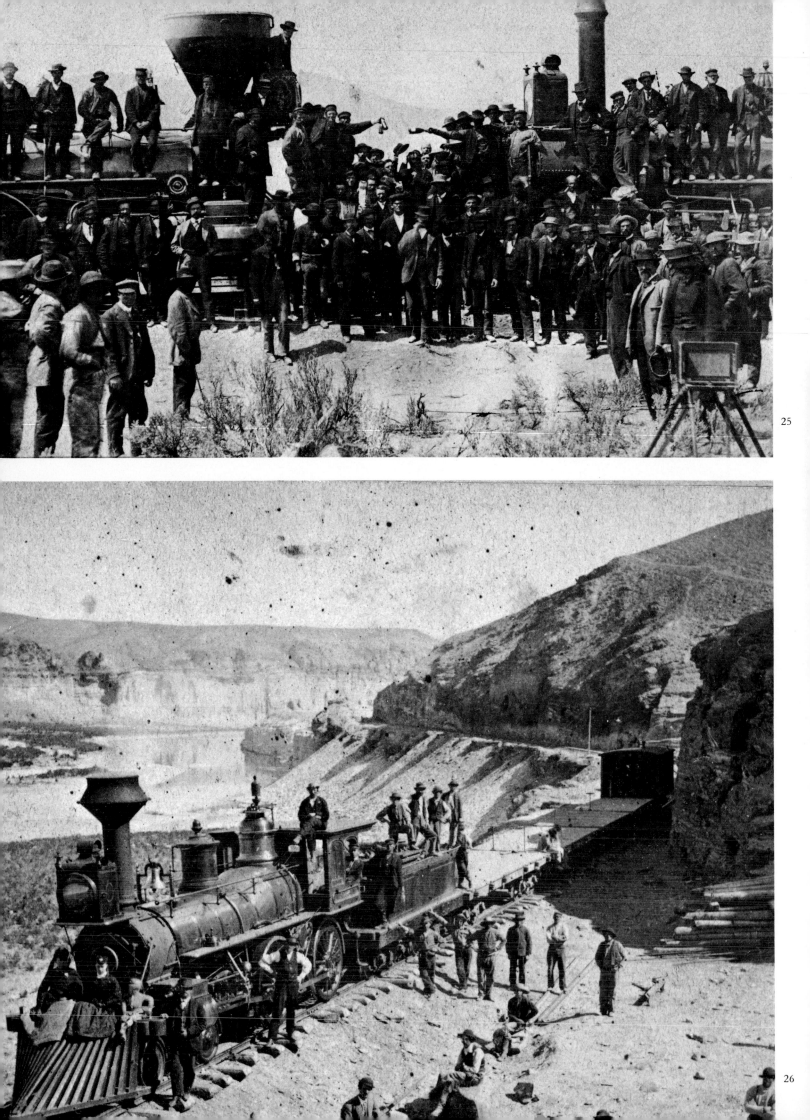

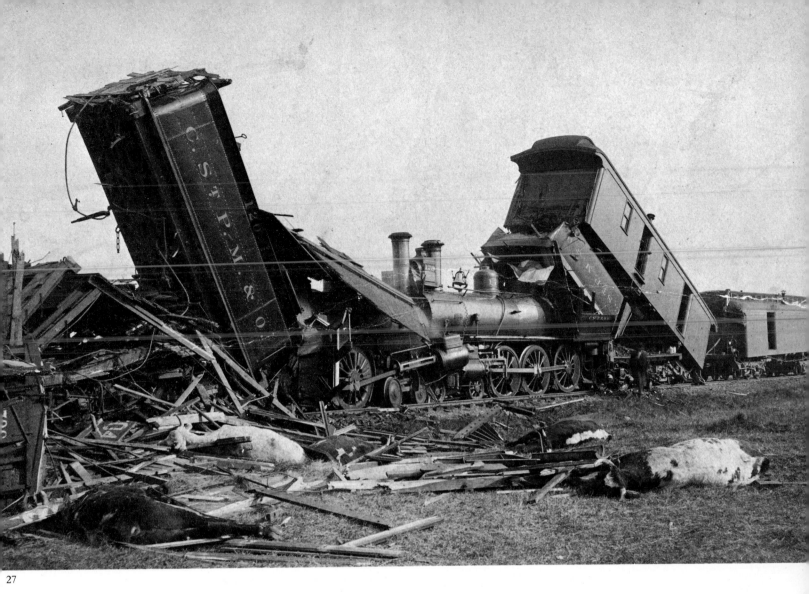

27

25. Connecting the Union Pacific and Central Pacific Railroads at Promontory Point, Utah, May 10, 1869; photo by C. R. Savage. 26. Rock cut, Green River, Wyoming, 1869; photo by C. R. Savage. 27. Head-on collision, September 9, 1881, on the Chicago, St. Paul, Minneapolis & Omaha Railroad, near Menomonie, Wisconsin; photographer unknown.

MAY 5, 1886.

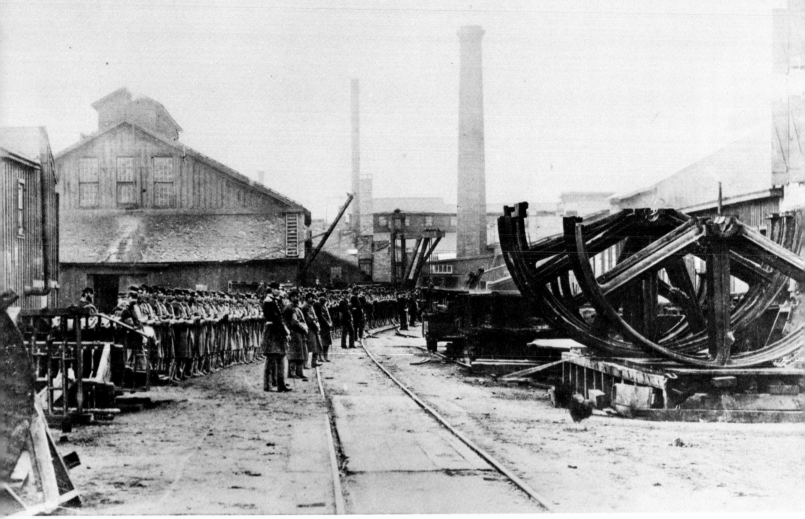

28. Allis Reliance Works, Milwaukee, Wisconsin, under the protection of state militia (first general labor strike), May 1886; photographer unknown.

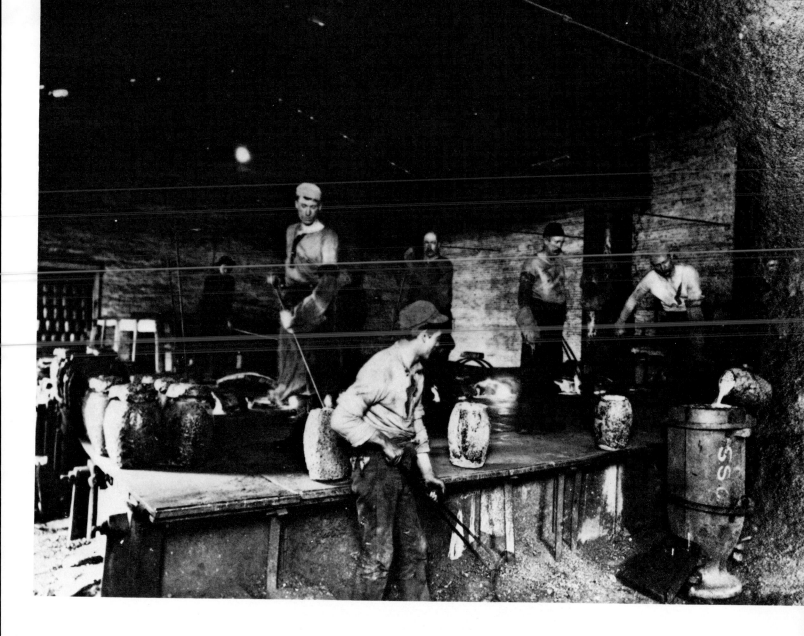

29. Pouring ingots, crucible steel process; no date; photographer unknown.

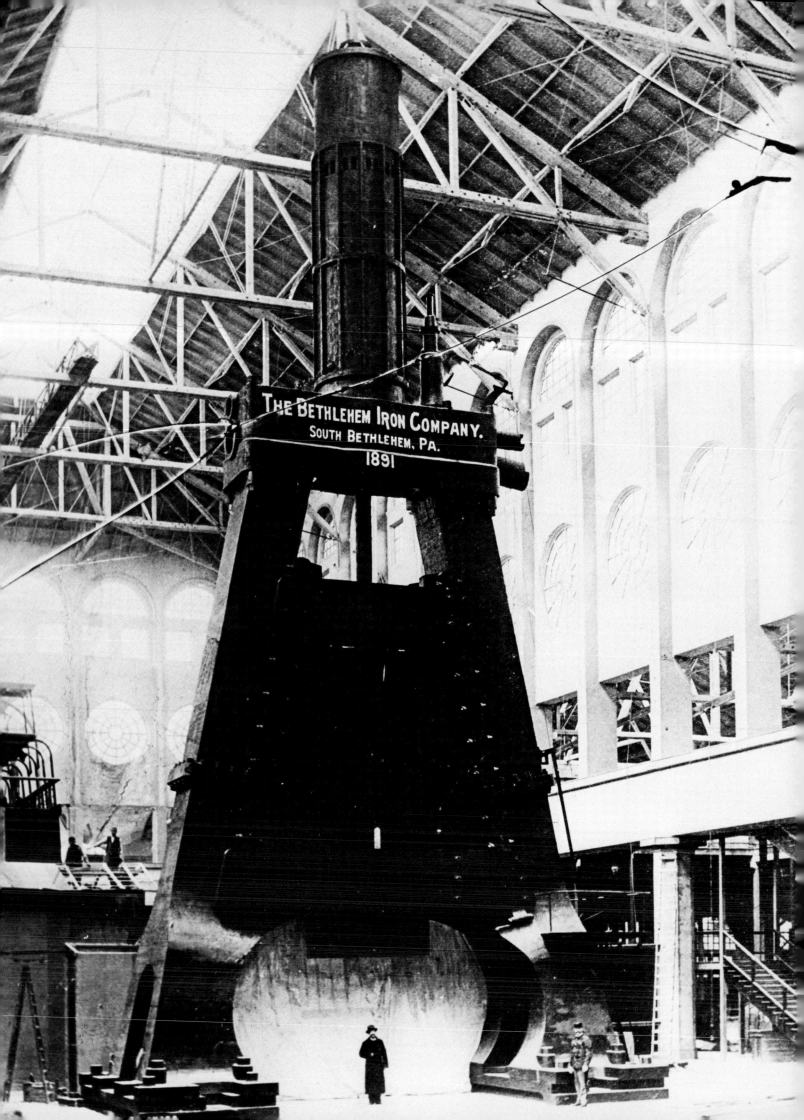

31

30. 125-ton steam hammer (with a man for scale) made by the Bethlehem Iron Company, 1891; photographer unknown.
31–34. Four-part panorama of the J. Edgar Thompson Steel Works, Braddock, Pennsylvania, ca. 1900; photo by the Detroit Photographic Co. (*Continued on the next two spreads.*)

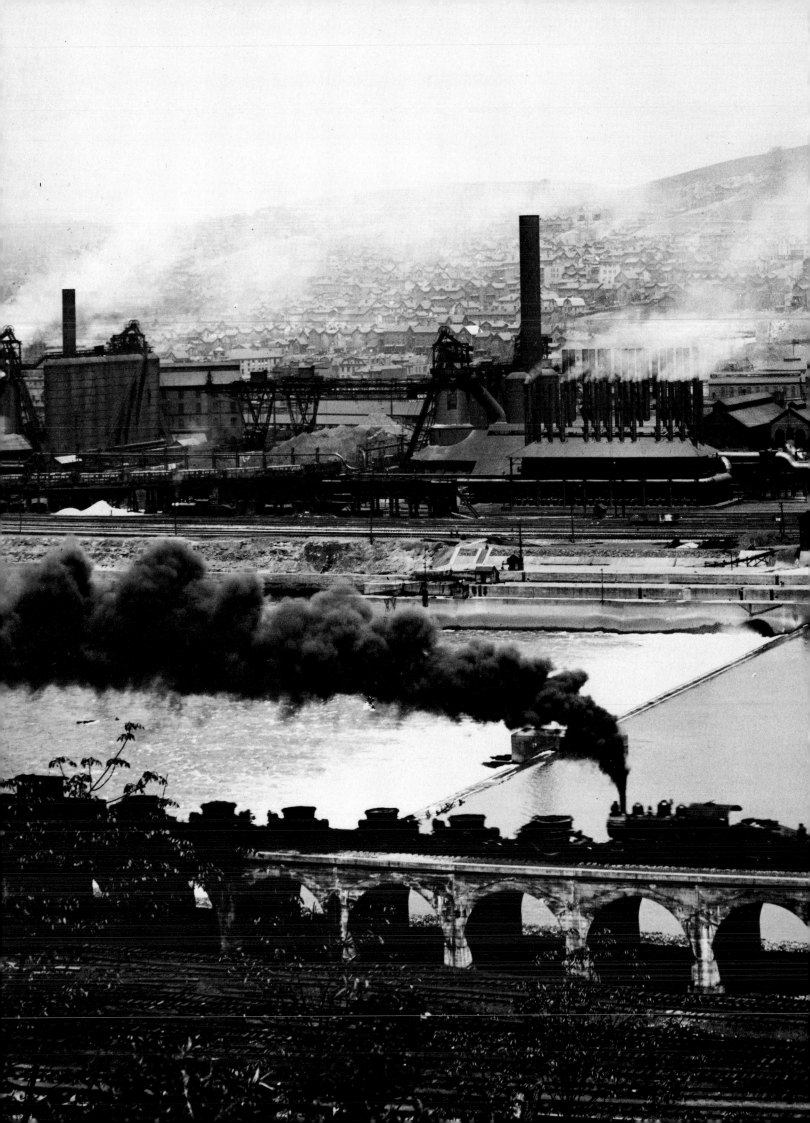

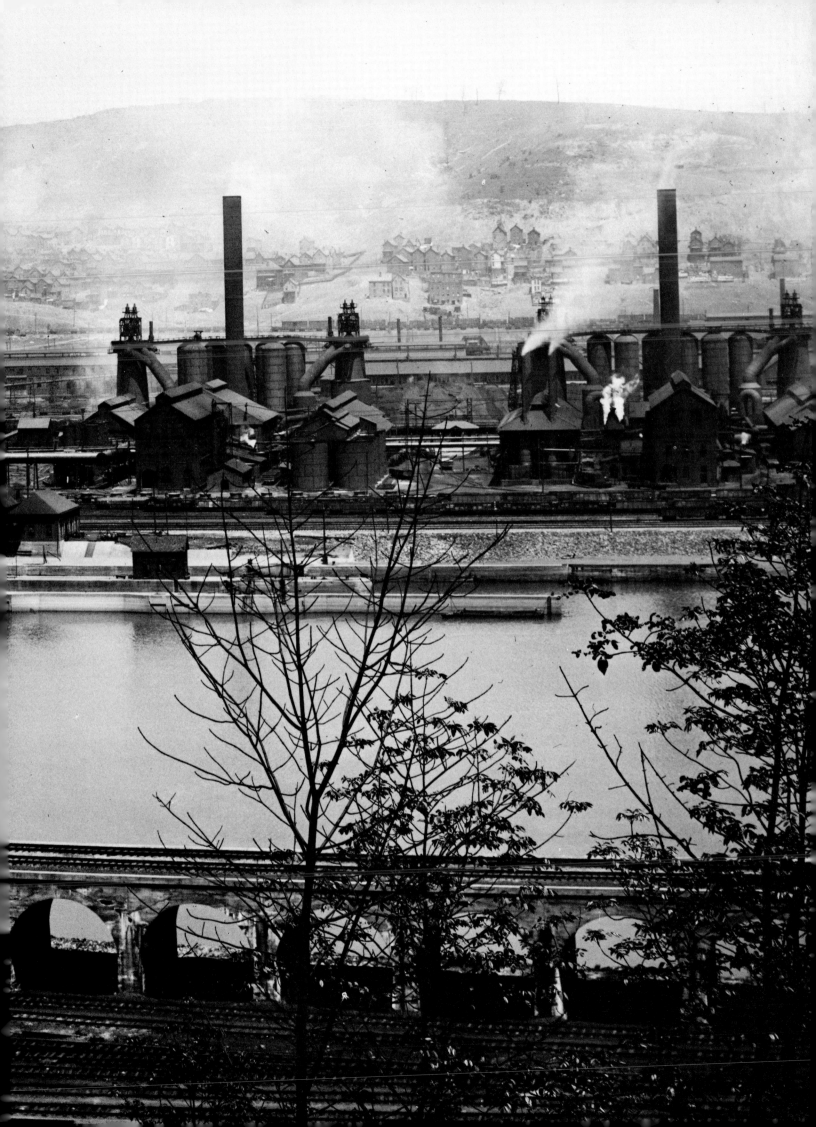

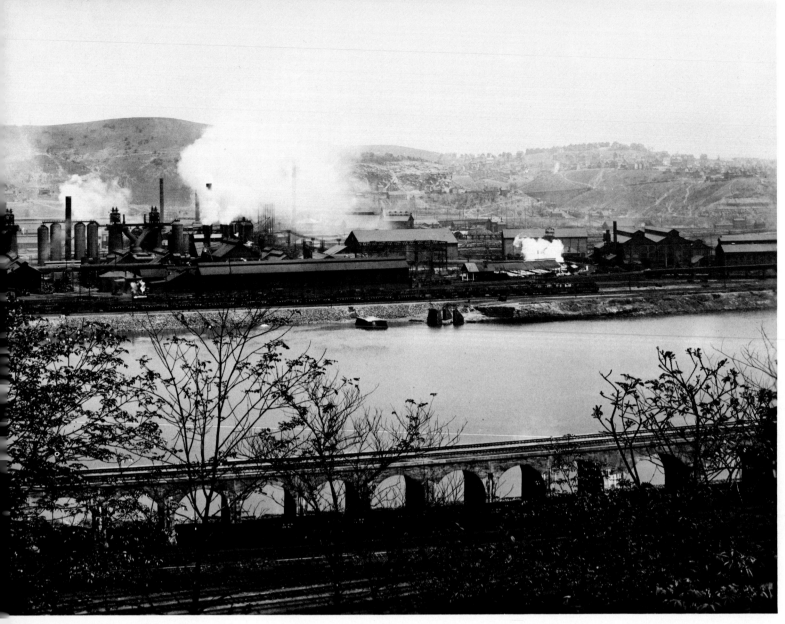

33

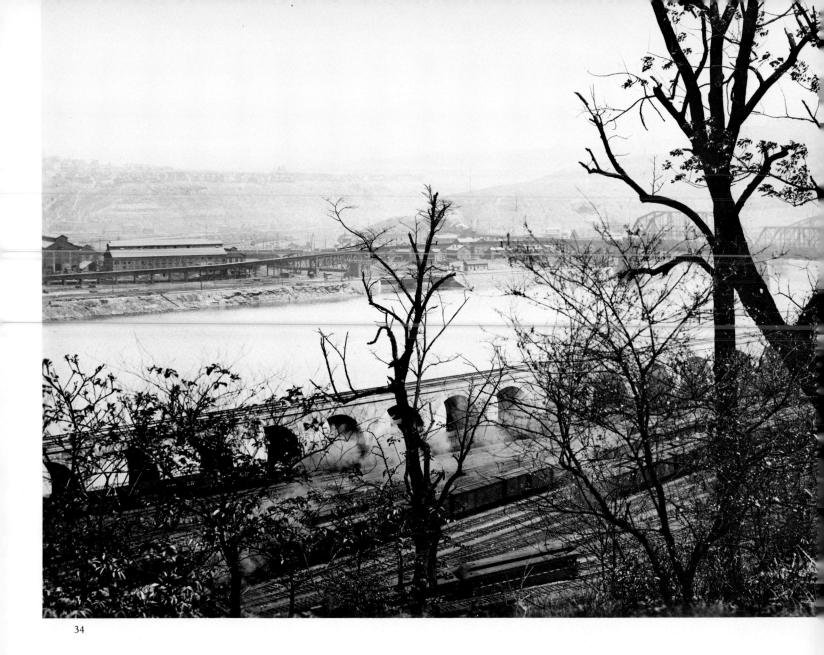

34

(*Conclusion of the panorama.*)

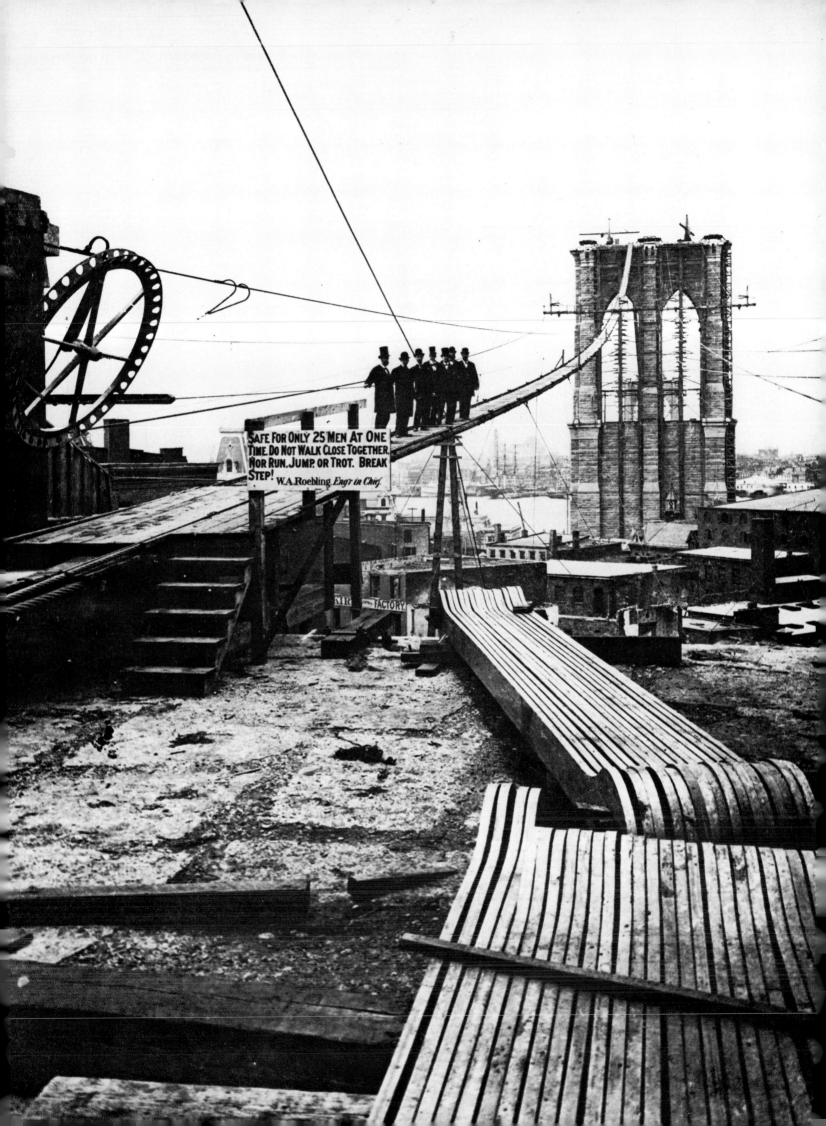

SAFE FOR ONLY 25 MEN AT ONE
TIME. DO NOT WALK CLOSE TOGETHER.
NOR RUN. JUMP. OR TROT. BREAK
STEP!
 W.A. Roebling. Eng'r in Chief.

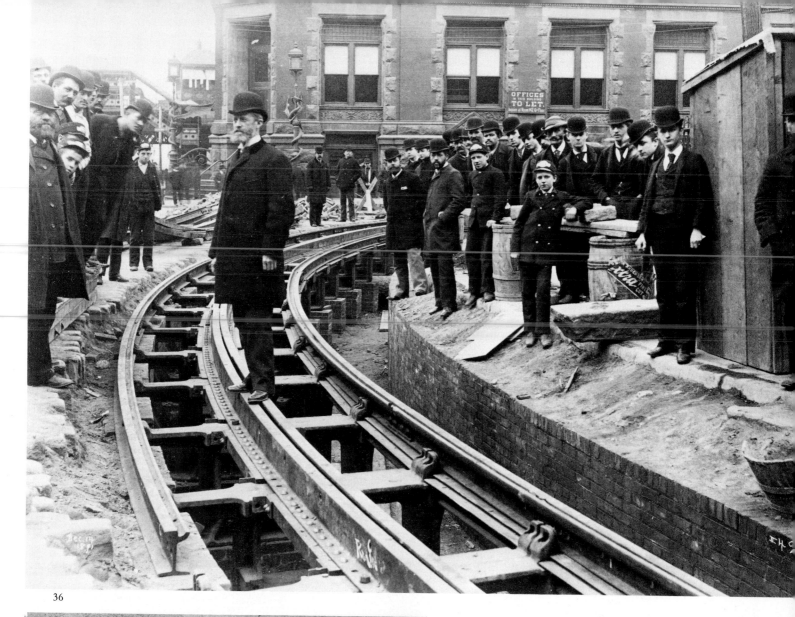

36

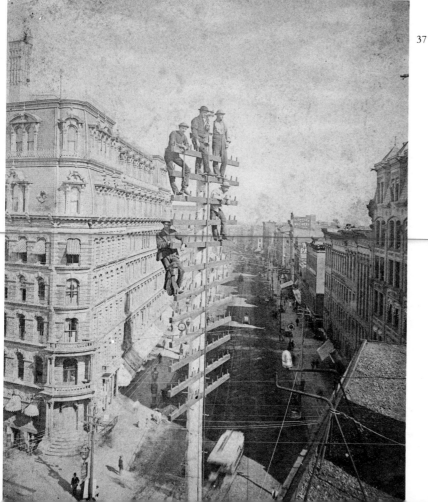

37

35. Brooklyn Bridge under construction, with engineers on the footbridge, 1878; photographer unknown. **36.** Cable-car line construction, New York City, December 14, 1891; photo by Langill. **37.** Telegraph linemen on a pole 95 feet high, corner of State and Main Streets, Rochester, New York, ca. 1885; photo by the Arcade Photo Co., Rochester.

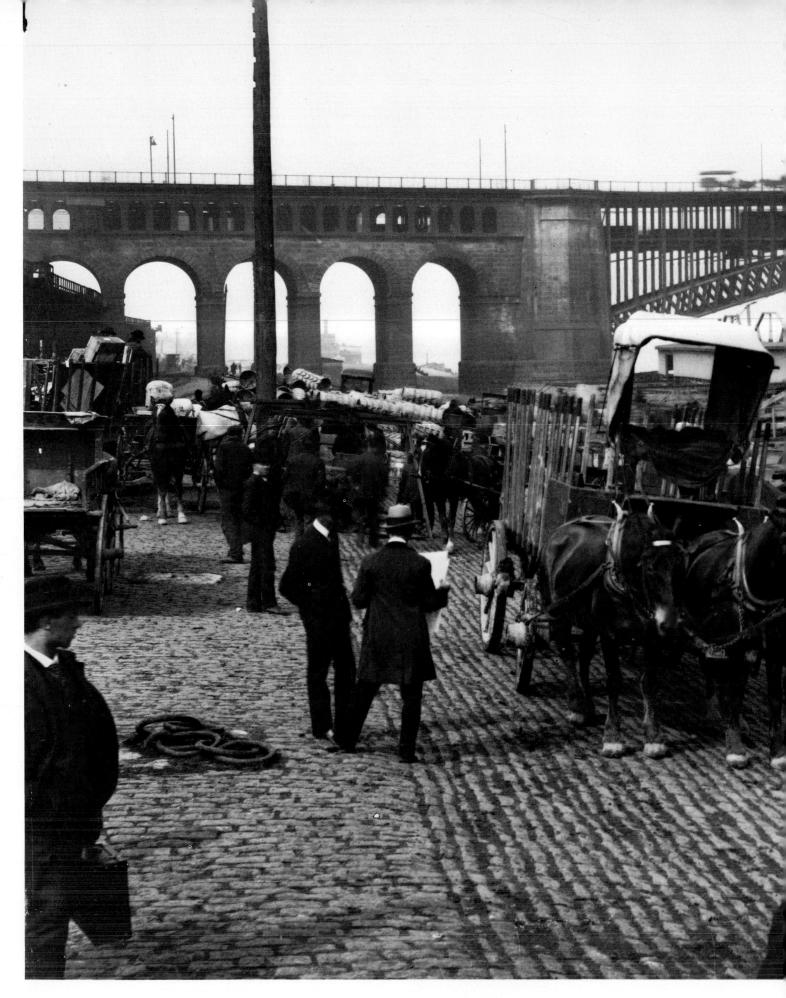

38. The St. Louis, Missouri levee with Eads Bridge in the background, ca. 1903; photo by George P. Hall.

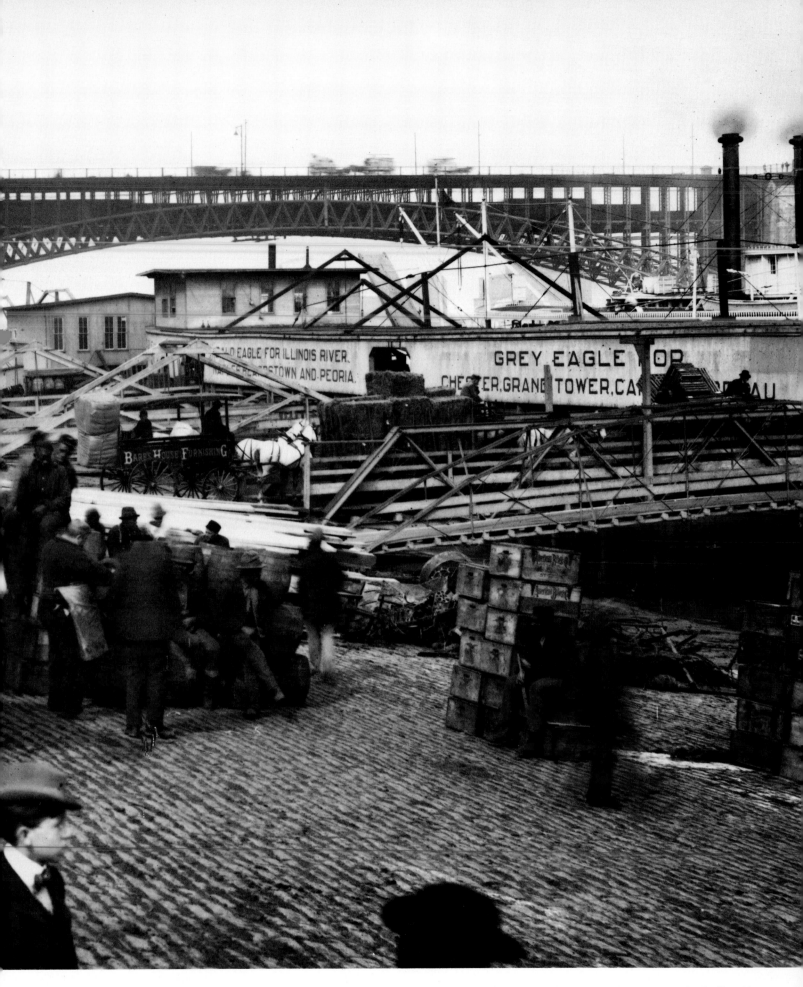

Overleaf: **39.** Workers coming off shift during the construction of the Louisiana Purchase Exposition in St. Louis, 1903; photo by George P. Hall. **40.** Skeleton of the Fuller (Flatiron) Building, New York City, ca. 1901; photo by George P. Hall.

Following spread: **41.** Brooklyn and Manhattan with the Brooklyn Bridge, ca. 1900; photo by George P. Hall.

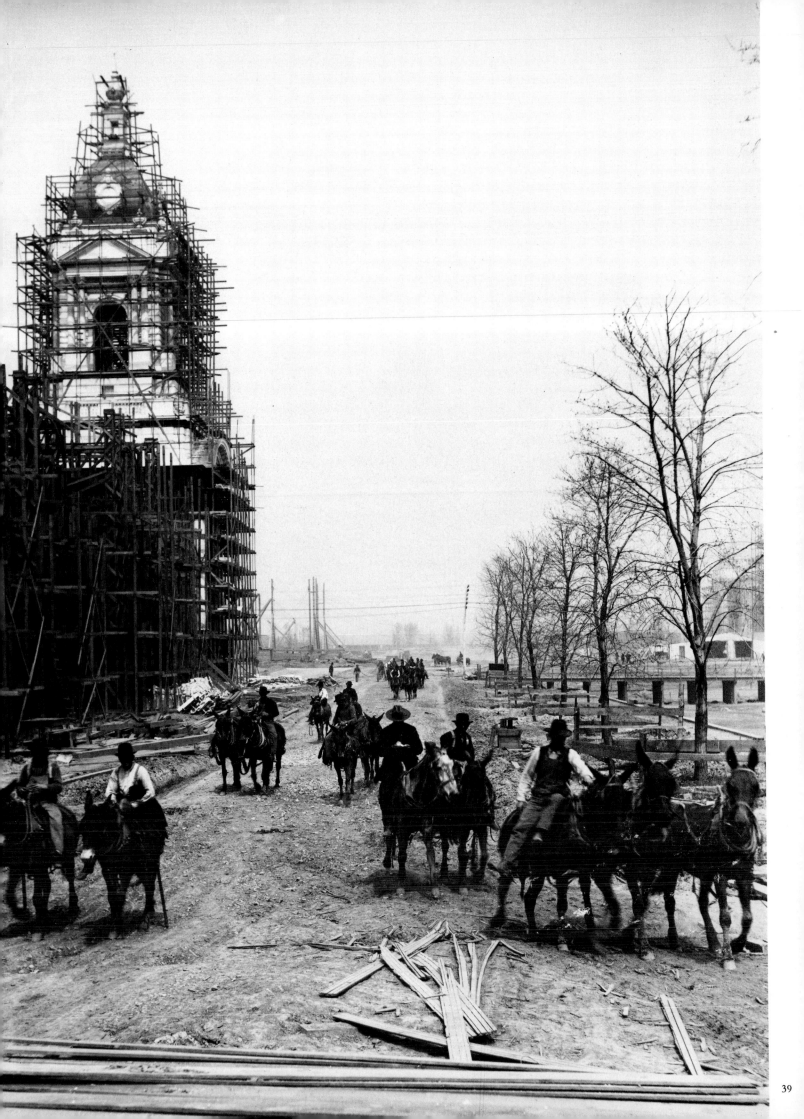

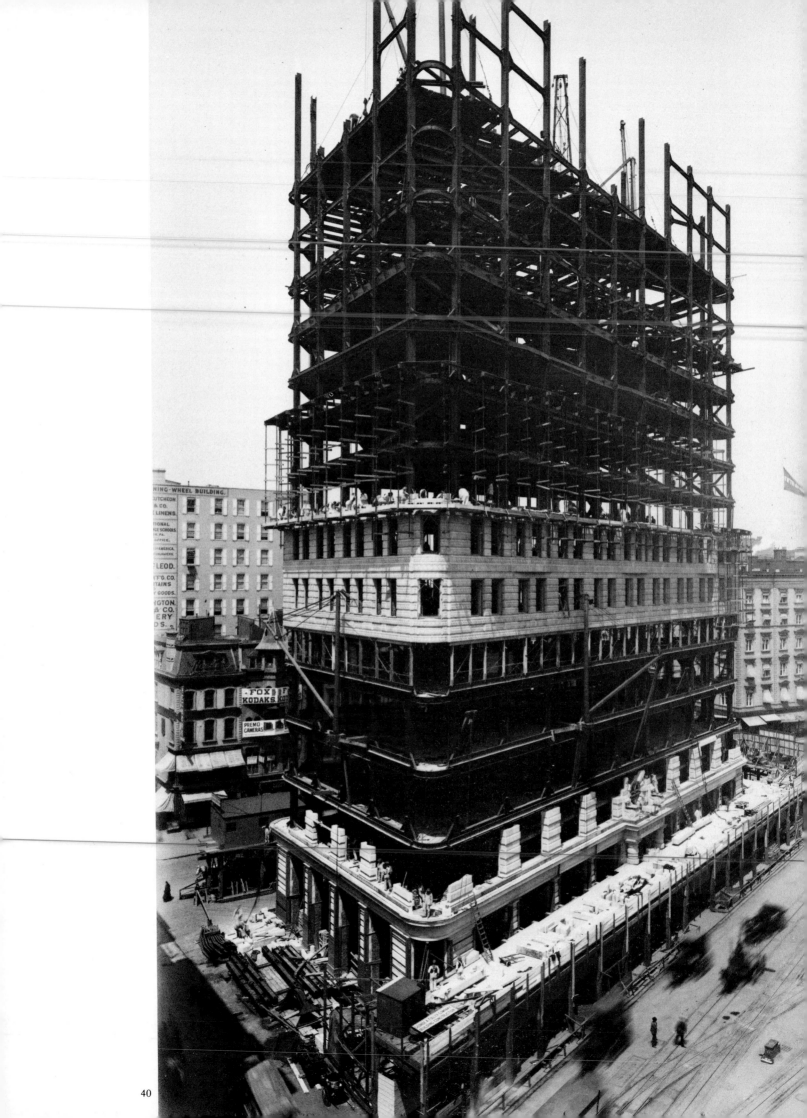

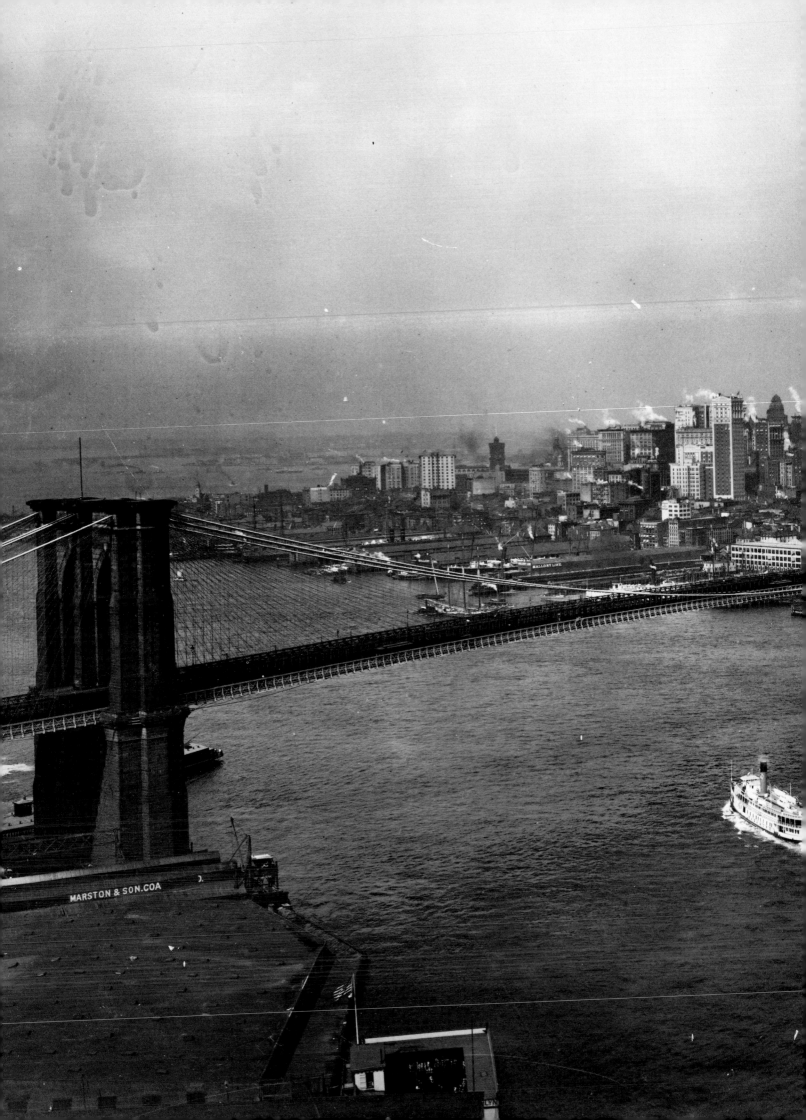

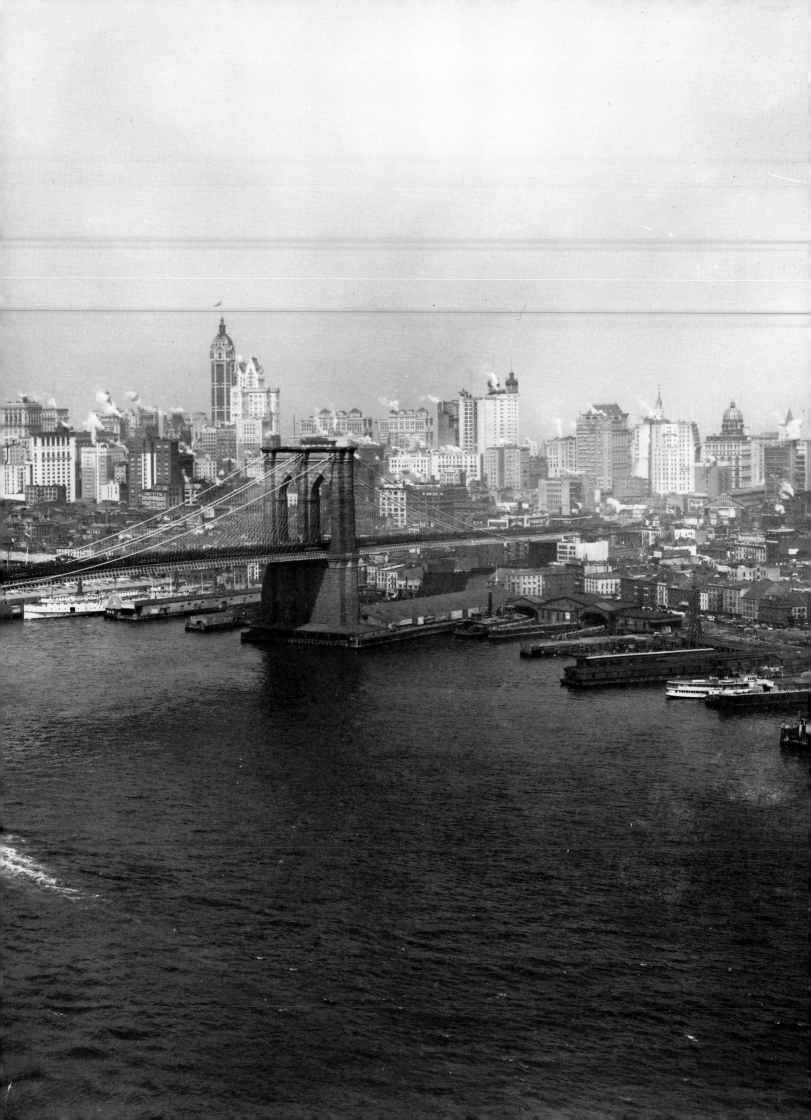

CAMERAS CAN COMMUNICATE!

The two decades between the turn of the century and the end of World War I were a period when American photographers began to grope toward an awareness that the theme of national industrialization was rich, not only in technical detail but also in symbolic and metaphoric elements. The market for photographs was changing and people's attitudes were changing. By 1910 many of the larger newspapers and magazines had developed the capability of printing photographs using a screen of tiny dots to reproduce the tones of the pictures. At the same time, many of the country's best writers and thinkers were calling for social change and a more responsible attitude toward those people who had been left behind or damaged by the pell-mell rush to industrialization. The general climate of questioning that pervaded the years which historians call the "Progressive Era" also took into account the nature of art. Young men (and even a few women) were visiting Europe and returning with the message that art did not consist of academic paintings of morality and nostalgia, but instead involved a search for images and symbols relevant to the period. In order to respond to the demands of the new era, photographers would need to be able to move beyond the straightforward task of recording exactly what a factory or machine or worker looked like. Fortunately, technical changes in photography itself made this transition a great deal easier than it might have been.

Technical changes have always been important to photography but few have had the impact of the introduction of dry-plate negatives in the late 1880s. Suddenly photographers could buy their negative plates from suppliers with the light-sensitive emulsion already coated on and dry. The plates were relatively stable chemically and with care could be kept for months. These glass plates were heavy and fragile, but they offered excellent precision and flatness and continued to be the choice of most professionals until well after World War I. For those who found the plates too difficult to deal with, there was an alternative by the 1890s in the form of the new flexible roll films. Although these new films could not be held as perfectly within the camera's plane of focus as a glass plate could (because of a certain tendency to curl and buckle), they were much lighter and easier to use. Amateurs took to the new roll films by the thousands, and as cameras improved professionals began to use them too. In addition to making George Eastman a very rich man, these new films made photography a far more mobile medium. Whether glass dry plates or roll film, the new negatives, with their emulsion pre-coated and dry, had the effect of breaking the technical leash that had previously bound photographers to their darkrooms.

Changes in the way a medium such as photography is used do not come overnight, nor are all photographers affected to the same degree. Many, such as William Henry Jackson and the less well-known but excellent New York photographer George P. Hall, saw little reason to change their basic commitment to the expository style, emphasizing fine technique and great detail. In the country's interior, far from the urban centers of creative change, the straightforward approach never went out of style at all. The historian has cause to rejoice in this for it has guaranteed a continuing record of factories, workers, new inventions (such as the automobile and the airplane), biggest buildings, longest bridges, worst riots and disasters. The visual record of a country undergoing change is an important part of the image of industry.

The automobile fascinated turn-of-the-century Americans, and well it should have. This first major application of assembly-line techniques was rapidly changing the outlines of American life. By the mid-1920s the majority of American families owned a car of some sort and mobility increased accordingly. Small country stores went out of business as rural people discovered that they could find much better prices by driving into town. Cities began to add new growth rings at their outer edges as the middle class, freed from the necessity of living near a streetcar line, headed for the supposed advantages of open country. The factories that produced these new automobiles were changing rapidly themselves, becoming more and more efficient and productive. In an age that loved efficiency, the general public enjoyed photographs of assembly lines and marvelous new machines, and so the photographs were taken. People also wanted to see the images of those who created these changes and so, again, the photographer was called on. For example, Nathan Lazarnick, a professional photographer of unusual skill, captured a moment which quivered between the solemn and the bizarre when he invited a beaming Henry Ford to climb aboard his Model A for the camera. The viewer can almost feel the tremendous pride and glee that Ford felt in his accomplishment. This was the dawning of the machine cult and Ford was its rising high priest. Who had a better right to grin fiercely into the camera?

The turn of the century saw the introduction of an entirely new way of moving people about with the invention of heavier-than-air flying machines. This particular industry was still in the curiosity stage during these years but the curiosity was intense. Katherine Stinson at the seat of her 1914 "pusher" seemed to understand that she symbolized the newest of new industries. Even the fact that she was clearly an attractive young woman helped to set avia-

tion apart from the earlier rail and auto industries, which were generally regarded as men's work in those days.

As more and more Americans felt their lives touched by big industry, more curiosity developed concerning the nature of large-scale business enterprise. Some businesses began keeping their own visual records of their activities (Ford, for example, was a pioneer in this area). Others were featured in the extensive catalogues of the Keystone View Company in stereopticon slides. Between 1900 and 1920 this company sold literally millions of slides on all subjects from religion to travel to industry in order to satisfy the curiosity of Americans. In the case of industrial photographs, the object was to show viewers what sort of things a certain industry did and to give some sense of the scale of a given business enterprise. In other words, these were expository pictures. People wanted to see what went on in a mine or a factory and so they bought sets of stereopticon slides and peered at them through the flimsy, unwieldy viewers.

Across the country from roughly 1900 to 1920, men and women stood beside their machines in obvious pride at being a part of the national process of industrialization. During the First World War women worked in heavy industry for the first time and were photographed with their tired-proud faces staring into the camera from their newly entrenched position, behind the lathe. The machinery was larger than ever and people were proud of that fact. The products were bigger, the furnaces hotter, the smoke smokier and, in most cases, photographers had done their job when they had captured a good clear image of these new wonders.

On the other hand, there were a few photographers of unusual drive or, perhaps, unusual sensitivity who were, by about the turn of this century, becoming dissatisfied with the straight expository way of working. Their search for ways to incorporate emotional impact into their images was touched off by different factors in different cases. In some instances, the desire for political and social reforms led to attempts to maximize visual impact. In some cases, market demands may have played a role, for the magazines and newspapers were making more and more use of photographs and these mass-oriented media demanded that their visual images contain a strong emotional appeal. Several photographers who led the search for industrial symbols appear to have been either uninterested in, or unaware of, either the reform ideology or the market realities of their period, however. These men were interested in a way of seeing which had more to do with the new ideas in art that were coming out of Europe at the time. A brief look at several of the men who took the lead in changing the way photographers approached industry may help to bring some of these motivations into better focus.

Lewis Hine's career is a case in point. Hine, more than anyone else before him understood that a camera can be used to provoke approval or disapproval. The angle of the camera, the lighting, the pose of the subject can all affect the finished picture and predispose the viewer in one way or another. While Hine was a true product of the progressive era, and therefore believed that profit-oriented industry held out the best promise for man's upward social progress, he also believed strongly that American industry was in need of reform. A gentle, quiet man, Hine could be vicious in his photographic attacks on those industries

which worked children in dangerous or unhealthy conditions or forced women to work hours that were inhumanly long for wages that were obscenely low.

Hine was a humanist, a deeply political man with a strong feeling for the underdog in society. His work in photography began shortly after the turn of the century, in a period when the terrible social costs of the first generation of national industrialization were becoming all too clear. Hine went into the textile mills of the South and found ten-year-old children working twelve hours a day. His camera recorded their sad faces and the tangle of dangerous machinery that formed their environment. He photographed newsboys in New York City who hawked their papers on the streets in all weather to earn a pittance. He found children working in the heat and fumes of glassworks and tin shops. He found women and recent immigrants working in crowded and awful conditions, and he photographed it all. He used side lighting (which he called "Rembrandt lighting") to relate his images to the old masters, consciously adding gravity to the photographs. He had no qualms, either, about consciously posing a young immigrant woman in such a way as to recall classical madonnas. Hine considered himself to be in a battle with forces of evil and he used whatever visual weapons he could command.

Hine's photographs were widely used. Reform groups such as the Russell Sage Foundation used them to illustrate their studies of urban problems. The popular magazine *Charities and Commons,* owned by the reform-oriented Kellogg family, retained Hine on its staff for several years. His big 5″ × 7″ glass-plate camera became a real force in bringing before the comfortable middle class of the period the visual evidence that not all Americans had benefited from the new industrialism. Slowly Americans began to change their thinking regarding labor. Less and less could the professional class think of workers as mere figures on a profit-and-loss column. One reason for the effectiveness of Hine's work was that Americans, being essentially pragmatists, accepted without question the idea that "the camera does not lie." It would be years later (by which time the camera had learned to lie quite glibly) before Americans would start to question this prime article of visual faith.

By World War I Hine had demonstrated that he could use his camera to support a political position. He had learned to select his subjects, to use pose, light and surroundings to emphasize his feelings. What Hine had done, others could learn to do. Photography was no longer confined to the simple recorder role. It could express a point of view. The visual vocabulary that would soon be known as industrial photography had been enriched.

During the same period that Hine was at work, using the camera to press for political action, others were learning to use the camera on an entirely different level to express their own emotions. When these men directed their cameras at American industry, they saw it in terms of symbols and metaphors. Their images, much less direct than those Hine produced, were yet, in their own way, more powerful. Men like Alfred Stieglitz and Alvin Langdon Coburn were not primarily industrial photographers (if anybody was in those days) but they did, on occasion, photograph industrial subjects, and when they did they brought something new to the field. Both men had studied art in Europe and both took the symbolic

language of painters as their model. When Stieglitz photographed a railway station he did not see it in the literal manner of his predecessors. He did not even see it in the way of most of his contemporaries. While the vast majority of photographers continued to be preoccupied with "the thing in itself," Stieglitz saw the dark and gloomy station with its hulking engine and brooding clouds as "The Hand of Man." He saw the power imprisoned in the locomotive and the strength of the metallic rails and conveyed all this to the viewer, along with a troubling presentiment that man's hand might not be entirely beneficial. In other cases Stieglitz was attracted to the lights of the modern city and the soaring architecture of America's iron age. He returned time after time to New York City's skyscrapers, trying to capture the feeling they evoked in him of grace and power and beauty.

Alvin Langdon Coburn used a camera in a similar way. He was not a bit interested in reform politics, but he was deeply interested in elevating photography to the level of accepted art. When he went to Pittsburgh to photograph steel mills, he saw the smoke and grime of heavy manufacturing as an ultimate symbol of American progress. The New York harbor affected him in much the same way. Here were men at work. Here were power, energy and massive production. Here was something uniquely American. The influence of French Impressionism may be seen in his technique, for he often used soft focus (a bit gratuitously, to the modern eye), but his selection of angle and emphasis was unerring. Coburn saw the factory's chimney belching smoke as an iron-age symbol of progress long before most photographers had learned to think in those terms. He saw rhythm and pattern in the industrial landscape and he knew how to communicate these feelings to those who viewed his photographs.

Coburn, Stieglitz and Hine are familiar names that we recognize and can discuss, partly because they did help to expand the visual language of their day. Their names are also remembered because of fortuitous historical accidents. They all worked in and around New York City, then as now the center of American communications. They became so well known that their work has been preserved by museums and libraries in careful association with their names. This is as it should be, for all three were tremendously influential, but it should not blind us to the fact that fine work was also being done by hundreds of less well-known photographers, who have in some cases even remained anonymous. Who, for example, took the beauti-

fully detailed photographs of Henry Ford's early manufacturing operations?

When the historian encounters historically important collections of early industrial photographs, he will nearly always find a majority of them marked "photographer unknown." In fact, anonymity is a major problem in the serious consideration of industrial photography as a style, for people who deal critically with photographs (or paintings, or novels, or poems) usually like to know who produced the work they are analyzing. This is a natural impulse, but the information is not really always necessary. If a picture's primary significance is historical, it may not be particularly useful to know who took it. If a photograph is unusually beautiful or striking, it still stands out in a collection whether it is supported by a "known" photographer's reputation or not. Thus, anonymity may actually purify our estimate of a photograph. We are forced to look at the image on its own terms instead of saying to ourselves, "Isn't that a beautiful Stieglitz?" American industry was operating on a very large scale by the turn of the twentieth century, and this scale often rendered its photographic observers anonymous. Their names were simply lost in the corporate vastness. We can be thankful, however, that their visions have, at least in some cases, survived.

The United States was changing rapidly during the first two decades of the twentieth century. Cities were swelling with newcomers from abroad as well as native Americans (both white and black) arriving from rural areas. These people had to learn to live together in the complicated new environment of the industrialized city. They had to try to understand themselves in relation to the new patterns of life in which they found themselves immersed. They picked up the popular magazines and newspapers; they listened to political leaders; they joined organizations; they sought in all sorts of ways to understand their new social roles. They were influenced by speeches and printed matter, but more and more they were also influenced by the photographic images that they encountered. An image of a soaring bridge might make them proud to be a part of America's wonderful new technology. An image of a child in a textile mill might make them angry. A photograph of Henry Ford sitting in one of his cars might remind them of the classic American dream, the rags-to-riches story. In the hands of skilled photographers, the camera was starting to do more than just record. It was starting to lead.

ABOUT THE PHOTOGRAPHS

X. The Automobile (Photos 42–48)

No invention has done more to shape the twentieth century than the automobile. Americans in their restless search for mobility took to the family car in incredible numbers. In 1900 about 4000 cars were produced in this country. By 1929 some 4,800,000 were built every year. The automobile stimulated other industries, such as steel and glass manufacture and, of course, it set off a tremendous wave of highway building. Little wonder, then, that Henry Ford—whose development of the moving assembly line to the level of a high art made the automobile affordable to millions of Americans—was regarded as a major folk hero of his day. During the 1920s a British visitor wrote (without a trace of irony): "As I caught my first glimpse of Detroit, I felt as I imagine a seventeenth-century traveller must have felt when he approached Versailles." His sense of awe was not amiss, for the automobile was changing the Western world.

XI. Flight (Photos 49–52)

The nation's fascination with "firsts" and its love of technology insured that many photographs would be taken of the earliest attempts at flight. The aircraft industry was not large in the years before World War I, nor did it attain much importance during the early postwar years, but it aroused great curiosity and for many came to symbolize the tremendous potential of the industrial future.

XII. Mining (Photos 53–58)

As the country became industrialized, the demand for metal ores increased tremendously. In 1889 U.S. metal mines shipped 158 million dollars' worth of ore. By 1919, in spite of war and its destruction of international markets, U.S. mines shipped out 545 million dollars' worth of ore. In both the deep mines and the open-pit operations, men worked hard, often in dangerous surroundings. In addition, little consideration was given to ecological destruction. These conditions existed in American mining for the simple reason that nobody cared or considered it important to do anything about them. Production was what was wanted. Production was the goal and the source of pride for everyone in mining, from the top to the bottom of the industry. Production was achieved too, but the cost was considerable.

XIII. The Worker and the Machine (Photos 59–63)

The turn of the twentieth century saw the pace of U.S. industrialization quicken. The machines became larger and faster.

As yet, however, workers in the photographs do not seem to be intimidated by the monsters they tend. Rather, they appear to have been excited and proud of the scale of their endeavors. The women who entered heavy industry during World War I seem to have caught the enthusiasm of their male counterparts.

XIV. Lewis Hine on Labor (Photos 64–68)

By shortly after the turn of the century Lewis Hine was using his cameras to depict American industrialization in a new way. For the first time an American photographer was actually taking his camera into the factory and the sweatshop to show viewers the cost of industrialization in human terms.

XV. Stieglitz—the Industrial Symbol (Photos 69 & 70)

Alfred Stieglitz was certainly not an industrial photographer in any normal sense of the term, but he was interested in the modern industrial city as a source of symbols of twentieth-century life. His work was far more detached than Hine's. He never got down into the lives of the workers, for example. Yet photographs such as "The Hand of Man" and "The City of Ambition" did succeed in making universal statements on a level that was broader and more complex than Hine's work attained. Hine attempted to make his visual statements as simply and directly as he could. Stieglitz recognized ambiguities all around him.

XVI. Alvin Langdon Coburn (Photos 71–73)

Alvin Langdon Coburn was a thoroughly professional photographer who made a good living with his cameras. His portraits of important people and his informal, often rather pastoral, images of his friends and family were probably his best-known works in his own time. Coburn did like to photograph heavy industry, however, and accepted many industrial assignments. Like his friend and mentor Alfred Stieglitz, Coburn approached industry from a background of formal study in art. He was excited by the symbolic possibilities in a bridge or in a factory chimney. When he photographed a steel worker, he tried to capture an image that would stand for all workers. By combining some of Hine's emotionalism with Stieglitz's cool detachment, Coburn achieved a level of visual expressiveness on the subject of industrialization that no one before him had attained. After looking at a large block of his work, one cannot help but suspect that Alvin Langdon Coburn deserves the distinction of being called our first modern industrial photographer.

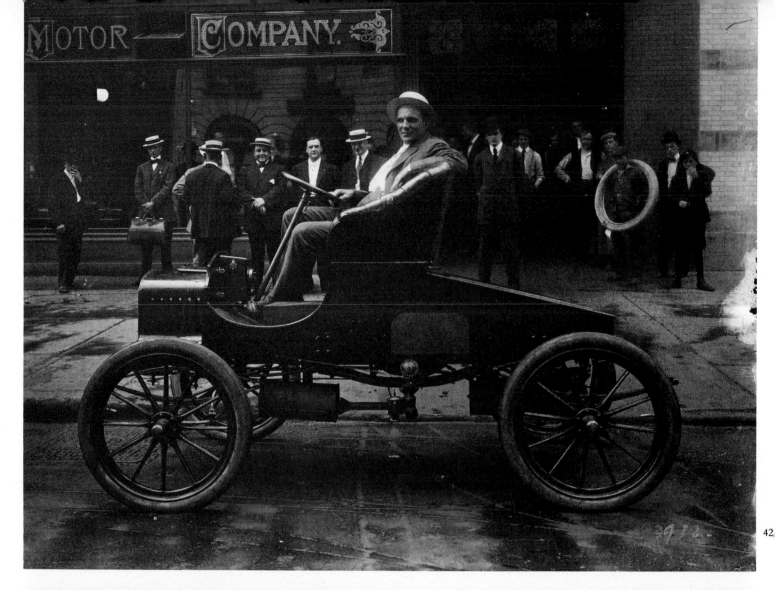

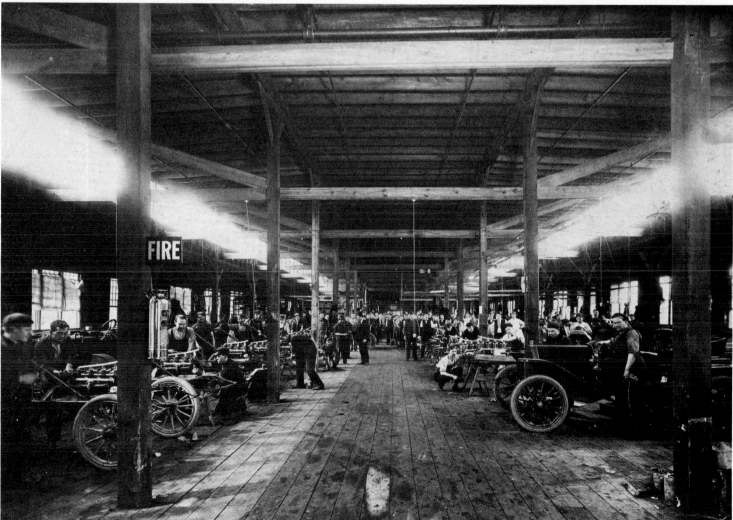

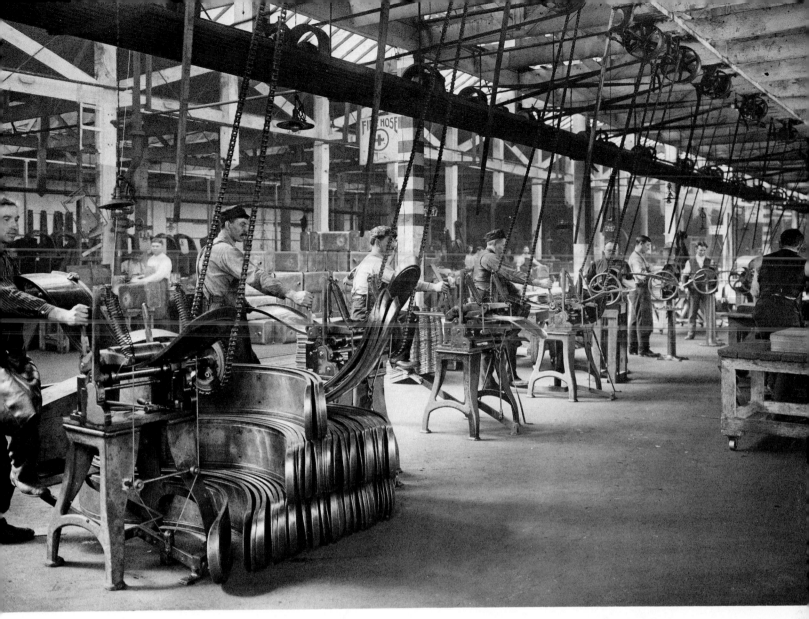

44

42. Henry Ford in his original Model A, Detroit, Michigan; no date; photo by Nathan Lazarnick. 43. Auto assembly room of the Overland Car Co., Detroit, ca. 1900; photographer unknown. 44. Bending fenders at the Overland factory, 1909; photographer unknown.

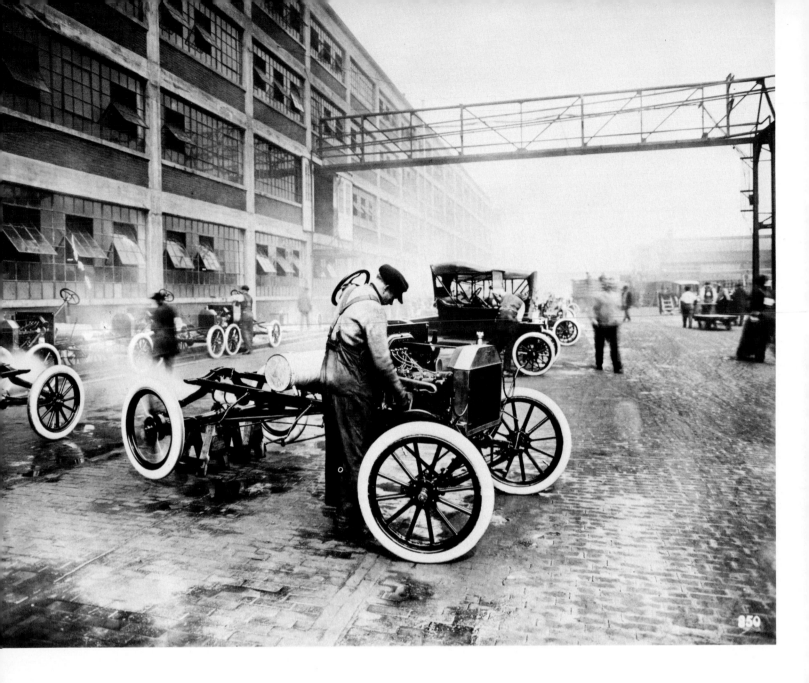

45. Ford assembly line, Detroit, ca. 1913; photographer unknown.

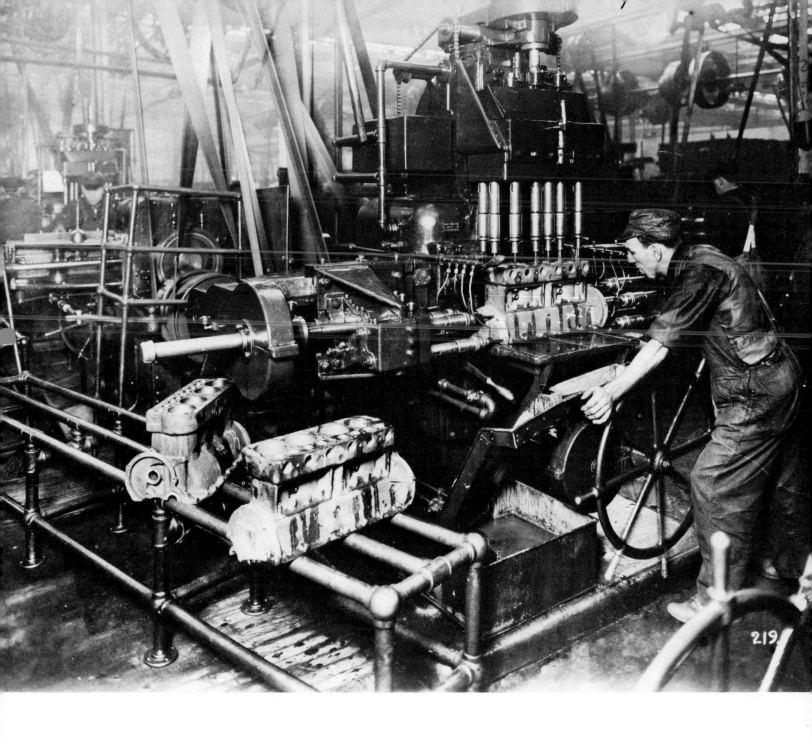

46. Milling cylinder blocks at the Ford plant, ca. 1913; photographer unknown.

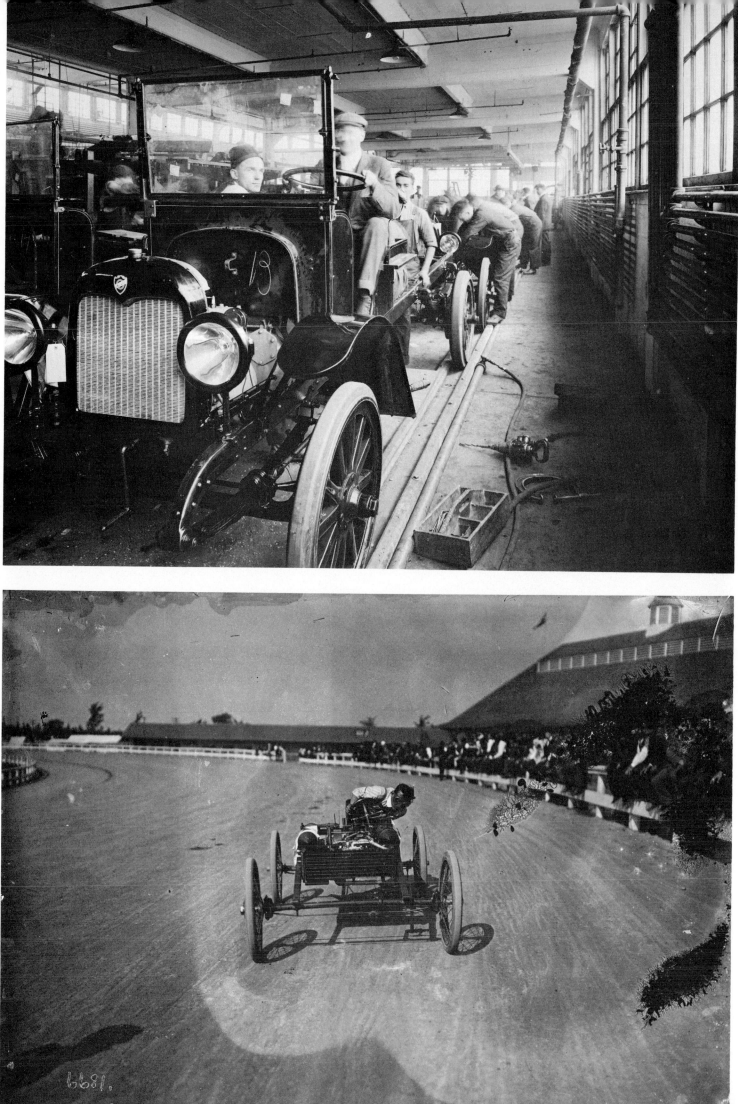

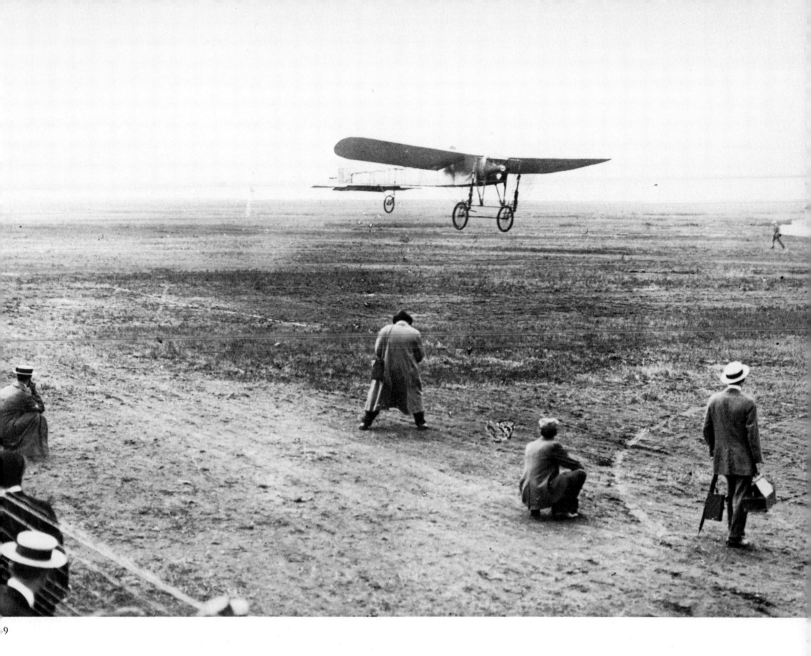

47. Truck assembly at the Maxwell Motor Co., Detroit, ca. 1918; photographer unknown.
48. Automobile racer; no date (pre-World War I); photo by Nathan Lazarnick. **49.** A Blériot airplane landing; no date (pre-World War I); photo by Jimmy Hare.

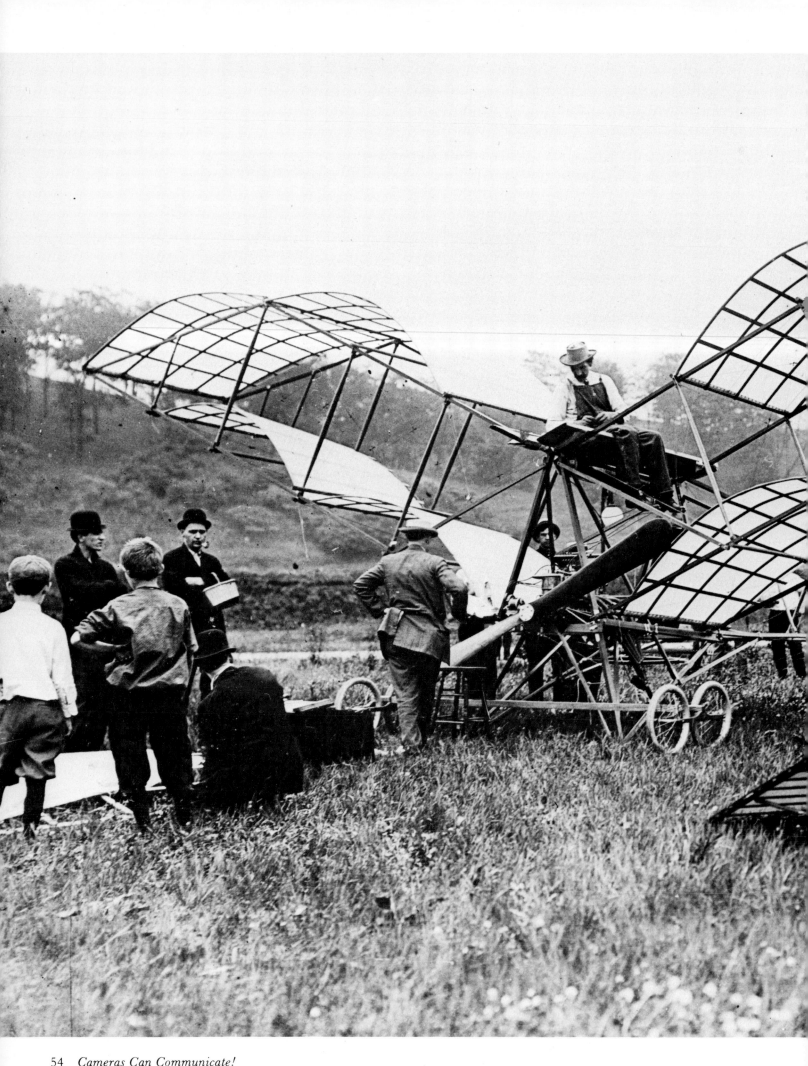

50. First attempt at motorized flight in the Pittsburgh, Pennsylvania area; no date; photo by Frank E. Bingaman.

Cameras Can Communicate! 55

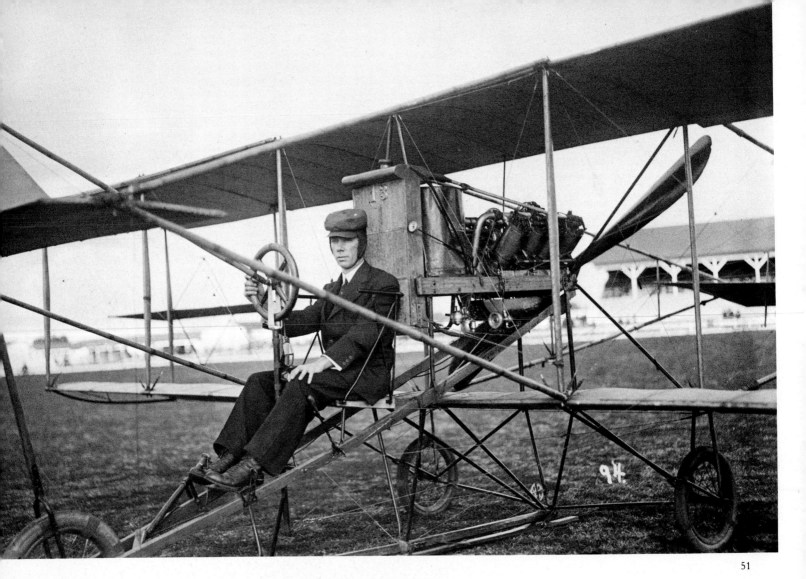

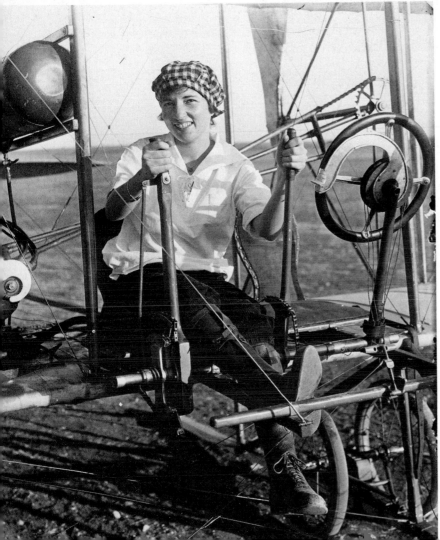

51. Coronado, California air meet, 1912; photo by Robertson.
52. Katherine Stinson in her Wright airplane, 1914; photographer unknown.

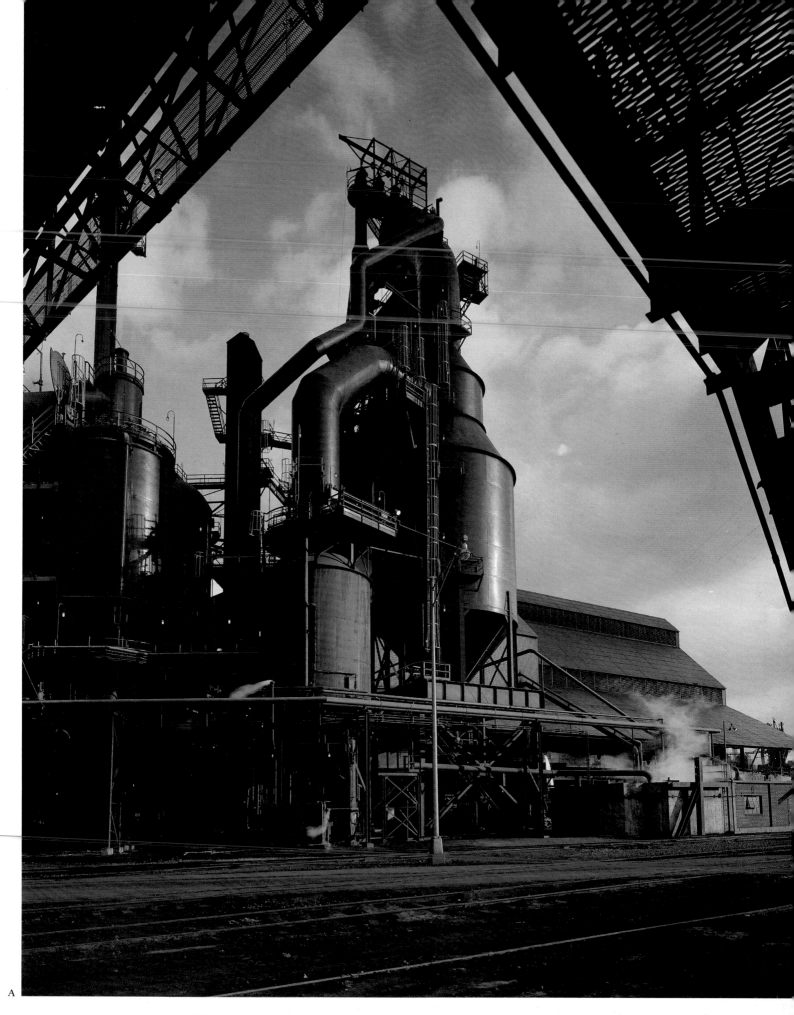

A

A. Exterior view of the J & L steel mill, Pittsburgh, Pennsylvania, ca. 1954; photo by Arthur D'Arazien.

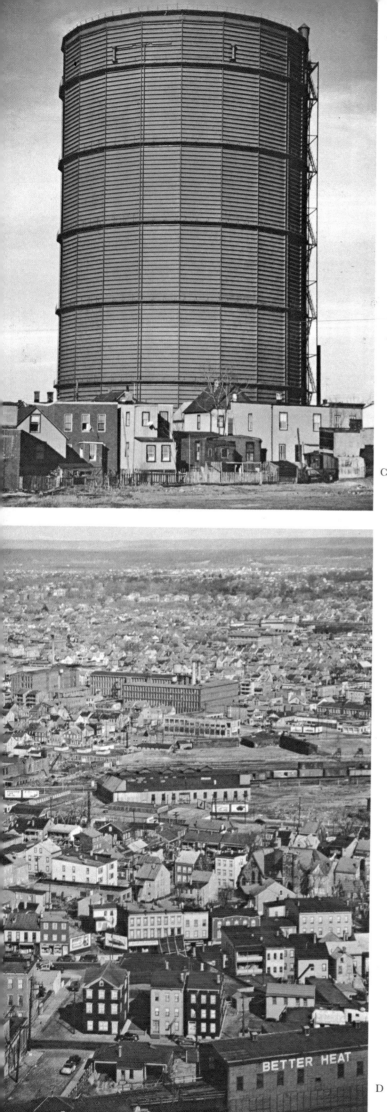

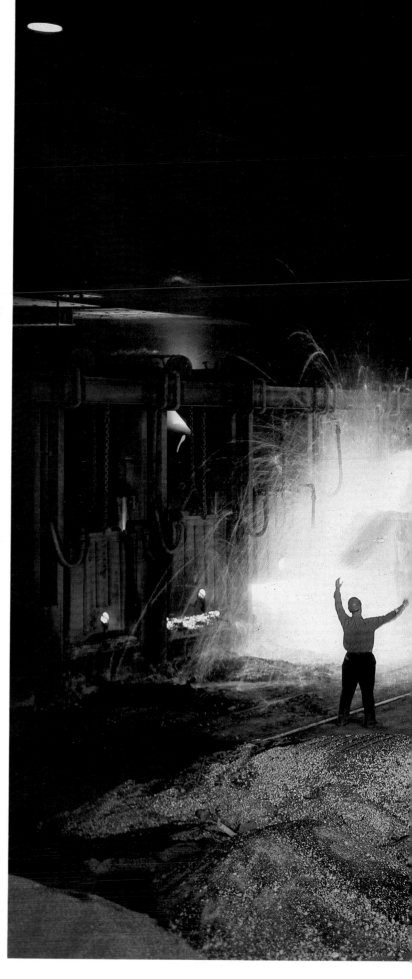

C. Houses and gas-storage tank, North Bergen, New Jersey, 1950; photo by Fenno Jacobs.
D. View of Paterson, New Jersey, 1950; photo by Fenno Jacobs.

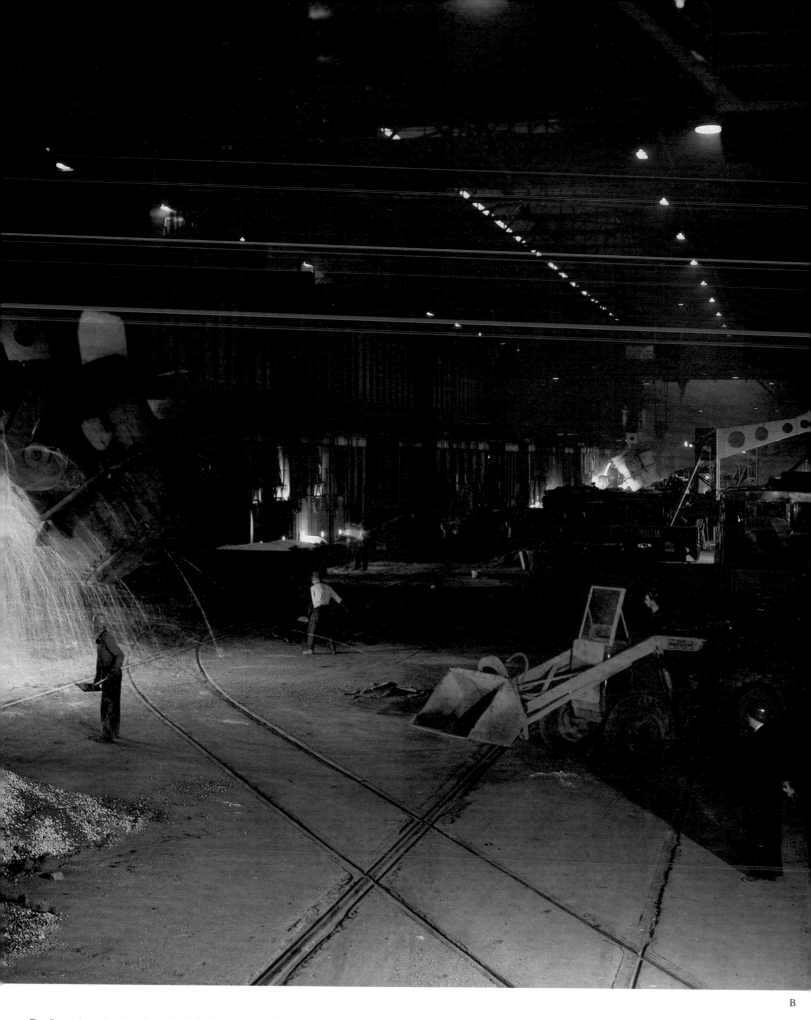

B

B. Open-hearth charging, J & L Steel, ca. 1954; photo by Arthur D'Arazien.

E

E. Steel bar passing through rolls at Aliquippa [Pennsylvania] bar and billet mill. The bars are run out onto a cooling bed, then cut to length. 1955; photo by Clyde Hare and Ivan Massar.
F. Cold water is sprayed on the bottom of a steaming Bessemer converter before removal for reconditioning—cleaning and replacing tuyeres. 1955; photo by Clyde Hare and Ivan Massar.

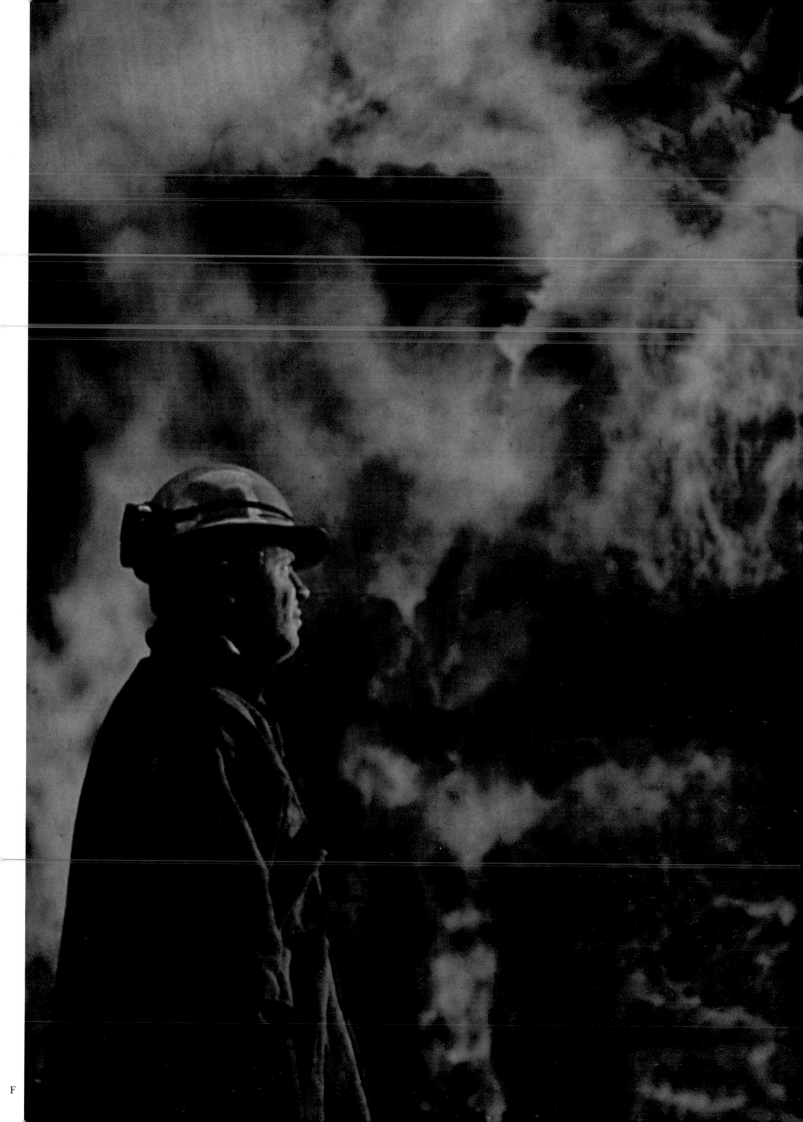

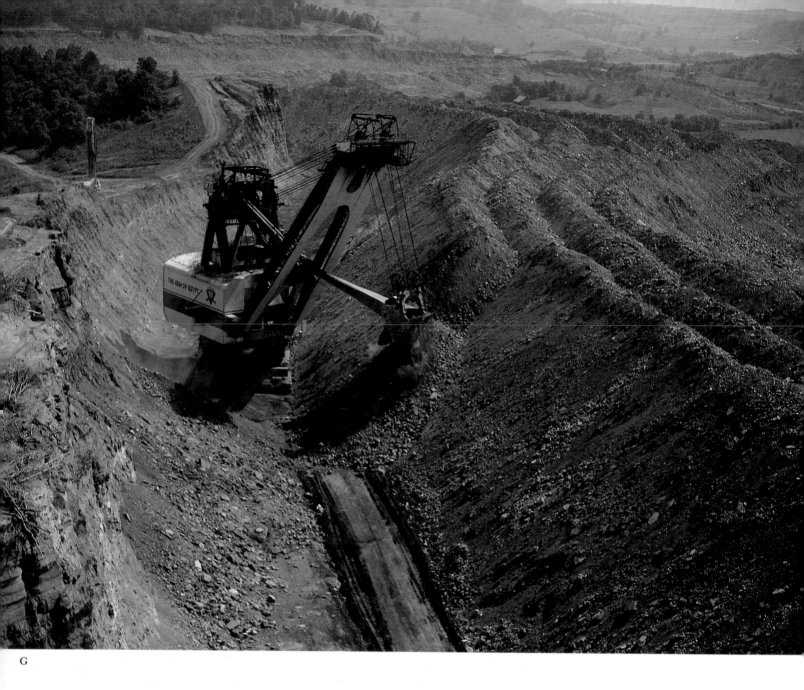

G

G. The "Gem of Egypt," a giant earth-moving machine used by the Hanna Coal Co. for coal stripping near St. Clairsville, Ohio, 1972; photo by Charles E. Rotkin. H. Steel scrapyard, New Jersey, 1971; photo by Arthur Lavine.

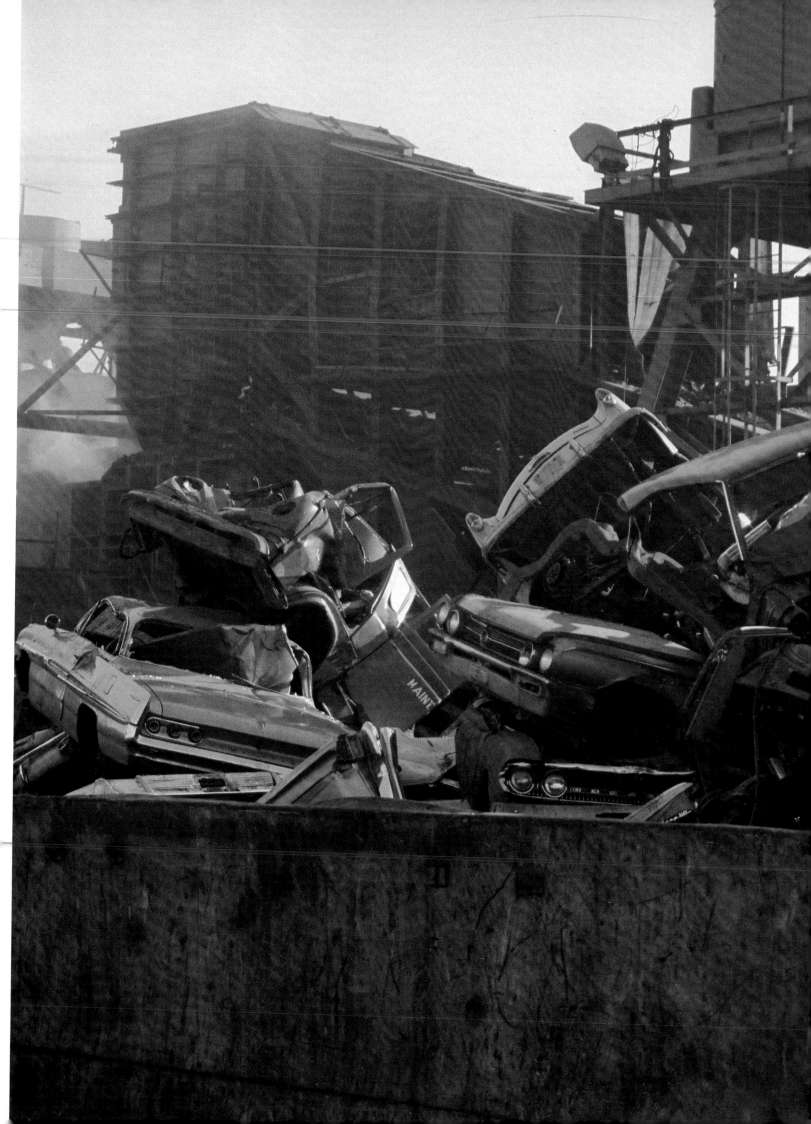

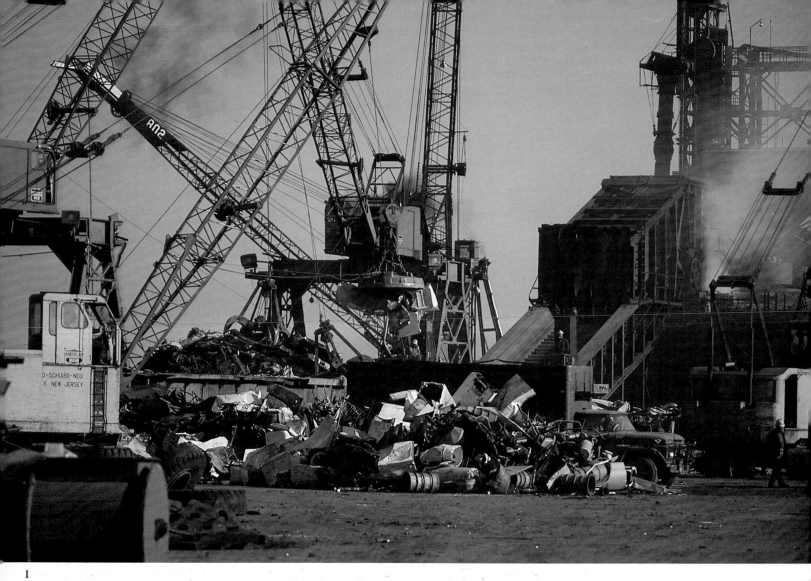

I

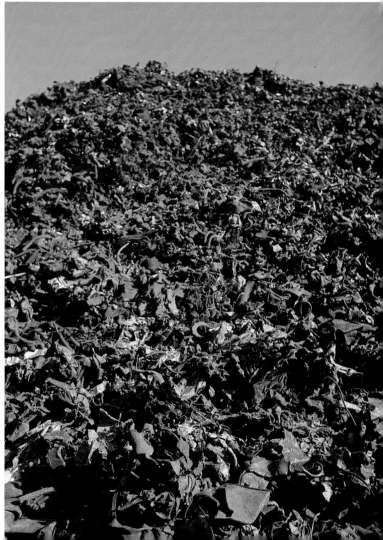

I & J. Steel scrapyard, New Jersey, 1971; photos by Arthur Lavine.

J

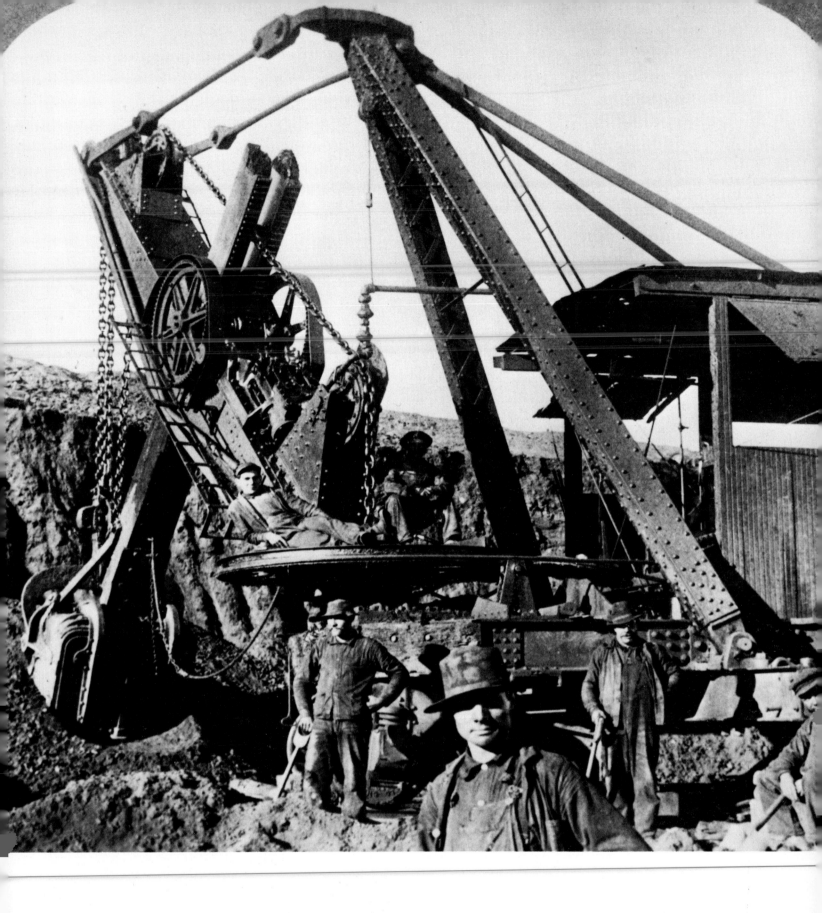

53. Open-pit mining in the Mesabi Range, Minnesota, ca. 1906; photographer unknown.

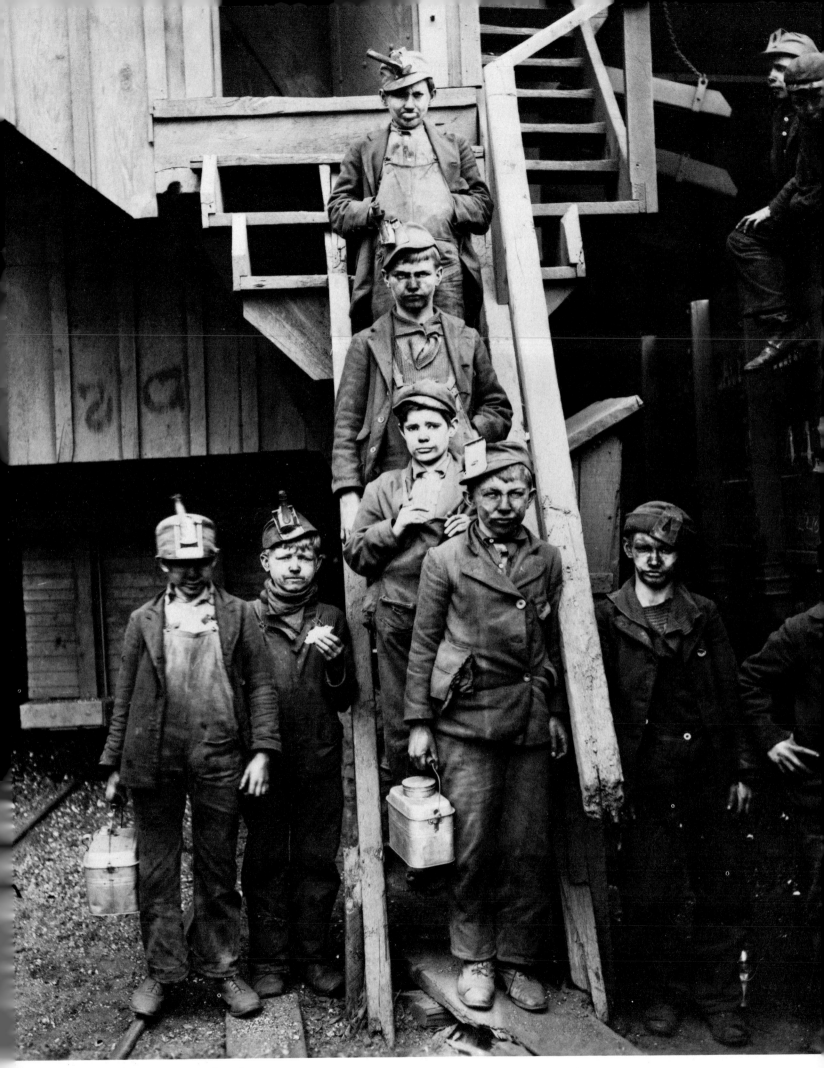

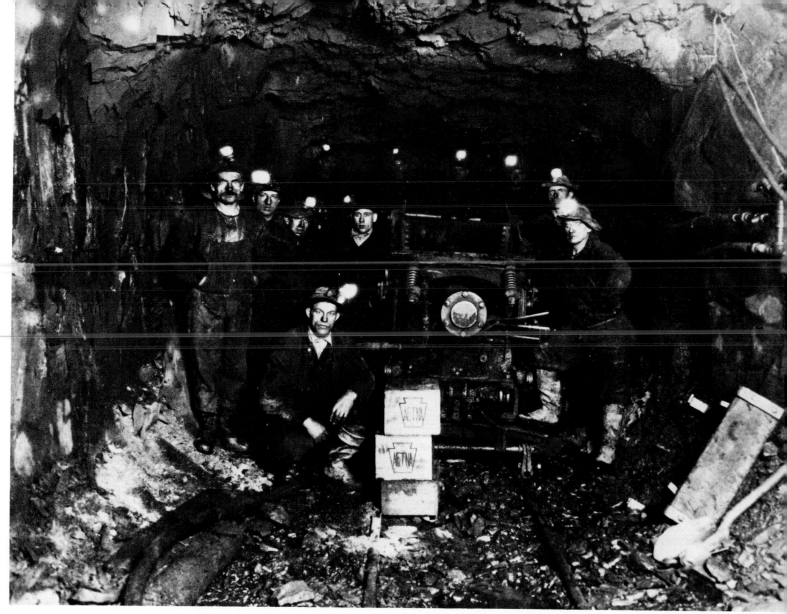

55

54. Breaker boys at the Kingston, Pennsylvania, coal mine, ca. 1900; photo by the Detroit Photographic Co. 55. Underground in the Barnes-Hecker mine near Ishpeming, Michigan; no date; photographer unknown.

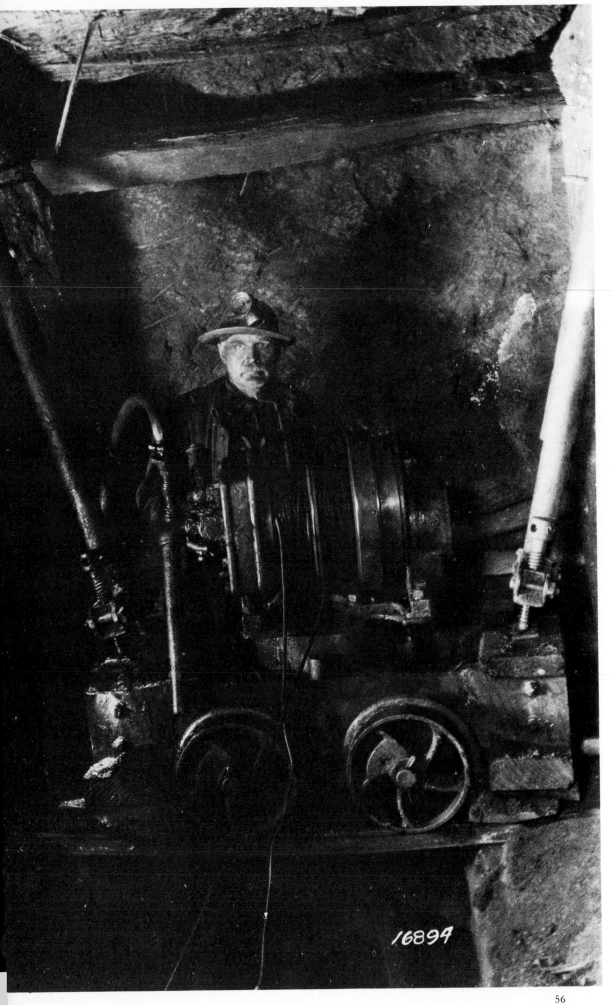

16894

56. A "Little Tugger" hoist on a turntable in a Michigan iron mine, 1926; photographer unknown. 57. Coal-handling equipment, ca. 1900; photo by C. P. Gibson. 58. Steam shovel loading at No. 2 Pit, Alpena Mine, Oliver Iron Mining Co., 1911; photo by L. P. Gallagher, Duluth, Minnesota.

56

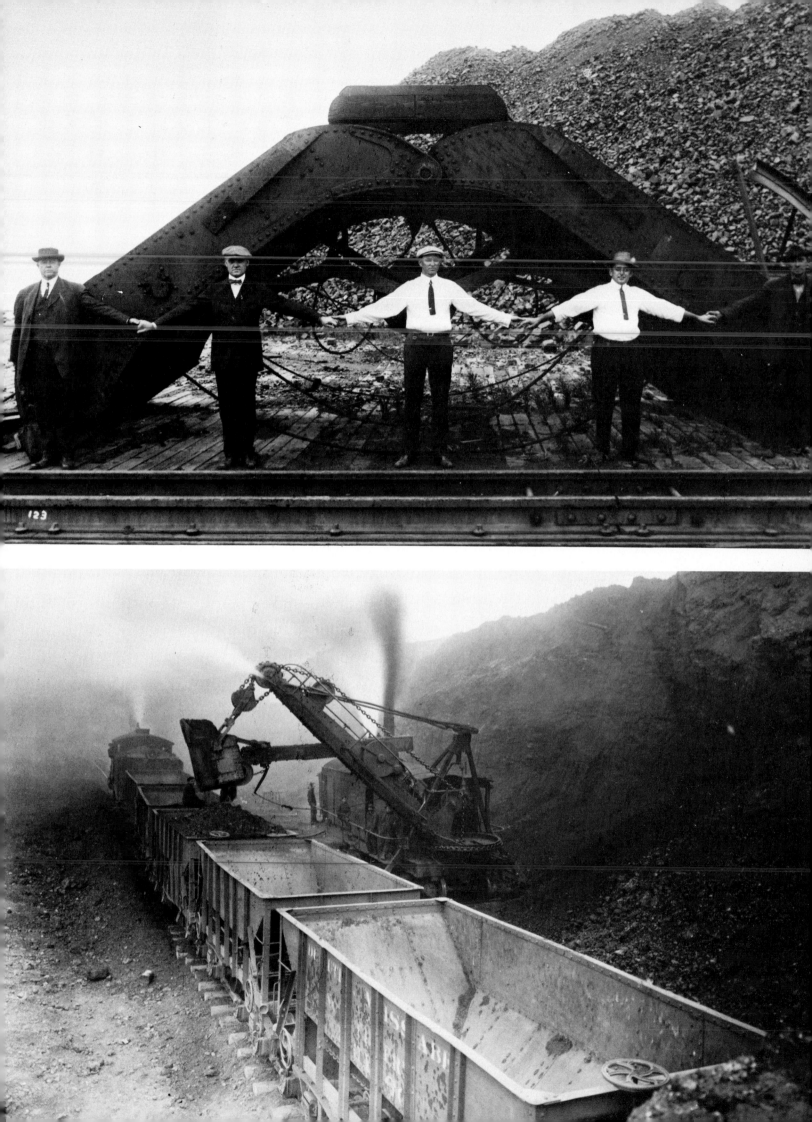

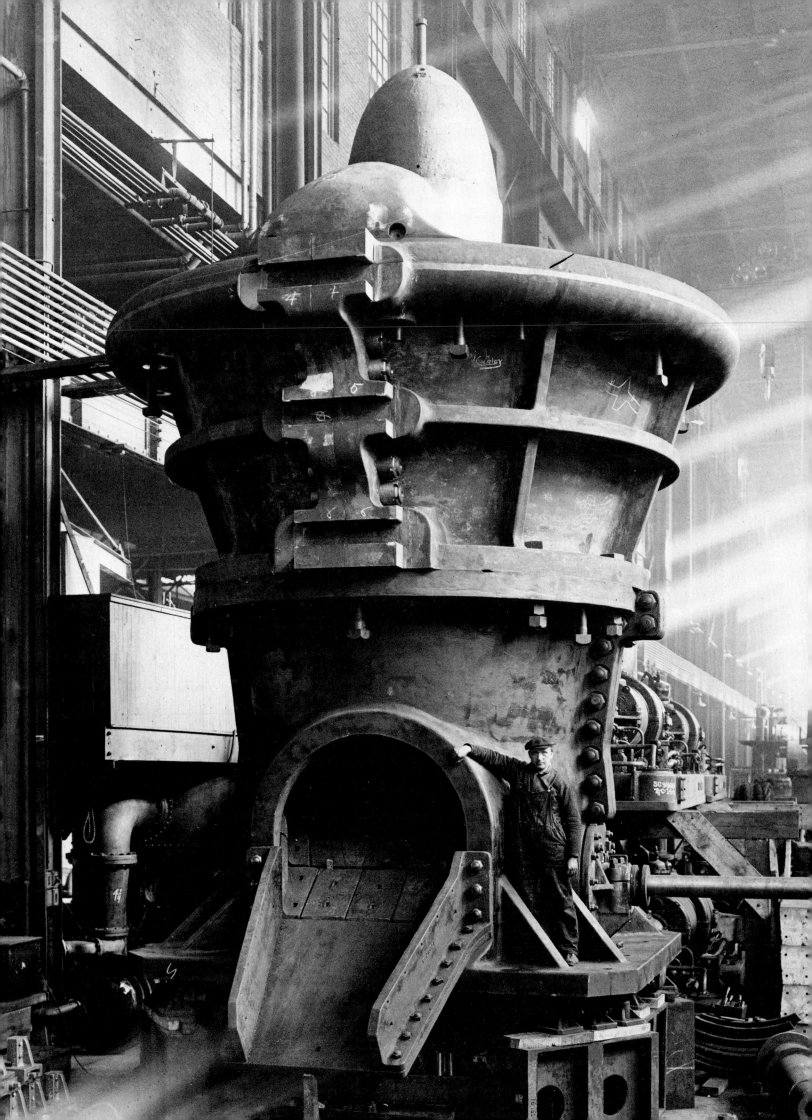

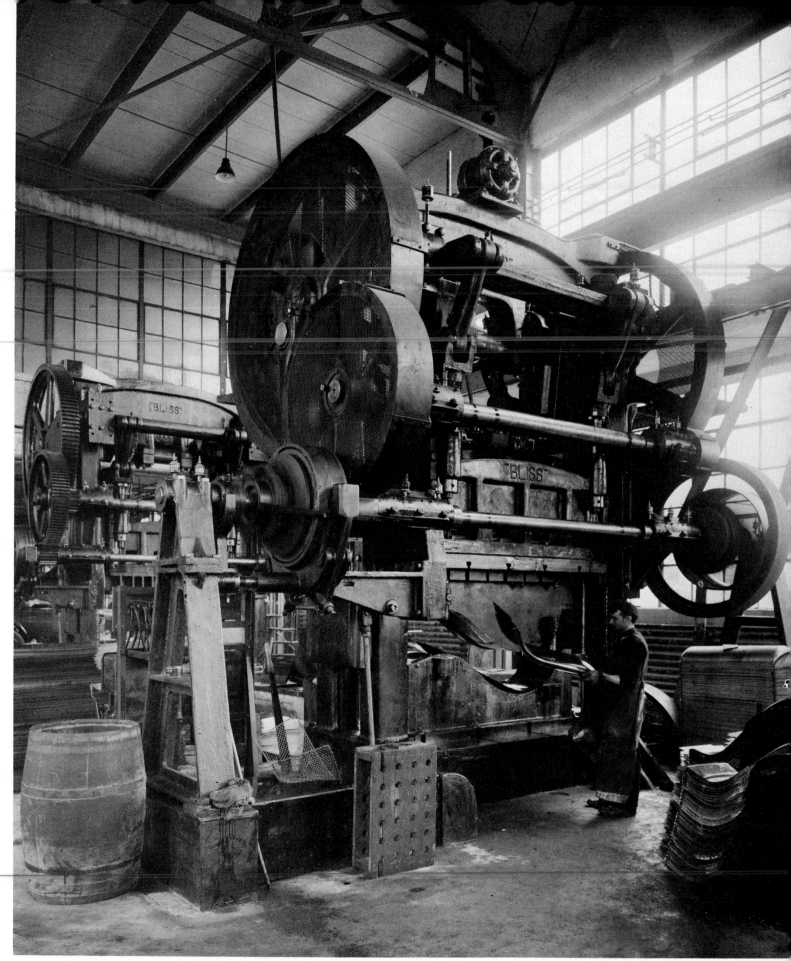

60

59. Front view of an Allis-Chalmers No. 27 double discharge ore breaker, built in Milwaukee, Wisconsin, for the Utah Copper Co.; no date; photographer unknown. **60.** A Bliss punch press in the sheet-metal department of the Chalmers plant, 1918; photographer unknown.

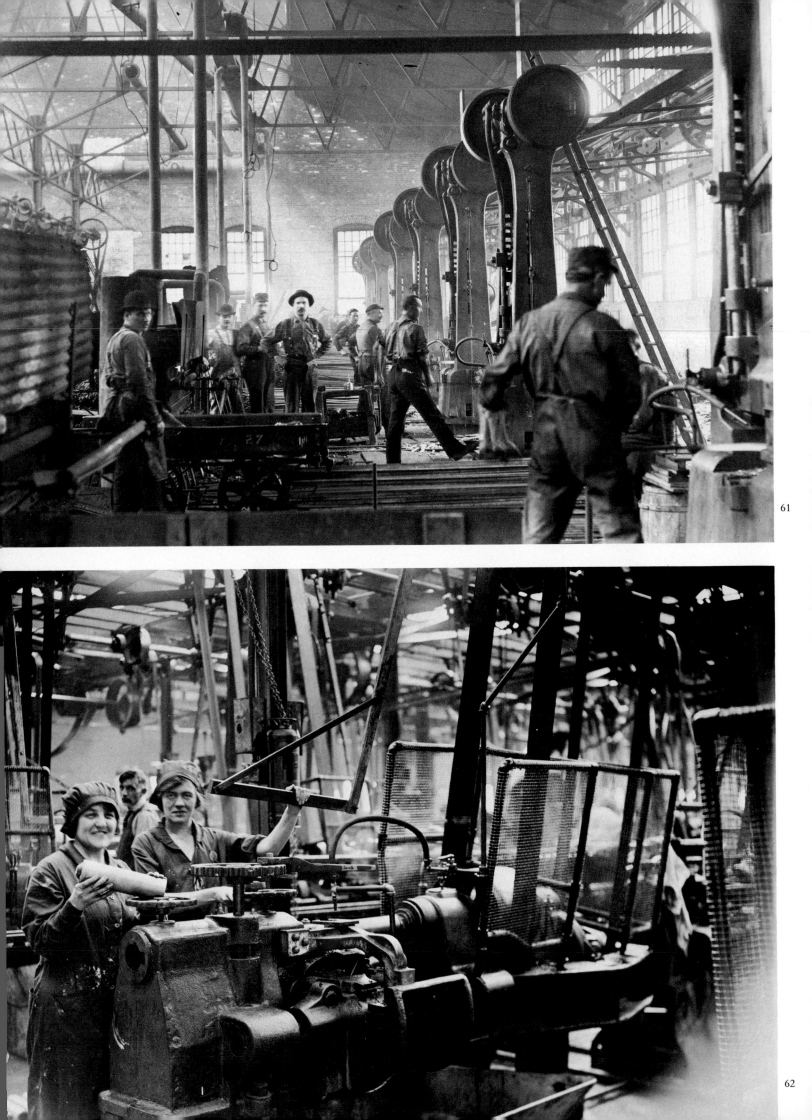

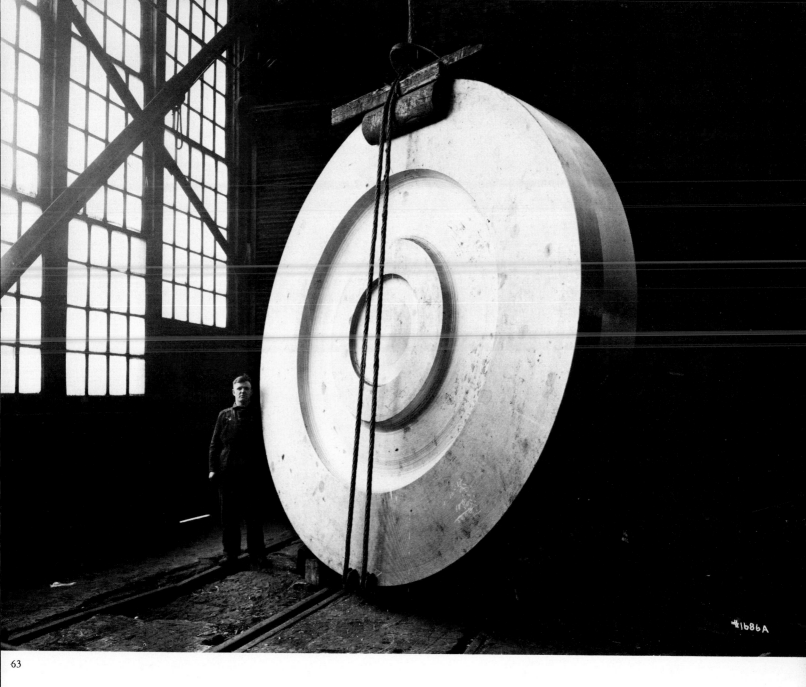

63

61. Operating hot forge trip-hammers at the McCormick factory; no date; photographer unknown. 62. Women running a large lathe in the Chalmers plant, probably June 1918; photographer unknown. 63. Worker with a huge gyroscope suspended from a crane, No. 6 Machine Shop, Bethlehem Steel Co., Bethlehem, Pennsylvania, 1921; photographer unknown.

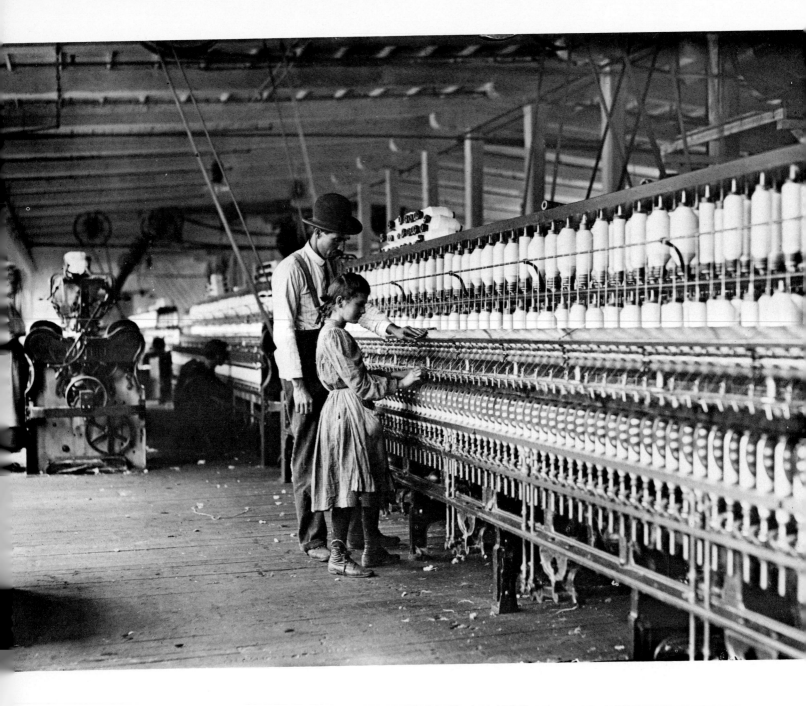

64. "The Boss Teaches a Young Spinner in a North Carolina Cotton Mill" (Hine's title), 1908; photo by Lewis Hine.

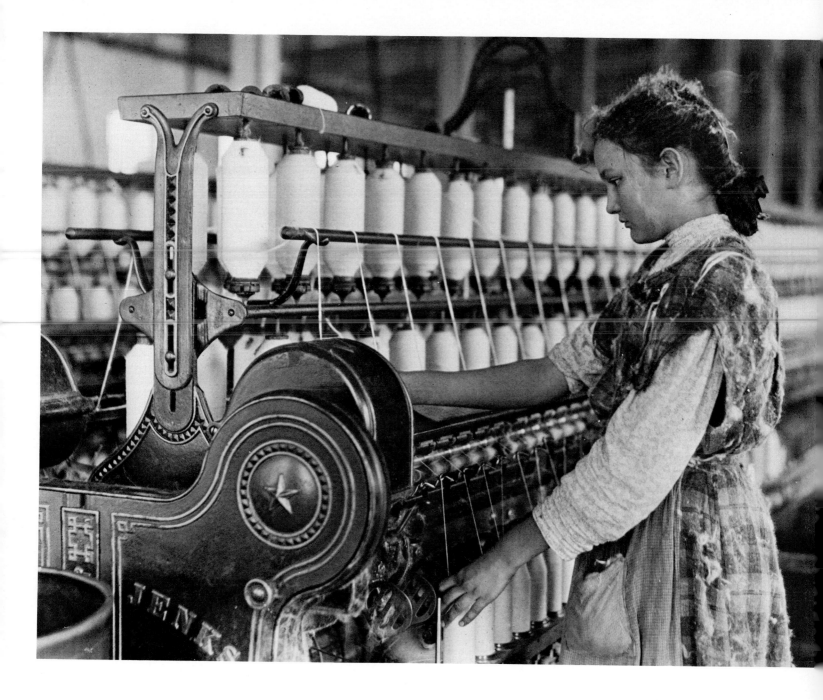

65. Girl in a spinning mill, 1908; photo by Lewis Hine.

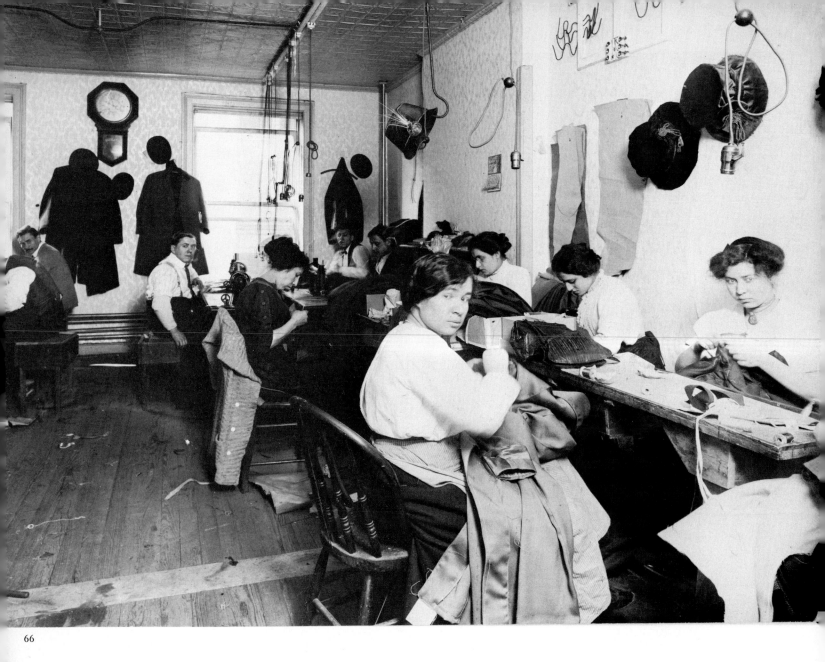

66

66. Sewing in a New York sweatshop; no date; photo by Lewis Hine. **67.** Boys working in a West Virginia glasswork; no date; photo by Lewis Hine. **68.** Boys in the mine, 1908; photo by Lewis Hine.

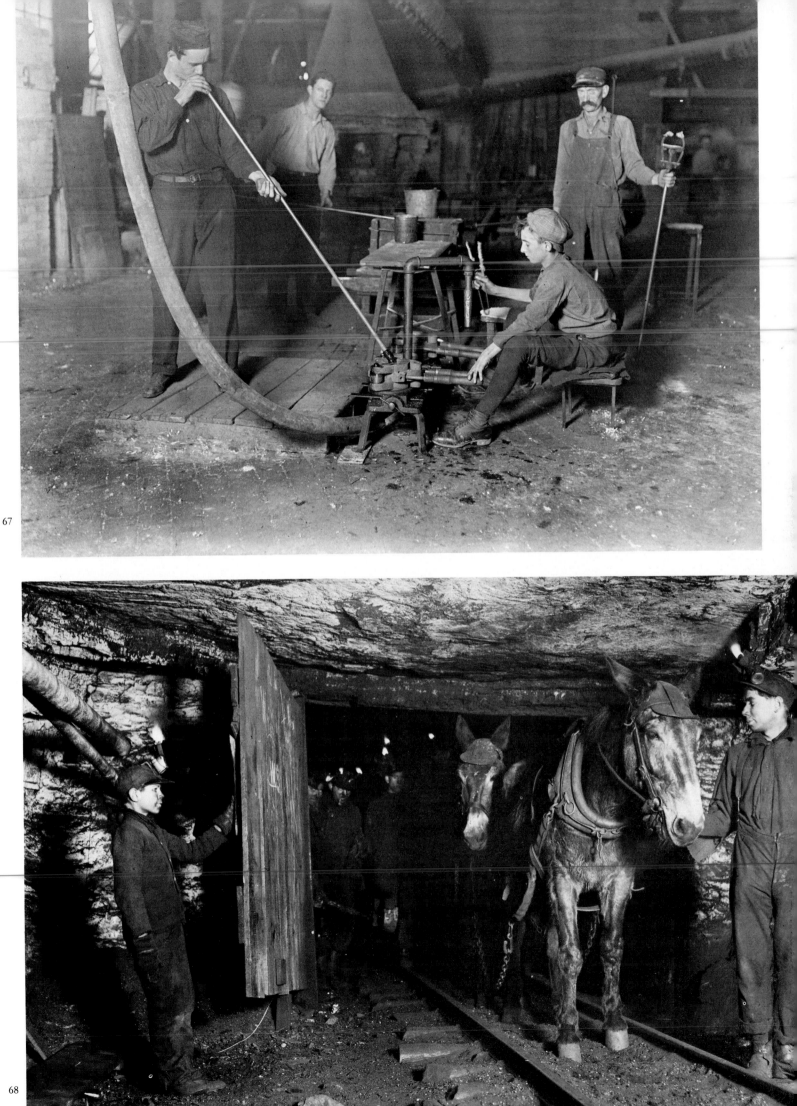

69. "The Hand of Man" (Stieglitz's title), 1902; photo by Alfred Stieglitz.

70 *Cameras Can Communicate!*

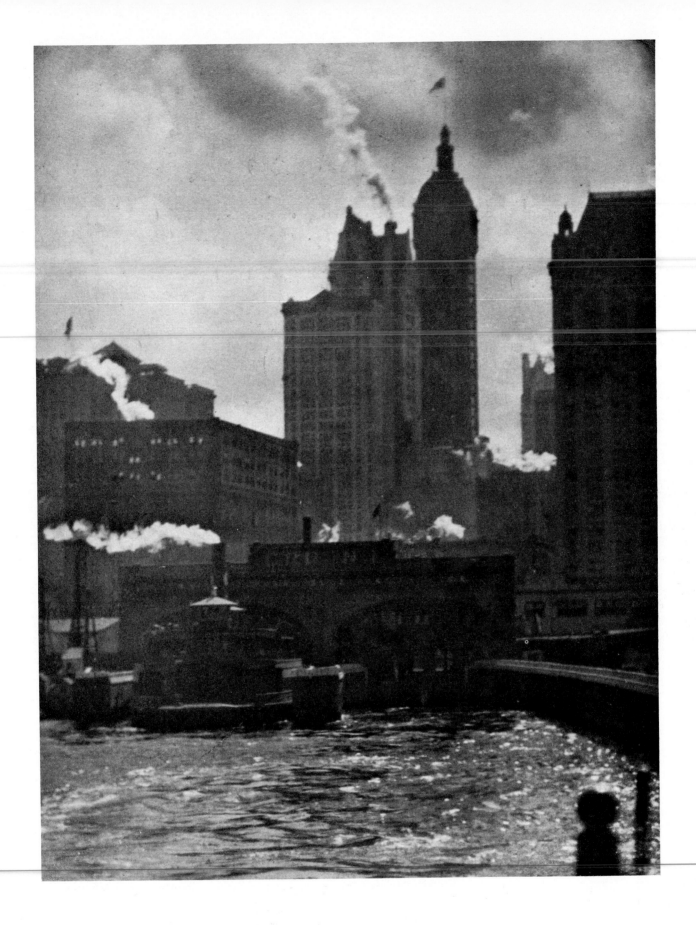

70. "The City of Ambition" (Stieglitz's title), 1910; photo by Alfred Stieglitz.

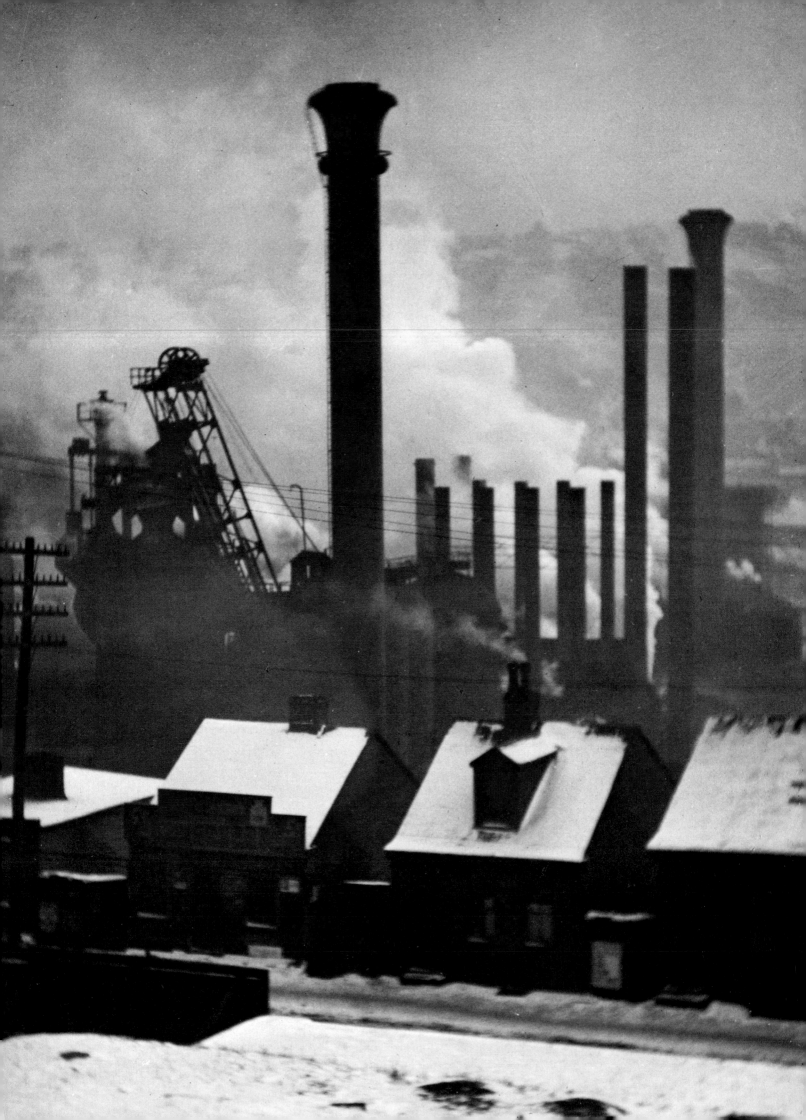

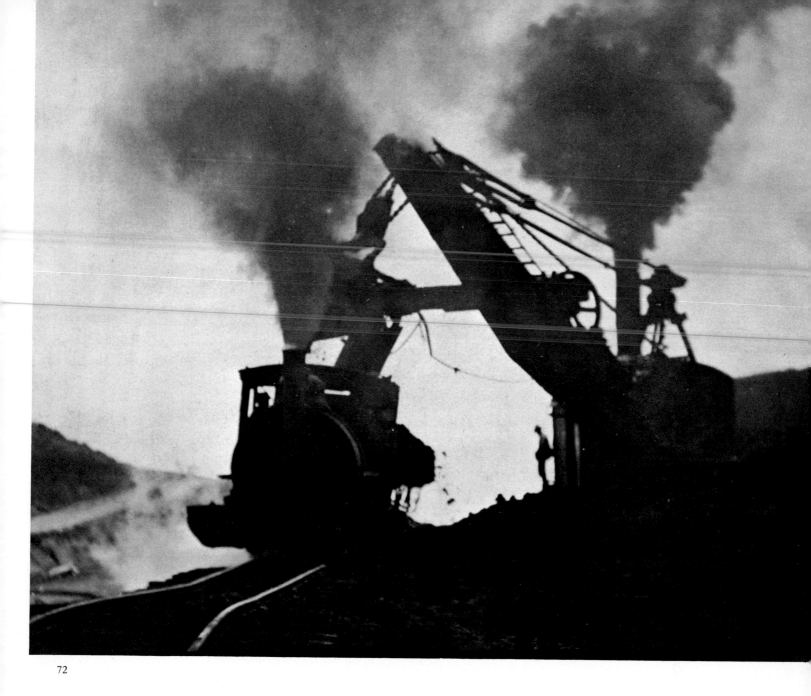

72

71. Chimneys, Pittsburgh, 1910; photo by Alvin Langdon Coburn. **72.** Locomotive and steam shovel, Pittsburgh; no date; photo by Alvin Langdon Coburn.
Overleaf: **73.** Steel mill with steam tug on the river, Pittsburgh; no date; photo by Alvin Langdon Coburn.

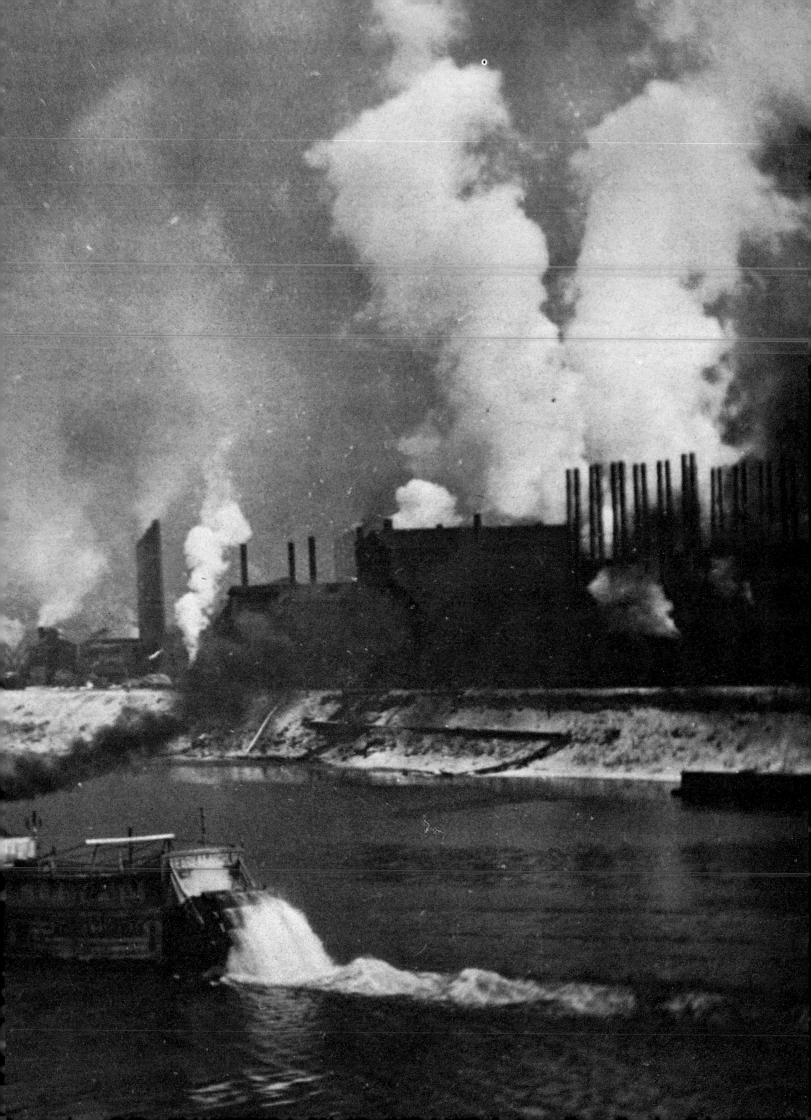

INDUSTRIAL PHOTOGRAPHY IN AN INDUSTRIAL AGE

If the late nineteenth and early twentieth centuries can be characterized as America's iron age, then surely the twenty years between the wars can be called the age of hardware. It was a time for buying and cherishing things—things that had not been available a few years earlier. The 1920s, in particular, were a period of generally high wages and intensive advertising of new products, and Americans responded with the innocent materialism of a child in a toy shop.

There were about nine million automobiles and trucks in this country when the First World War ended. There were twenty-six and one-half million by 1930. The Depression slowed, but did not stop this growth, for Americans had discovered that the personal car was a perfect complement to their restless, mobile way of life. The electrical industry boomed as people discovered the convenience and pleasure of home appliances such as electric irons and vacuum cleaners. In 1912 only about a sixth of the homes in the United States had electricity. By 1929 nearly two thirds of all American families were enjoying the new power source. Growth of this sort made growth in other areas possible. The radio industry, for example, was a child of electrical power. From one operative commercial station in 1920, radio grew to five hundred commercial stations by 1924, using the simple formula of music, entertainment and the hard sell.

The Depression may have, for a time, shaken the national faith in the free enterprise system as the best method of delivering the largest volume of material things into the most hands, but it did not shake the national commitment to the things themselves. A family might not own a new car, it might have a hard time buying a radio or a vacuum cleaner, but those things remained functional goals of the era.

A good clear look at the age of hardware can be gained by viewing the work of regional commercial photographers. As late as the 1920s and '30s these people were relatively unaffected by the stylistic considerations that were becoming more and more important in the national media such as magazines and some of the larger newspapers. Local photographers still worked "straight," with their object being simply to show clearly what the customer wanted shown. A good illustration is the work of the firm of Caufield and Shook in Louisville, Kentucky. The Caufield and Shook Photographic Studio was already a well-established business in Louisville when World War I ended, and it still exists today. Over the years it has hired a large number of highly competent local professionals who have been sent out on practically any conceivable commercial assignment. During the 1920s and '30s the firm's big 8 × 10 inch cameras captured a tremendous record of Louisville, a fairly typical middle American town, caught up in the normal commercial concerns of the time. Here were people making things, selling things and buying things. It was a record of reality, the industrial process in action.

Often crude, sometimes outrageous, the images of Louisville remind us that Sinclair Lewis' character Babbitt was not entirely a figment of the novelist's imagination. Babbitt was real; he commissioned pictures like these, paid out good money for them and showed them to his friends. When Lewis wrote about Babbitt fondling the shiny new fixtures in his bathroom or reveling in the odor of a new car, he often used the term "worshipful" to indicate the depth of his character's feelings. The word was well and consciously chosen, for it reflected attitudes that were real.

Every age must have its own religion, unique and suited to its needs. The period between our two world wars was a time when the term "industry" held out for many the hope of social salvation and the machine was elevated to the status of a cult object. It was an age in which the engineer was often regarded as a functional artist and the results of his designs were considered beautiful. When Americans looked about themselves at their new cities and their huge industries, capable of tremendous output and amazing production speed, they felt a sense of pride and accomplishment. It seemed a very fine thing to be a part of the cult of the machine.

The cult of the machine clearly dominated the national magazines, the larger newspapers and radio by the late 1920s. By the early 1930s it had been enthroned securely within the world of "serious" art through major museum exhibitions and an increasingly sophisticated use of industrial themes by painters and photographers of higher than ordinary stature and craftsmanship. In the rarefied atmosphere of the art world, including serious photography, the pace may have been less frantic than the huckstering that went on at the popular level, but the commitment to the machine cult was no less real. By World War I, the intensely sensitive photographer Paul Strand was aware of the beauty of design and texture that could be found in functional machines. Unlike Stieglitz and Coburn in the earlier days, Strand was not so interested in discovering poetic or symbolic elements as he was in the pure, direct perception of the thing itself. When Strand photographed a machinist's lathe in 1922, he instinctively moved in on the area of the machine where most of the actual work takes place. Here, where the machine was most functional, it was also most beautiful.

Writing in the same year, Walter Gropius, founder of

the Bauhaus school for industrial design in Germany, laid his finger on the key point that was to dominate the thinking of so many American artists within a few years. He suggested that art existing for its own sake was no longer a valid idea—if indeed it ever had been. Instead, he called for a "fusion" of the best design ideas of artists with the most functional ideas of engineers. "What is important, then," he wrote, "is to combine the creative activity of the individual with the broad practical work of the world." The result of such a combination was to be better, more beautiful buildings, tools and machines. Gropius' idea was hardly a new one (its roots go back at least as far as classical Greece) but it caught the tenor of the times perfectly. In an age dominated by hardware, it was natural that artists and serious photographers should find beauty in machines.

The best-recognized photographers, those who received the most attention from magazines and newspapers, clearly reflected the intellectual climate that surrounded them. Lewis Hine, the gadfly of industry before World War I, became thoroughly caught up with the idea of documenting men and machines during the 1920s. For several years he devoted most of his time to the creation of a large personal file of pictures of workmen of different ethnic backgrounds working with the brawny machinery of heavy industry. The resulting book, titled *Men at Work,** illustrated how Hine's documentary style could be adapted to show the photographer's approval of industry as clearly as it had expressed his earlier disapproval of child-labor practices. Hine's images were fairly simple and directly to the point. These were good, strong men working to make America better through industry. In 1931 Hine's imagination was captured by the construction of the Empire State Building. Nearly sixty years old at the time, Hine followed the workmen to the very top of the huge structure, lugging with him a large camera and film holders. The resulting photographs are among his best. His admiration for the men who went high on the steel girders (he called them "skyboys") and his sense of wonder at the sheer scale of the undertaking show clearly in almost every image.

In both *Men at Work* and the Empire State series, Hine's message was exactly consonant with conventionally accepted ideas of progress in the years between the wars. A building that was bigger was, by nature, more interesting than a smaller structure. Machines that could produce more were generally understood to be better than those which could not. Hine's images fit within the mind-set of the era; they raised few questions.

Though they are visually far more sophisticated, a similar statement might also be applied to the photographs of Charles Sheeler and Margaret Bourke-White. Their work often broke new visual ground. Intellectually, however, it reflected the predominant thinking of the period. Writing in 1930, Margaret Bourke-White reflected ideas that were a logical extension of Gropius' earlier statement: "Any important art coming out of the industrial age will draw inspiration from industry, because industry is alive and vital. The beauty of industry lies in its truth and simplicity: every line is essential and therefore beautiful."

* First published 1932; reprinted by Dover 1977 with a supplement of Hine's Empire State Building photos.

Sheeler's approach was coolly taxonomic while Bourke-White's was warm and emotional. Both, however, may certainly be classified among the acolytes of the machine cult. Sheeler's stately pictorialism saw the strength and harmony of industrial architecture and machinery. Bourke-White saw beautiful abstract patterns in the workings of a textile mill and the sinuous curves of a turbine. It is important to recognize that both artists worked without cynicism. Like Lewis Hine, they were genuinely involved in the contemporary enthusiasm for things mechanical.

Sheeler, who was primarily a painter of industrial scenes, executed relatively few industrial photographs, but those he did were extremely influential. The best known series was done in 1927 for the Ford Motor Company and featured the Ford River Rouge steel plant. By 1929 Bourke-White was accepting major industrial assignments, including a series for the Otis Steel Company. A comparison of these two series (or at least those examples of them that have survived) shows that Bourke-White was already moving off in directions that were distinctly her own. She would still use a Sheeler-like pictorialism when the mood struck her, but more and more she was moving her camera in close to capture the significant detail.

The new and advanced styles of industrial photography came at an opportune time from the standpoint of management. American businesses were changing rapidly in the 1920s and '30s. The days of the large-scale personally owned business were drawing to a close. A few rugged individuals like Henry Ford still clung to the old entrepreneurial ways, but they were a rapidly diminishing breed. Most large-scale business was now in the hands of professional managers, men who had trained themselves for years in highly specialized schools to manage the destinies of huge corporations which were in turn owned by tens of thousands of stockholders. An experienced executive, who has managed the public relations of several major corporations, including Jones & Laughlin Steel and Allegheny Ludlum Steel, over the last thirty-five years, pointed out in a recent interview that the change in corporate structure changed the nature of public relations and the way that businesses used photographs. In the early days, he noted, people could personify American steel production in terms of the rags-to-riches story of Andrew Carnegie. They could envision American oil refining as good or evil depending on how they felt about John D. Rockefeller. As businesses grew and became more complex, this sort of humanizing identification was no longer possible. The presidents of large corporations were usually anonymous, men the majority of Americans seldom heard of or saw. What was needed was a way to establish a "corporate image" in the public mind without the strong personality of the entrepreneur as a focus.

By the end of the 1920s, some of the best minds in corporate management were beginning to realize that the vision of a great photographer could be of tremendous value in providing the public with a visual way of relating to the company. Just as pictures on the walls of cathedrals in Europe during the Middle Ages gave the public an iconographic means of relating to the vast organization of the mother church, Bourke-White's new industrial iconography reassured people that they were a part of something tremendously important.

In terms of its effectiveness in diffusing the image of the beauty and vitality of large-scale industrial enterprise, no

medium was more active in the United States than *Fortune* magazine. Henry Luce's journalistic experiment began in the difficult year of 1930, weathered the first years of the Depression and went on to become the nation's most powerful and articulate spokesman for industrial management. During the early years its pages often carried the photographs of Margaret Bourke-White. In fact, it seems fair to say that her work set the visual tone of the magazine. Through its images, its editorials and its reportage, *Fortune* consistently supported the idea that big, exciting things were happening in American industry. Writing in the first issue, Luce himself identified the magazine's theme:

> *Fortune's* purpose is to reflect Industrial Life in ink and paper and word and picture as the finest skyscraper reflects it in stone and steel and architecture.
>
> Business takes *Fortune* to the tip of the wing of the airplane and through the depths of the ocean along be-barnacled cables. It forces *Fortune* to peer into dazzling furnaces and into the faces of bankers.
>
> *Fortune* must follow the chemist to the brink of worlds newer than Columbus found and it must jog with freight cars across Nevada's desert. *Fortune* is involved in the fashions of flappers and glass made from sand.
>
> Into all these matters *Fortune* will inquire with unbridled curiosity. And, above all, *Fortune* will make its discoveries clear, coherent, vivid so that reading it will be one of the keenest pleasures in the life of every subscriber.

At a cost of one dollar per issue, *Fortune* was clearly not a magazine aimed at the workingman. Its audience was to be those people who believed, as Luce did, that most of the really important things that get done in society are done by industry, and therefore the really important people are those who guide industry. Over the years, *Fortune* has remained remarkably true to its original conception. Frankly elitist, it has featured the very best in writing, analysis, graphic art and photography. Through the Depression years the magazine maintained a positive stance, carefully featuring the strongest and most reassuring aspects of American business. The approach paid off from a financial standpoint, for executives, junior executives and those who had hopes of becoming executives bought and read the magazine regularly. *Fortune* also yielded visual dividends, for in its pages industrial photography coalesced into an identifiable form. By the late 1930s, when other national magazines such as *Look* and *Life* sought visual images that would mean "industry" to their readers, they found themselves adopting the general visual approach of *Fortune*. Bourke-White and other *Fortune* photographers had so completely dominated the imagery of industry that other photographers were more or less forced to work along similar lines.

If *Fortune* spoke for management, it can be fairly said that newspapers, in search of action and drama, often spoke for labor during the 1930s (although whether they did so intentionally is open to question). The Depression awoke organized labor from its fat 1920s lethargy and, with the encouragement of New Deal legislation guaranteeing the right of collective bargaining, labor began to gather strength and flex its muscles. By the middle and late 1930s, confrontations between labor and management were common and newspaper photographers were there with their big 4 × 5 press cameras and flash bulbs to catch "the action."

The labor violence of the 1930s was by no means the first in United States history. Terrible strikes had wracked the country during the 1870s, 1880s and 1890s. The year 1919 had witnessed over a thousand strikes as workers had attempted to readjust to the postwar economy. The difference from the standpoint of photography lay in the fact that cameras and film had not been able to cope with strikes very well in the earlier days. Even as late as 1919, it was hard for most photographers to take their equipment out into the streets and operate it effectively as reporters in a fast-changing situation. A few remarkable photographs exist today from the violence of 1919, most notably those of the Chicago race riots, but for the most part earlier photographers had to content themselves with photographs of the aftermath of violence. By the mid-1930s, however, photographic technology had advanced considerably. Lighter cameras, fast films (modern ASA 100) and synchronized flashbulbs allowed photographers to capture records of industry's growing pains that would have been technically impossible a few years earlier. Like those in management who realized that photographs could be a powerful force in the molding of public opinion, the leaders of labor soon discovered that a picture of strikebreakers beating up workers was worth many thousand words to their cause. Like management, they learned to select pictures that supported their point of view. Photographs played a role in precipitating the pro-labor legislation of the later 1930s, often depicting the American worker as the victim of brutal treatment. A glance through the labor photographs that have survived gives convincing evidence that workers were about as apt to dispense violence as they were to receive it. The point, however, is that leaders were learning to select images. At both levels, labor and management, there was increasing sophistication in this area. The technique remained effective, for most Americans continued to adhere to a touching faith that "photographs do not lie."

Which brings up the question, do photographs lie? Assuming that situations are not faked, the camera must record what is before it, but that recording may be a highly selective process. As cameras have become lighter, faster, easier to operate under difficult conditions, the scope for this selectivity has been enlarged. Photographers have had more and more "truths" at their disposal. In general this has been beneficial in the United States, a country with so much media diversity that all sides have had an opportunity to present their visual versions of "truth." Historically, the enlargement of our visual photographic language, through the increasing technical facility of the camera, has tremendously increased the range of the visual record of Americans struggling to learn to live together in the bewildering new landscape of the industrial city.

ABOUT THE PHOTOGRAPHS

XVI. The Image of Commerce (Photos 74–81)

As the nation turned in the 1920s from the dark concerns of social reform and world war, it became almost obsessed with the goals of production and material progress. "The man who builds a factory builds a temple," decreed President Calvin Coolidge; "the man who works there worships there." This attitude was mirrored in hundreds of towns across the country and it showed up clearly in the anonymous commercial photographs that were made by the thousands.

XVIII. Lewis Hine (Photos 82–87)

Lewis Hine's *Men at Work* series and his construction photographs of the Empire State Building are among his very best images, although they are often overlooked in favor of his earlier photographs of child labor and immigrants. Hine genuinely loved working men and women and he enjoyed the milieu of the factory and mine. His work was a straightforward expression of those feelings.

XIX. The Artists of Functional Beauty (Photos 88 & 89)

By the early 1920s some of this country's most sensitive artists were aware of movements in Europe, and particularly in Germany at the Bauhaus School of Design, to weld fine art and practical engineering together into a new art form which transcended both. Men like Paul Strand were discovering the beauty of functional things. The painter-photographer Charles Sheeler showed the abstract purity of line that was often present in large-scale industrial scenes as well as the power that could come from well-selected details.

XX. Margaret Bourke-White (Photos 90–93)

No consideration of the field of industrial photography could be in any sense complete without the work of Margaret Bourke-White. During the late 1920s and early 1930s this hard-driven, often hard-bitten, young woman virtually defined the visual grammar of the industrial photograph. She was a master of both the Sheeler-like long shot and the Strand-like detail. Her work in various corporate annual reports, and especially for the newly created *Fortune* magazine, placed her in the most preeminent position among American photographers who worked in industrial subjects. If Coburn can be called the first identifiable American industrial photographer, then Bourke-White can certainly be called the creator of the fully developed modern field of industrial photography. Within the technical limits of her day, she did it all, and she did it very, very well.

XXI. Labor Unrest in the 1930s (Photos 94–103)

Not all industrial photography of the 1930s was concerned with stately grandeur of industry or the beautiful detail of a piece of machinery. While the best-known photographers did concentrate their efforts in that general direction, less well-known cameramen, usually working for newspapers, found themselves recording the cutting edge of industrial adjustment. The later 1930s were a turbulent time with a great deal of confrontation between labor and management, and now for the first time cameras were technically capable of recording the action. Generally competent and nonideological, the newspaper photographers left an important social record of labor trouble, and broke new stylistic ground in showing that their 4 x 5 press cameras could really capture dynamic images of men and women shouting at each other, insulting, pushing, hurting and grinning at each other. The "Battle of the Overpass" was a confrontation between United Automobile Workers organizers Walter Reuther and Albert Frankenstein, and a group of toughs hired by Ford. This series of three pictures was taken by news photographers from the *Detroit Free Press* and the *Detroit News*.

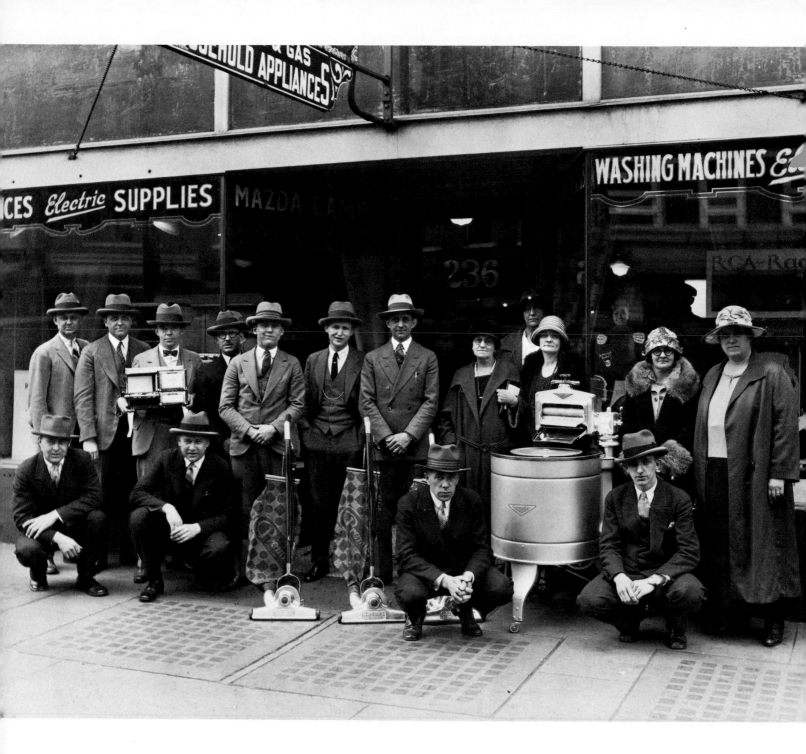

74. Electrical appliance sales force, Louisville, Kentucky, 1926; photo by the Caufield and Shook Photographic Studio.

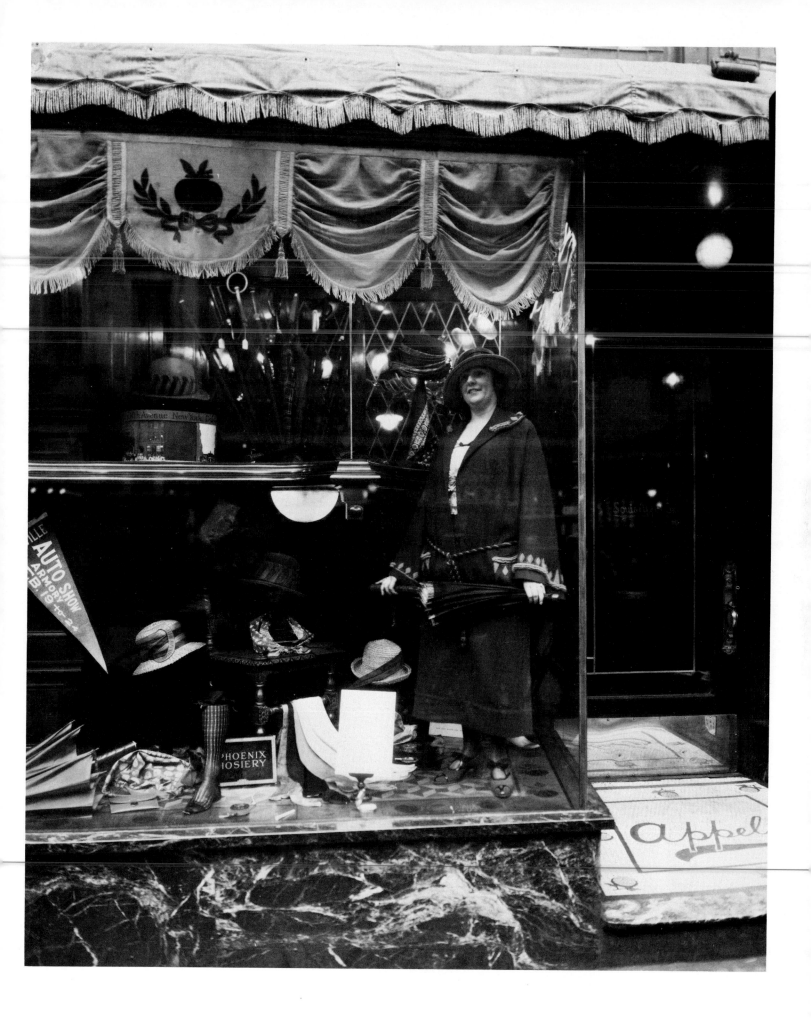

75. Ladies' apparel window dressing, Louisville, 1924; photo by Caufield and Shook.

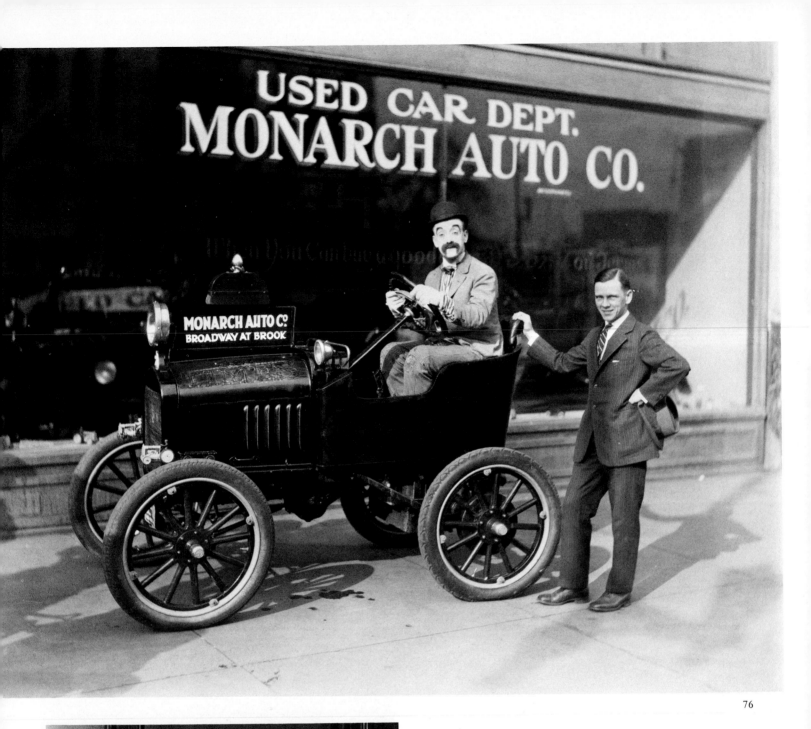

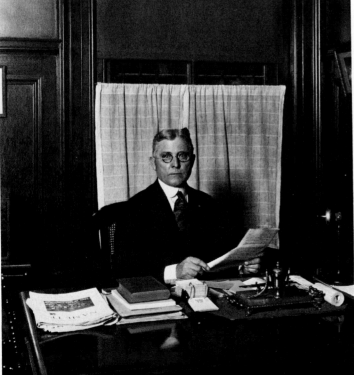

76. Used-car promotion of the Monarch Auto Co., featuring silent-film comedian Snub Pollard, Louisville, 1924; photo by Caufield and Shook. 77. Typical business executive of the 1920s, Louisville; photo by Caufield and Shook. 78. Electrical appliance repairman with motorcycle and sidecar, Louisville; no date; photo by Caufield and Shook.

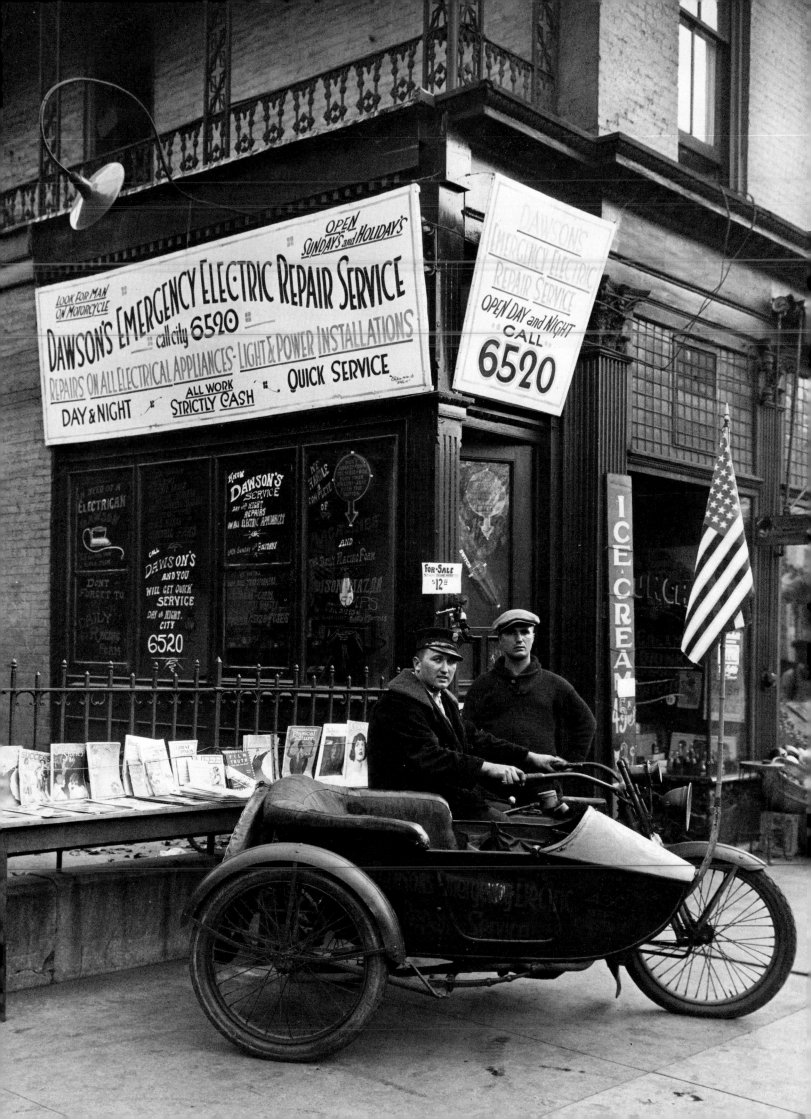

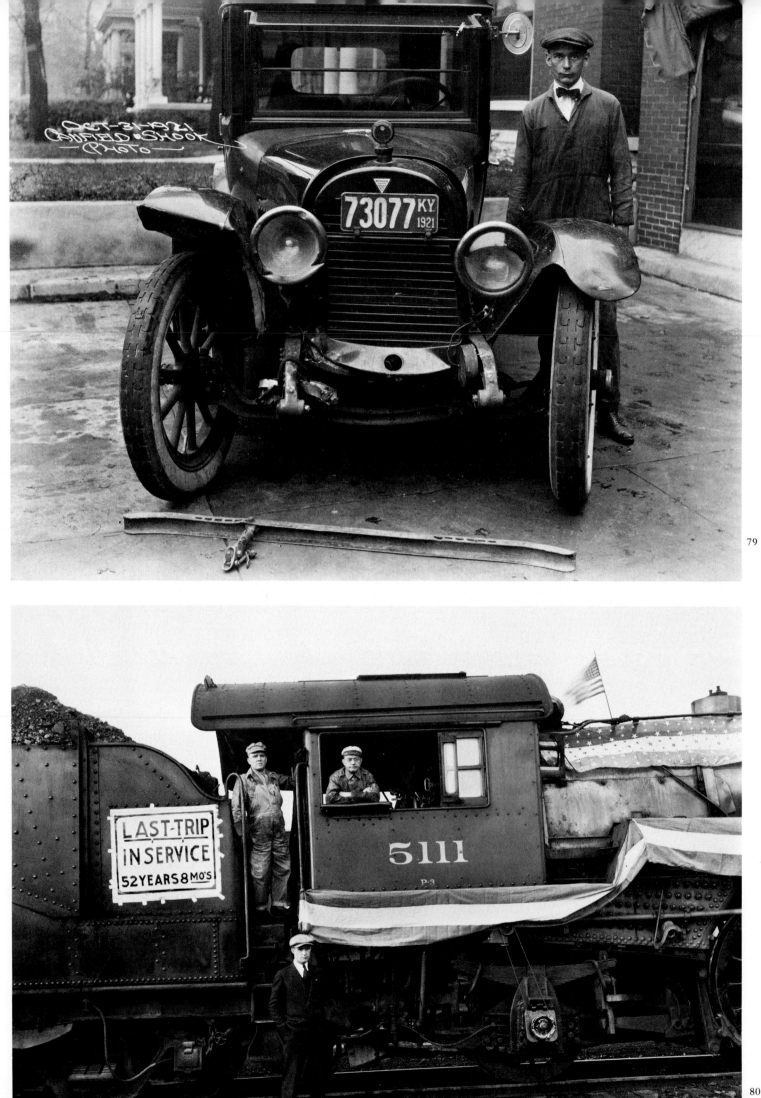

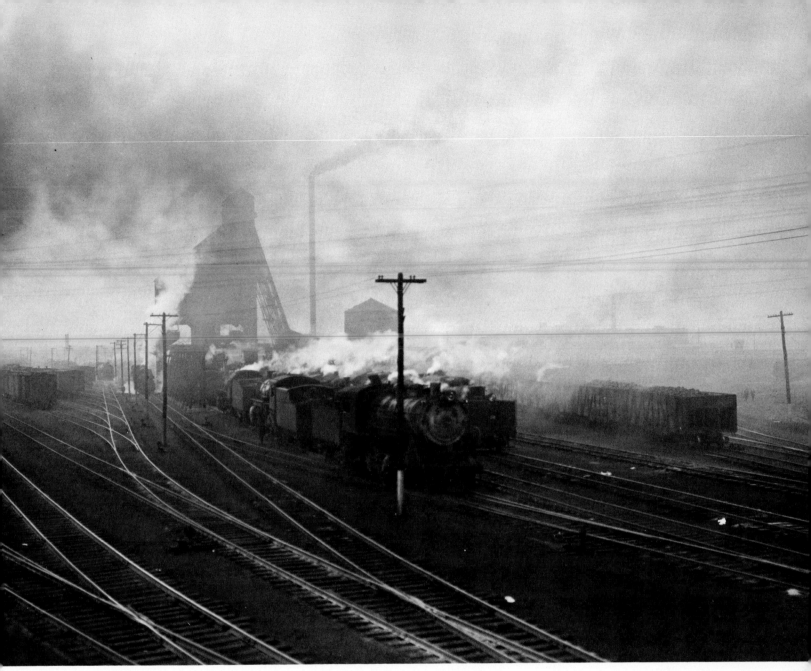

81

79. Hudson car with mechanic, Louisville, October 31, 1921; photo by Caufield and Shook.
80. Engine 5111, "last trip in service," Louisville, ca. 1931; photo by Caufield and Shook.
81. Engines in the railroad yard, Louisville, 1927; photo by Caufield and Shook.

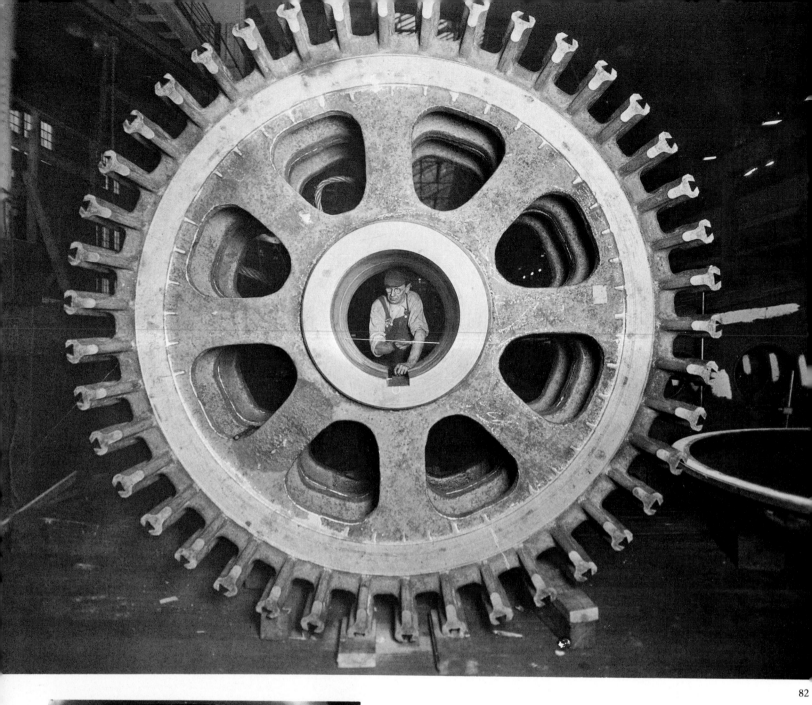

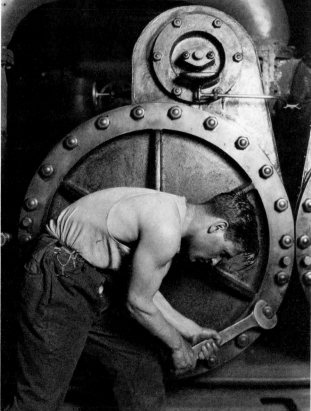

82. Workman with large transformer rotor; no date; photo by Lewis Hine.
83. Steamfitter, Pennsylvania Railroad, 1930; photo by Lewis Hine.
84. "Washing Up at Close of Day" (Hine's title); no date; photo by Lewis Hine. **85.** Coal miner resting near the seam face; no date; photo by Lewis Hine.

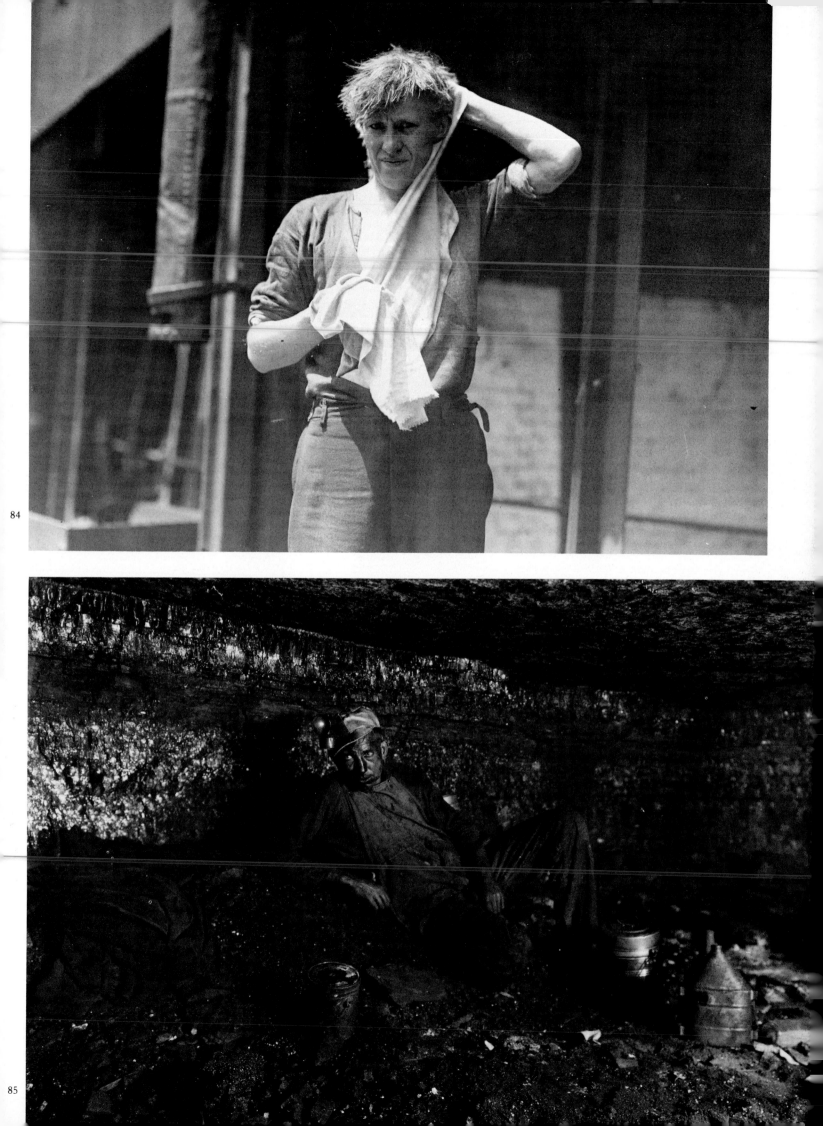

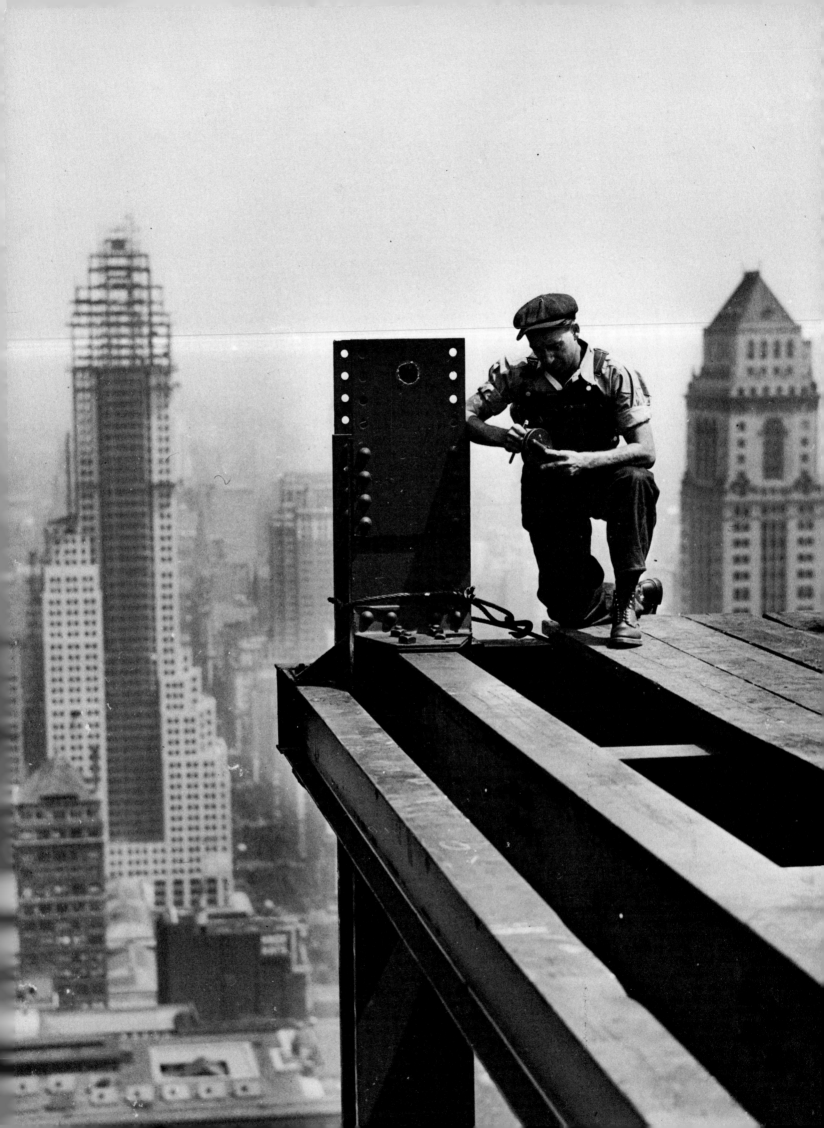

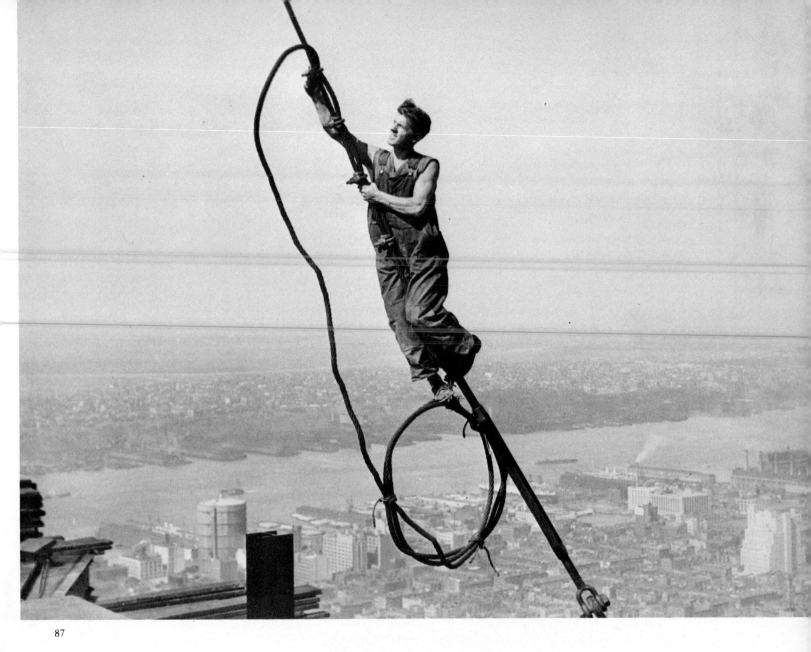

87

86. Worker with tape measure, Empire State Building, ca. 1931; photo by Lewis Hine.
87. "Icarus" (Hine's title), Empire State Building, ca. 1931; photo by Lewis Hine.

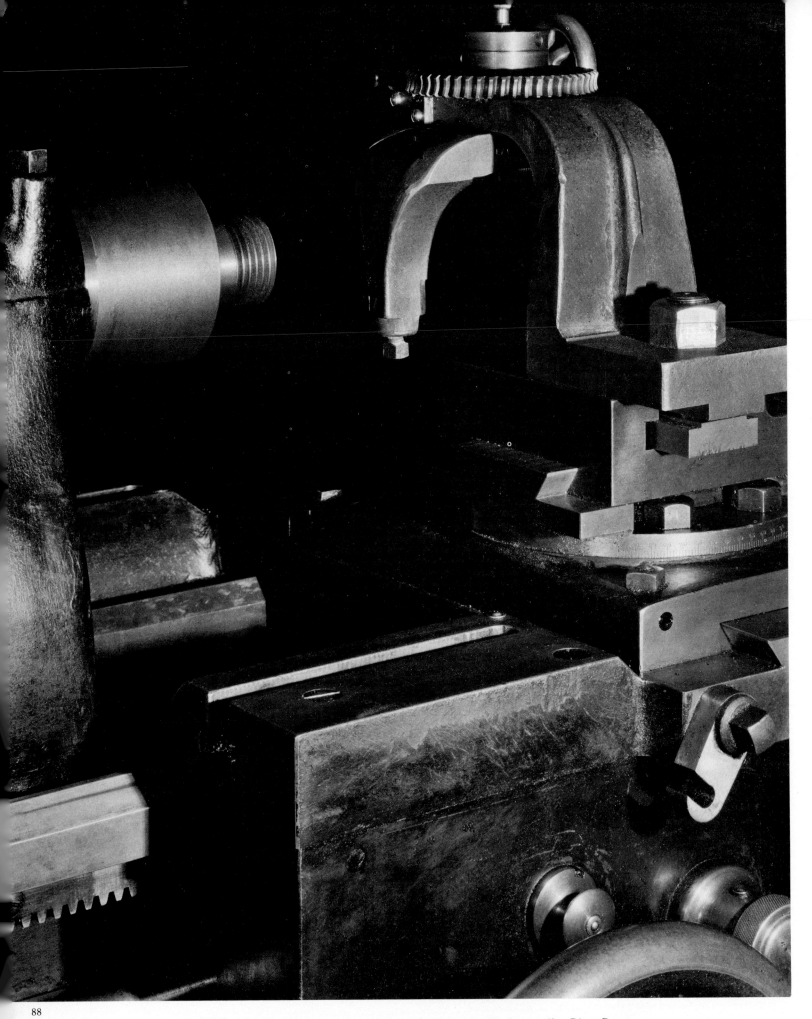

88. "The Lathe" (Strand's title); no date; photo by Paul Strand. **89.** Crosswalks, River Rouge Ford plant, 1927; photo by Charles Sheeler.

90 *Industrial Photography in an Industrial Age*

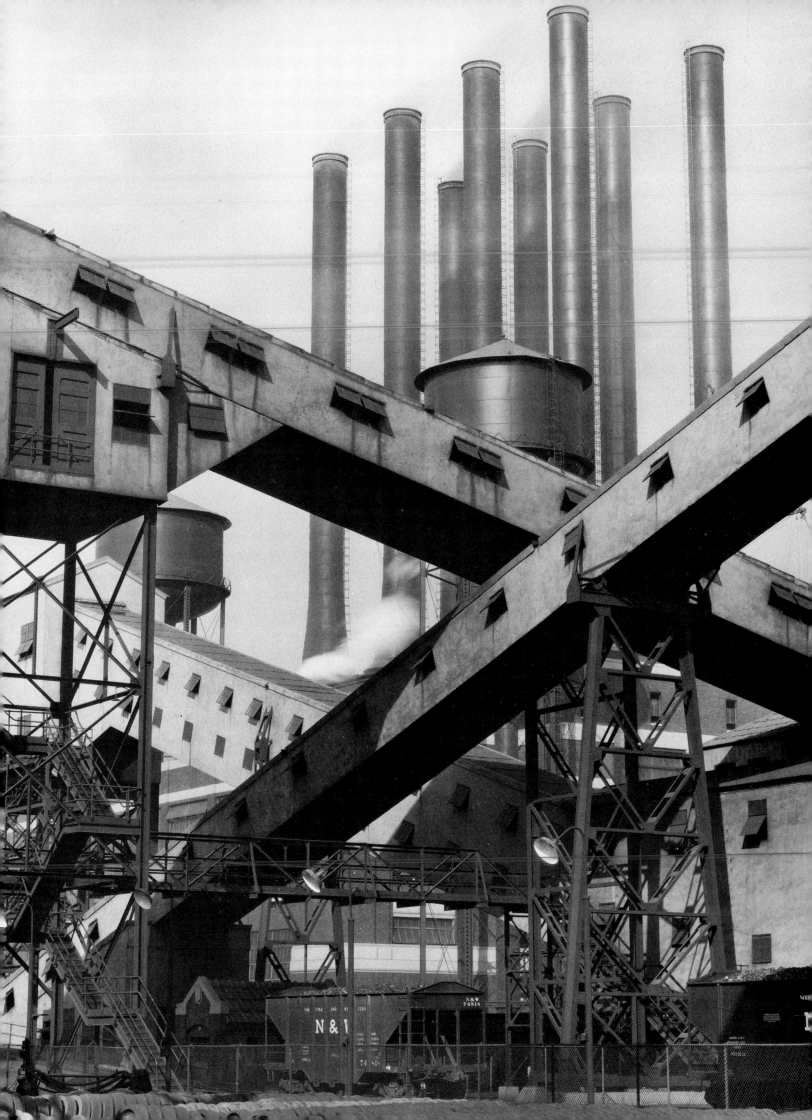

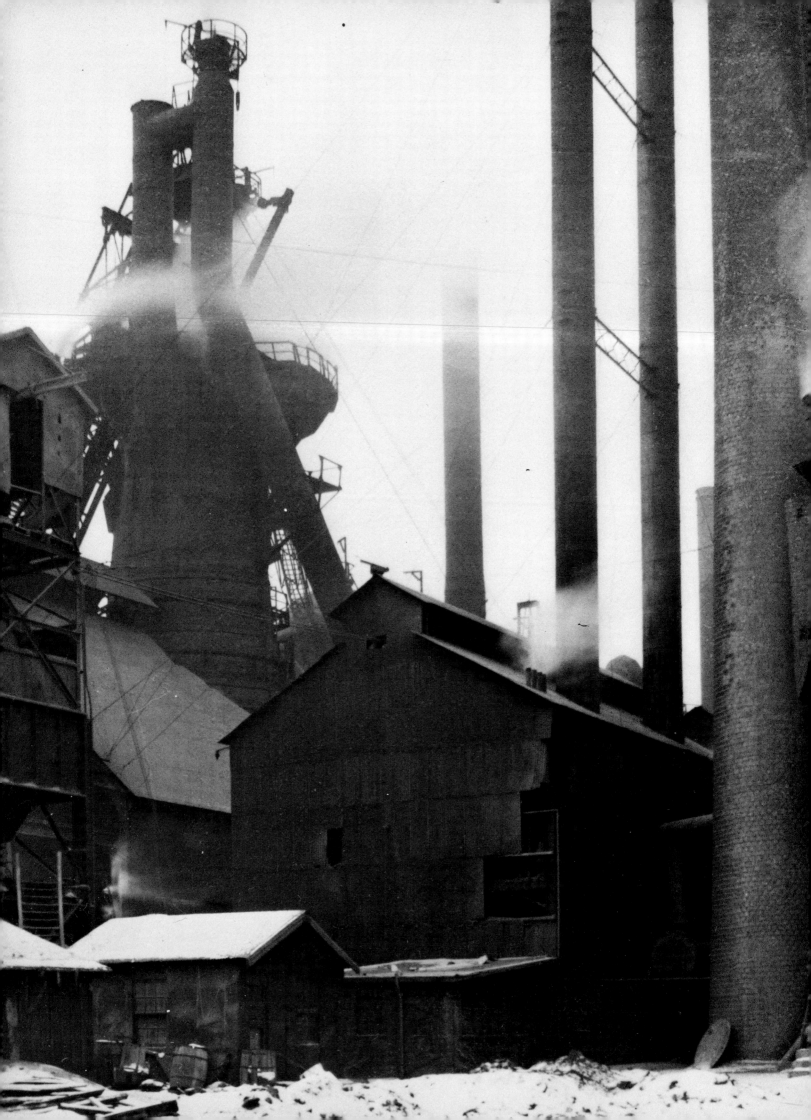

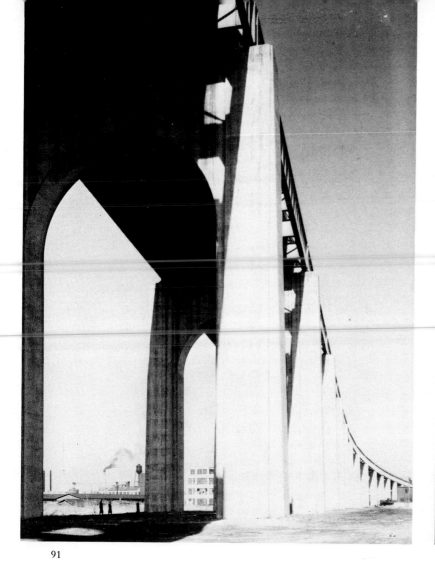

91

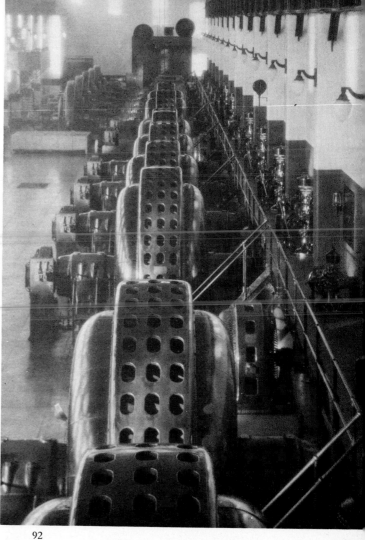

92

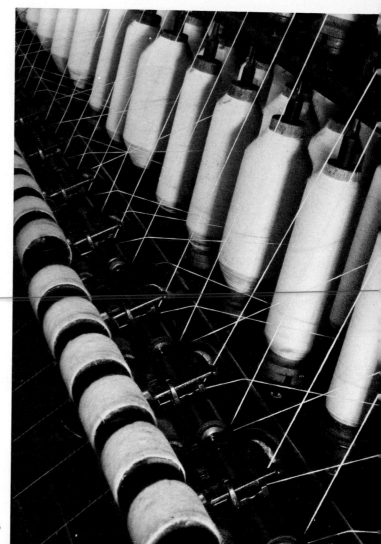

90. Otis steel mill, Pittsburgh (for the 1927 annual report); photo by Margaret Bourke-White. **91.** A viaduct constructed by the Port of New York Authority, taken February 1933 for an essay in the July 1933 *Fortune*; photo by Margaret Bourke-White. **92.** Niagara Falls power station, June 8, 1935; photo by Margaret Bourke-White. **93.** Amoskeag, New Hampshire, textile mill, May 11, 1934; photo by Margaret Bourke-White.

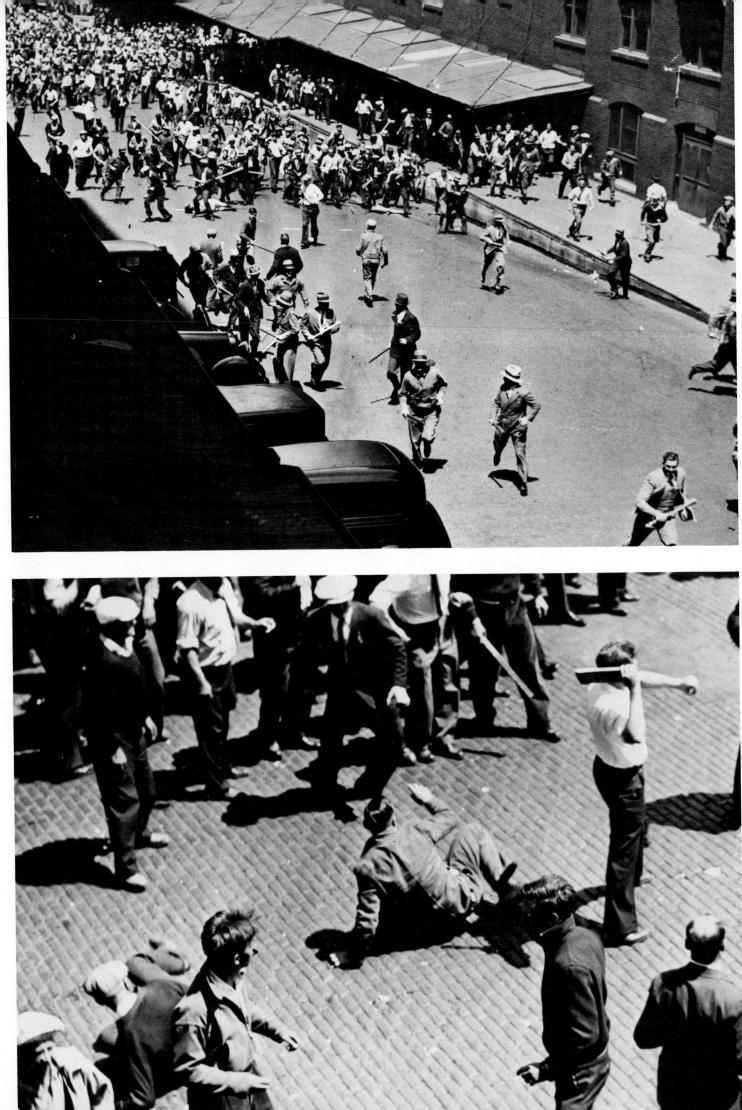

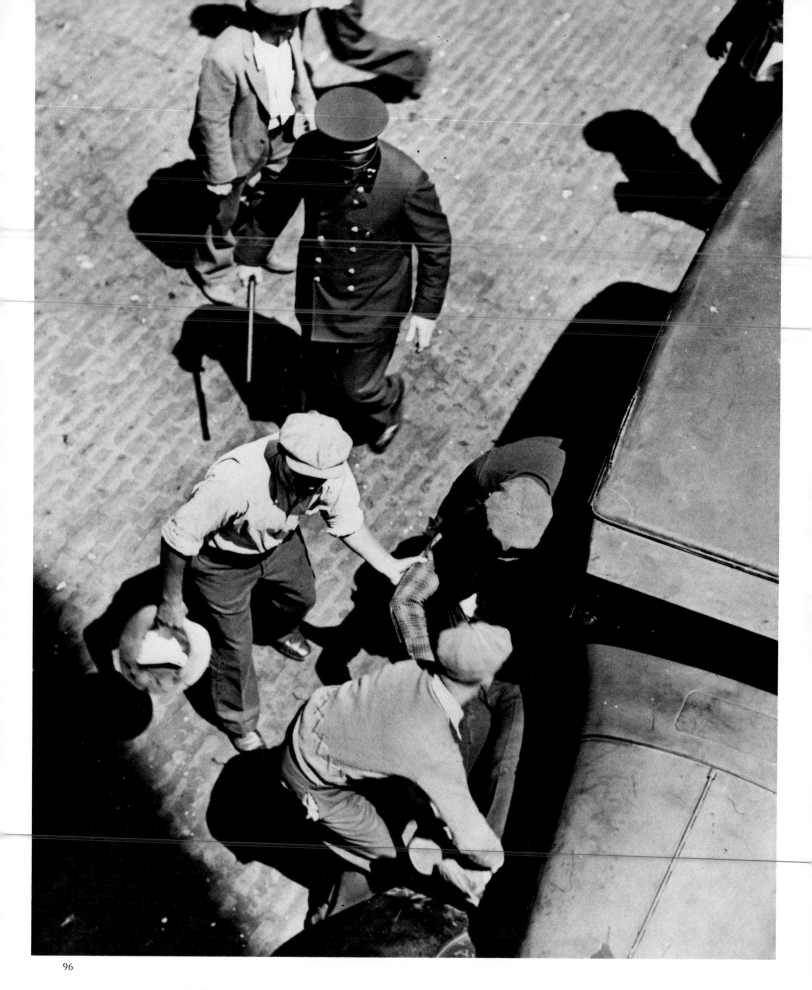

96

94. Strikers battle police in the riot at the City Market during the truck drivers' strike, Minneapolis, Minnesota, 1934; photographer unknown. **95.** Special policeman down in the City Market riot, Minneapolis, 1934; photographer unknown. **96.** Injured participant, City Market riot, Minneapolis, 1934; photographer unknown.

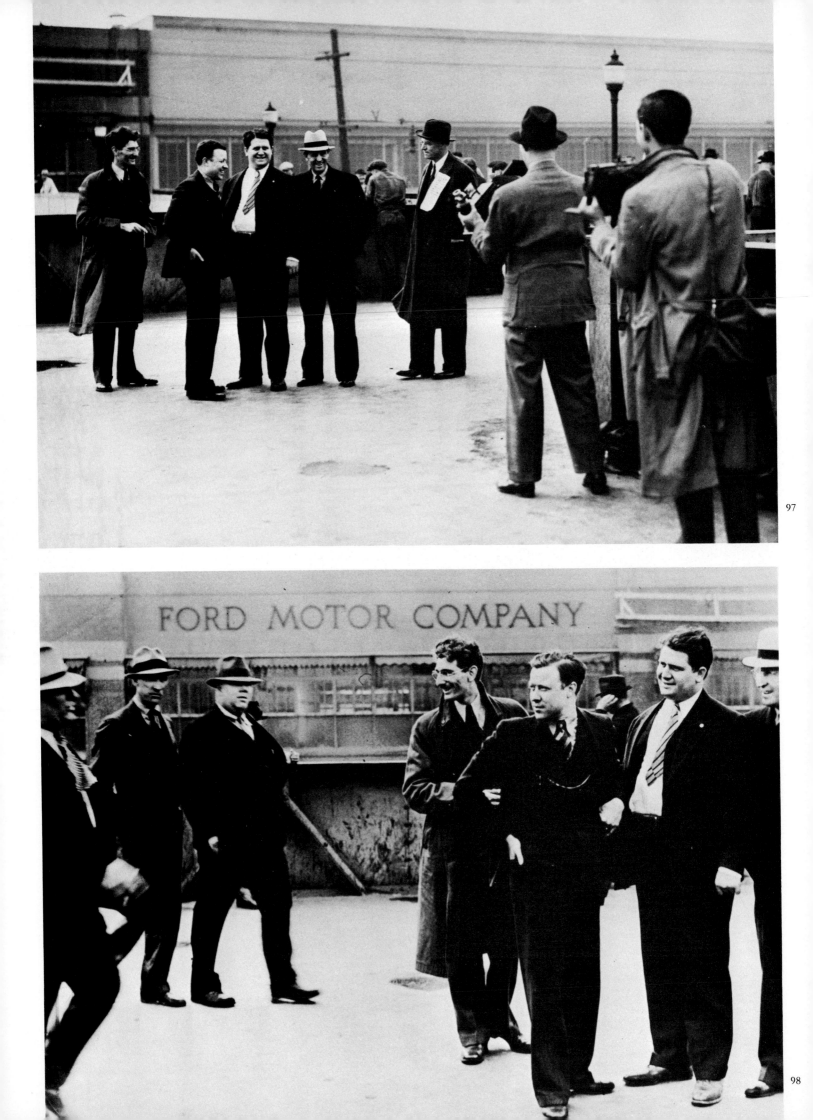

97

98

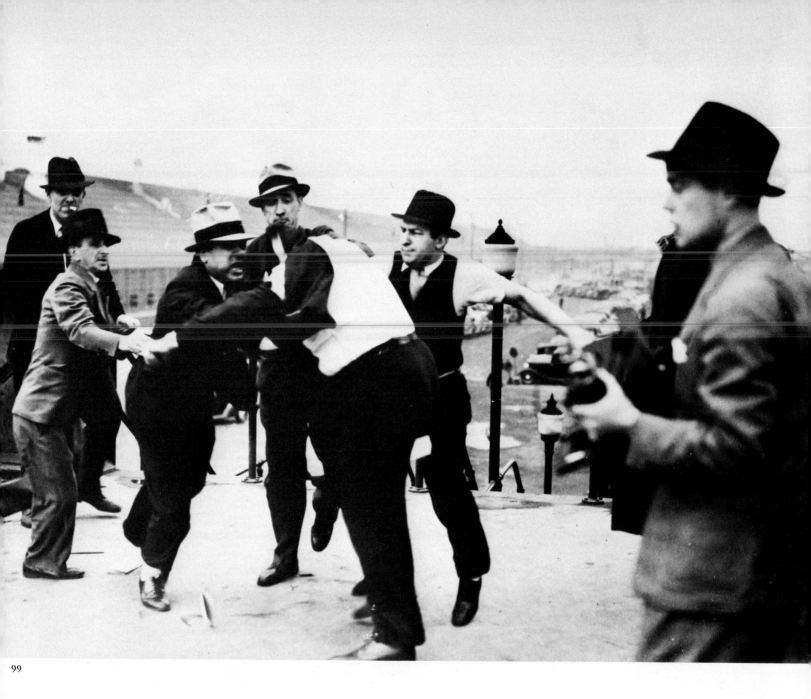

97. Part 1 of the "Battle of the Overpass," Detroit, May 26, 1937; photographer unknown.
98. Part 2 of the "Battle of the Overpass"; photographer unknown. **99.** Part 3 of the "Battle of the Overpass"; photo by James "Scotty" Kilpatrick, award-winning photographer for the *Detroit News*.

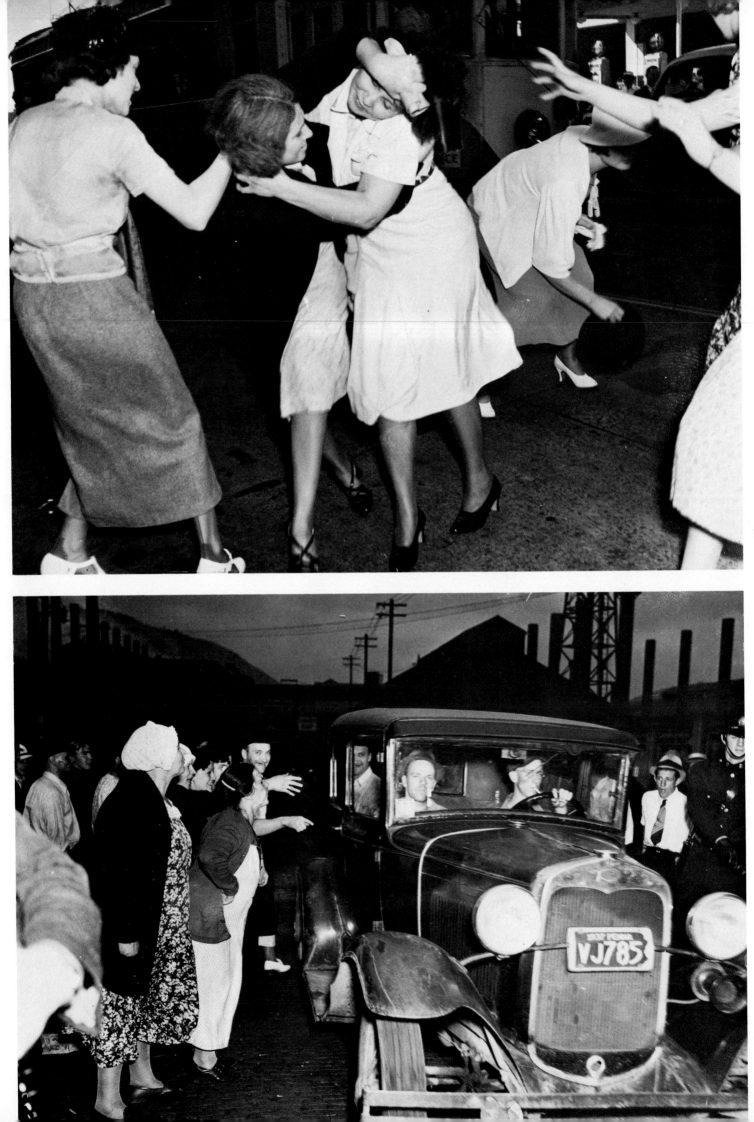

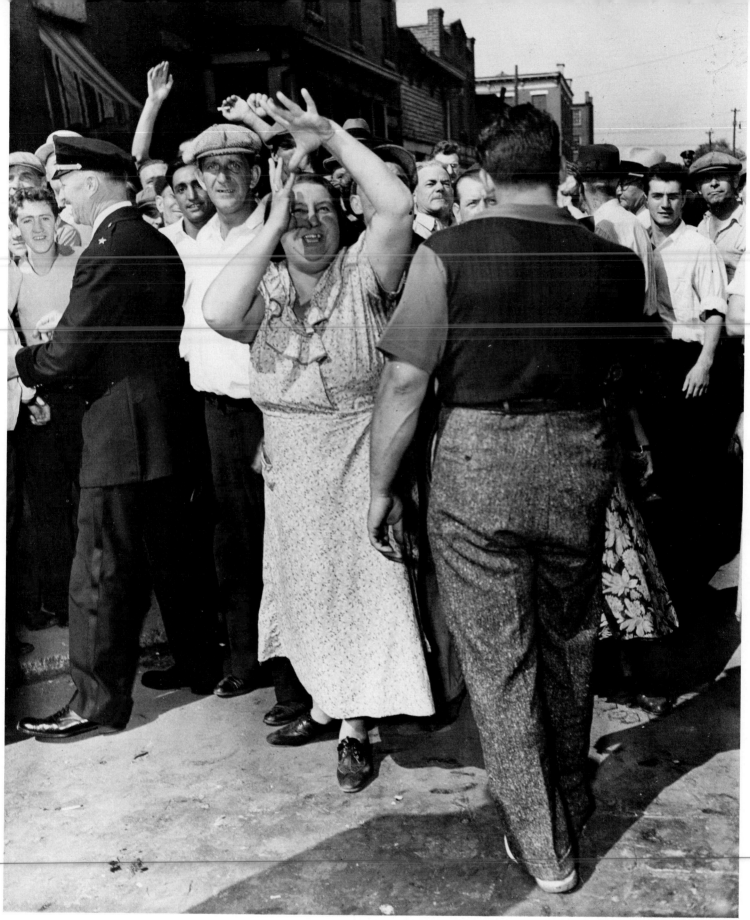

102

100. Ladies' garment workers fighting over the issue of organization, Atlanta, Georgia, 1937; photographer unknown. **101.** Women deriding returning workers during a steel strike, Johnstown, Pennsylvania, June 29, 1937; photographer unknown. **102.** Female demonstrator in a dock strike, New York City, 1937; photographer unknown.

Industrial Photography in an Industrial Age 99

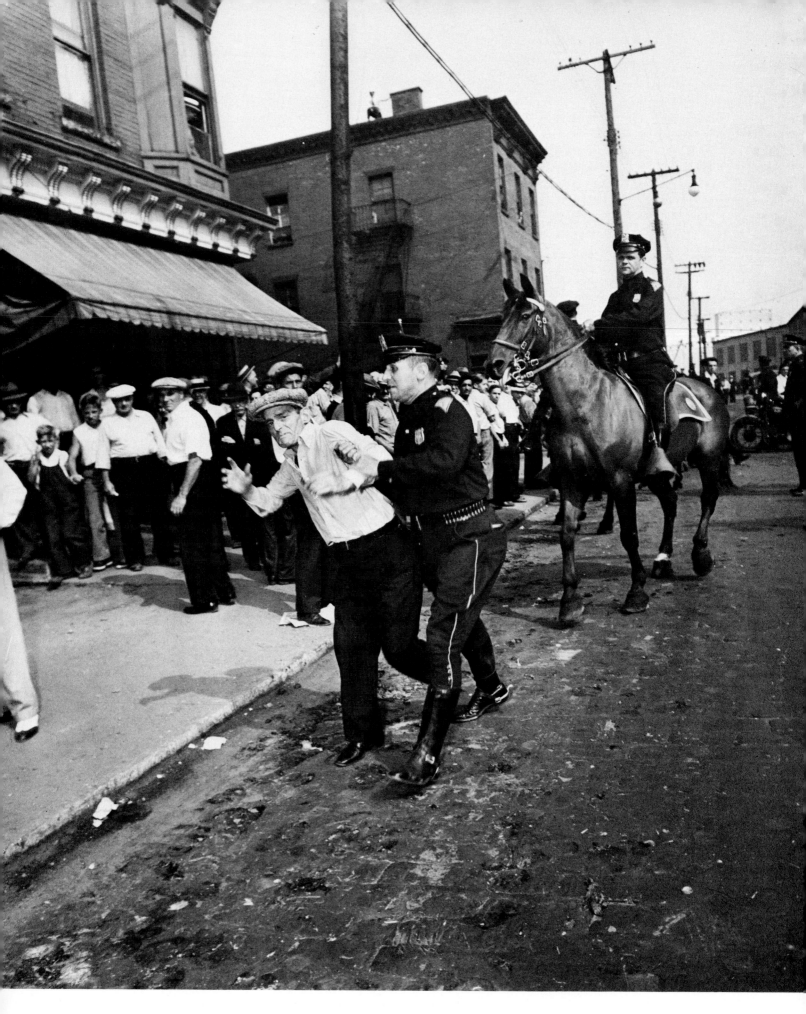

103. Police arresting a man accused of throwing rocks during the 1937 New York dock strike; photographer unknown.

THE MEDIUM COMES OF AGE

During the period between World War II and about 1960 a distinct maturing occurred in the field of industrial photography in the United States. A degree of consistency and controlled expressiveness was achieved which surpassed, overall, the performance of photographers in the earlier decades. There are several reasons why this happened when it did. Technical change, improved outlets for good industrial photographs, and the general temper of the times all helped to attract a large number of talented people into the field.

During the war and postwar years, the medium of photography was undergoing technical changes almost as important as the change from wet-plate to dry-coated negatives had been. Kodachrome film became available in the late 1930s and photographers were beginning to experiment with color transparencies as a serious medium of expression by the early 1940s. Within the same period, and more especially by the early 1950s, industrial photographers were learning to take advantage of the wonderful mobility and unobtrusive qualities of 35mm cameras in order to gain a sense of immediacy and naturalness in their work. Just as importantly, the field of industrial photography was developing a set of traditions—ways of approaching different given situations that would yield fairly predictable results. These conventions did not stop experimentation but they did give photographers working within the industrial milieu some guideposts. What may have been lost in terms of the first excitement of creativity was gained in terms of control over the image's message and impact.

The general temper of the times was conducive to good industrial photography. The 1940s and 1950s were a time when classic heavy industries had a major role to play in this country. Activities such as mining, steelmaking, assembly-line production and heavy construction have always been favorite subjects of photographers, since it is relatively easy to represent these on a visually "heroic" scale. Furthermore, viewer identification is usually no problem. Steelmaking *looks* like steelmaking. An aerial shot of an offshore oil rig is immediately recognizable. More modern electronics or service industries often confront the viewer with a bewildering landscape of knobs, dials and reels of tape. One veteran industrial photographer who was quite successful in the 1950s has recently balked at assignments involving large banks of computers. "What can you do with 'em?" he complains. "They look like a bunch of coffins in a phone booth."

World War II has been called an assembly-line war because so many guns, tanks, jeeps, aircraft and other industrial products were used. This helped to create a generally pro-industrial national frame of mind. The tinseled affluence of the 1950s (along with the fighting in Korea) accelerated production at all levels. The open hearths at Pittsburgh and the giant stamping presses at Detroit seemed once again to symbolize the nation moving forward as well as protecting itself against aggression.

The possibilities open to photographers who specialized in industrial subjects increased as more and more management teams realized the necessity for good public relations and the value of photography in promoting a strong corporate image. By the war years, several major corporations were establishing their own in-house photographic agencies, utilizing top talents to do interpretive photography that went beyond the usual simple documentation of company activity. One of the best of these early projects came about when a major oil company realized in 1941 that it had a really poor public image.

Standard Oil of New Jersey had just been cited in a Roper Poll as the most disliked large industry in the country in late 1941. In a bit of a panic, the company turned to one of the most thoughtful public-relations specialists in New York City, Earl Newsom, for suggestions as to what should be done. Newsom's answer, a treatise on the logic of the corporate image, ran for thirteen pages. After acknowledging that the company had a problem, Newsom addressed himself to some general ideas and directions (the italics are his):

> If knowledge is made up of *selected* bits of evidence, never *all* the facts; if an opinion or emotional attitude is a *montage* of *selected* images; then it becomes obvious that what is most important is *what* the selection is and *who makes* the selection.
>
> There are three ways in which public opinion of a corporation can be formed: (1) the selection of the images which are to be merged to form the opinion can be left to chance; (2) the selection can be left to those who for one reason or another do not wish the corporation well; or (3) the corporation itself can have a hand in making the selection.

Newsom went on to point out that Standard Oil of New Jersey was not a "bad company," that in fact it had a fine record in labor relations, inventions, general efficiency and other major concerns of the day (ecology and Arabian oil were unheard-of issues in 1941). By leaving its public image to chance, the company was simply insuring that its occasional errors or misbehavior would, because of their news value, become the major pieces of the "montage" from which most people formed their image of the company.

The Newsom memo had a great impact on the management of Standard Oil of New Jersey. They responded with the first major, long-range attempt by an industry to justify

its role in society through visual as well as written means. One of the basic ideas was to create a large file of fine photographs attempting to show every phase of the company's activities and its generally beneficial impact on people, towns and the country in general. These photographs would function as a visual resource for in-house publications such as Standard's trade journal, *The Lamp,* but it was also hoped that the file would be utilized by magazines and newspapers in need of excellent images relative to the oil industry.

The Standard Oil of New Jersey Photographic Project was conceived along the same lines as an earlier successful project that had been carried out by the federal government during the Depression. Beginning in 1935 under the Resettlement Administration, and later continuing under the Farm Security Administration, a group of truly fine photographers had succeeded in visually dramatizing the problems of poor farmers. The group had included Walker Evans, Arthur Rothstein, Russell Lee, Dorothea Lange and John Vachon among others—all later acknowledged masters of the craft of photography. The agency's director, Roy Stryker, had provided the guidance and protection that the group needed and had developed the idea of a permanent file that was open to the public. The F.S.A. project had succeeded brilliantly for poor farmers. The management of Standard Oil of New Jersey assumed that it would work equally well for them. They failed to realize that public trust in government had been high during the 1930s and thus magazines and newspapers had been able to utilize photographs from government sources without compromising their credibility with readers. Those same readers might not welcome photographs taken by a publicity department of a powerful private industry.

Attempting to insure the project's success, the management of SONJ followed the F.S.A. example as closely as possible. In 1943, Roy Stryker was lured from his government position and made director of the new project. He was given a healthy budget and a great deal of administrative leeway. Stryker was to hire the best photographers he could find and send them out on general assignments with maximum interpretive freedom. As the file in New York City grew, it was confidently expected that magazines such as *Life* and *Fortune* would make use of it and the general public's image of SONJ would be improved accordingly. Stryker did hire the very best of the younger photographers who were interested in industrial photography. Charles E. Rotkin, Harold Corsini, Todd Webb, Esther Bubley, Sol Libsohn and Edwin Rosskam all worked on the staff at SONJ at one time or another and the work they did was of very high quality. Established professionals like Gordon Parks, who was on the staff of *Life* magazine, John Vachon, who was with *Look* by that time, and Russell Lee, who free-lanced quite successfully, all took occasional assignments.

Because they were able to work in a supportive atmosphere, the photographers on the Standard Oil project found it possible to experiment fairly freely with style and even, to a degree, with point of view. Esther Bubley produced a long and extremely interesting series on soldiers and other transient Americans waiting in bus stations, the only connection with the oil industry being the rather tenuous matter of bus fuel. It was a good series, showing that the classic photo-documentary style could be adapted to the needs of an industrial client. The emphasis was not directly on oil, it was on people and the way a certain fuel affected their lives. In the same vein, Edwin Rosskam followed a group of riverboat men who transported oil in barges along the nation's rivers. Oil was always in the story, but under Stryker's direction, the emphasis was often on the people who drilled for it or transported it or sold it or used it.

When the situation called for the purely industrial image, emphasizing machinery or the sheer scale of business activity, Stryker's team had men who specialized in that approach too. Charles E. Rotkin's experiments with aerial photography established the very-high-angle photograph with dramatic angularities and abstractions as a permanent part of industrial photography's lexicon. Todd Webb produced beautiful and impressively honest pictorialist images that drew on the work of Sheeler in their formal integration of elements but went far beyond Sheeler's photography in the sense that Webb applied the approach successfully to far more situations and under more widely varying circumstances. Sol Libsohn's work was also often successful in identifying beautiful patterns in industrial situations.

Viewed today, the nearly eight thousand photographs that were done for Standard Oil of New Jersey under the direction of Roy Stryker comprise a tremendous record of one company's activities over an eight-year period in the middle and late 1940s. The photographs also form a record of stylistic growth and development as the photographers experimented with color and different ways of approaching an industry. From the point of view of management, however, the experiment was not a success. The photographic file was extensively used by the company's in-house publications and *The Lamp* quickly became the standard setter for the petroleum industry, but outside users from the country's national magazines and newspapers never materialized. What was worse, polls by Roper and other organizations showed that just about as many people hated Standard Oil in 1950 as had in 1941. The beautiful photographs had not gotten the message of oil outside the organizational structure of SONJ. *The Lamp* was, after all, the industrial equivalent of talking to oneself. Roy Stryker left the organization in 1951, tired of attempting to justify his office to an increasingly unimpressed management team, and the file went into semi-retirement. SONJ would continue to hire fine photographers and use excellent industrial photographs, but never again on the same scale. Stryker, however, remained fascinated by the industrial image and continued active in this field of photography. During the next two years he directed a visual study of the city of Pittsburgh, sponsored by the University of Pittsburgh, which yielded some of the finest photographs of the archetypal American industrial city that have ever been taken. Like Stryker, most of the young photographers who had worked on the Standard Oil project remained in the field, fanning out to different jobs in different cities and carrying their visual influence with them.

The failure of the Standard Oil of New Jersey project was probably unavoidable since it was based on the assumption that magazines and newspapers would rush to use photographs merely because they were beautiful or showed the activities of a company in a new and interest-

ing way. *Fortune* did use pictures from industrial sources from time to time, although even *Fortune* usually preferred to contract with free-lance photographers on an individual-assignment basis. Most other mass-circulation magazines, however, avoided images from industrial sources altogether because of the problem of credibility. Their readers would tend to suspect that any picture provided by a company such as Standard Oil was self-serving of industry interests. This is unfortunate since the Standard Oil photographers had at least as much creative freedom as did most magazine and newspaper photographers of the day, but it was a fact of life.

During the 1940s and '50s the general public usually formed its image of industry through the pages of national magazines such as *Life, Look* and, preeminently, *Fortune.* News stories concerning a specific industry might appear in the newspapers or on the new medium of television, but most of the visual images concerning industry (which were not advertising) appeared in the magazines. As the spokesman for large-scale industry, *Fortune* took the lead. The magazine's reputation was already well established and continued to grow throughout the 1940s and '50s. Among the men whose work often appeared on its pages were Fenno Jacobs, Arthur D'Arazien and Walker Evans. In the late 1940s and early '50s Jacobs' work seemed particularly interesting and ahead of its time. In terms of style, Jacobs was one of the first to realize that color photography was quite a different medium than black-and-white photography. His early color work showed an understanding that dominant colors often attract the eye to a given spot in the photograph quite independently of other compositional considerations. Most other photographers seemed to have trouble grasping this and composed their color photographs exactly as they would have black-and-white. In such cases the results were often as likely to confuse the eye as to inform it. Jacobs not only used color well, he also had good control over the idea of the photographic portfolio (not a photo-essay but a group of loosely related individually excellent photographs). Since *Fortune's* editors liked the portfolio concept, Jacobs' work appeared often. Jacobs was ahead of his time conceptually as well. For example, he was sensitive to environmental considerations years before such ideas became common. D'Arazien's work seems less original today, yet in its own time it was quite popular with *Fortune's* editors and, presumably, its readers. D'Arazien specialized in the industrial "big picture," requiring elaborate lighting effects and a great deal of special planning. Many of his techniques related, on a large scale, to the studio portraiture of the 1940s and the results were often technically spectacular. What was missing was the element of freshness. D'Arazien knew exactly what he was doing. Often he seemed to know too exactly what he was doing.

If work like D'Arazien's seems unadventurous to the modern viewer, *Fortune* occasionally featured the work of promising younger photographers who seemed to be doing something new with the visual theme of American industry. In April 1955 the magazine published a portfolio titled "Steel: A Fresh Focus" by Clyde Hare and Ivan Massar, two unknown young photographers who were doing assignments for Jones & Laughlin Steel. The photographs were all in color and showed that Hare and Massar, better than anyone who had preceded them,

understood that color photography was a new and different medium. In their work, color was an integral part of composition, bringing out an abstract pattern here, adding drama or emphasizing a point there. They used the brilliant hot colors they found in the steel mills to surround the workmen they saw with a visual cacophony so that the viewer actually felt the heat and glare and the noise. They used small 35mm cameras to achieve maximum flexibility of angle and approach. Some of the photographs were even nonobjective. That is, subject matter was not immediately identifiable since it had been made secondary in visual importance to the design and the color. This was all new and exciting in industrial photography.

The Jones & Laughlin project was a particularly fine example of a company-sponsored photographic agency during the 1950s. Interestingly enough, it also links up again with the name of Roy Stryker. In 1953 Stryker left the University of Pittsburgh and came to J & L to direct the development of a photographic library for that company. The management at J & L seemed really interested in a major visual resource. Stryker insisted upon a great deal of expressive freedom, and when it was clear that this would be available he made the change. As usual, Stryker was able to attract some of the brightest young photographers in the country (for by now his reputation was legendary) and the project was soon going well. Because the management of Jones & Laughlin never had the extremely high expectations that had existed at SONJ, Stryker found the atmosphere there quite good and, in fact, continued to act as a consultant on the J & L project for the rest of his active career.

It was Clyde Hare and Ivan Massar who did the great bulk of the work on the J & L project. Hare had worked for Stryker at the Pittsburgh Photographic Library project while Massar's training was at the California Art Institute. For three years during the mid-1950s their standing assignment was to interpret visually the entire operation of the J & L Steel Corporation. There was much to see and much to try to understand. Both men seemed to enjoy the experience.

Since the ecology issue was not the subject of broad popular debate in the 1950s, steelmaking was a comparatively "dirty" process when Hare and Massar carried their small cameras into the bright infernos of Pittsburgh. Oddly enough, this worked out very much to their advantage. Clyde Hare remembered it this way:

> Those mills in the fifties were noisy and they were hot! You had to be careful not to get a hole burned in your equipment. I guess they were more dangerous too, although we didn't worry much about that in those days. The great thing was that you could see what was going on. It was all right out in front of you. Those men were making steel! They were good at it too, and they were proud of their skills.
>
> Go into those same mills today and what do you see? A big green console with a man sitting up in a glass booth changing punch cards in the computer. I guess that you could say that in the '50s men made steel with machines. Today man is part of the machine that makes steel.

The "big green console" is, of course, much safer, far better from an ecological standpoint, and it probably makes better, or at least more consistent, steel. From the

purely visual standpoint, however, Hare knew exactly what he was talking about. Changes in heavy industry since those years, while excellent from an engineering standpoint, have often made the photographer's job more difficult.

The J & L project is important from an historical standpoint because Stryker and his people concerned themselves with a theme that was broader than merely recording the company's day-to-day work. Like Lewis Hine in the 1920s, they were fascinated by the interrelationships between man and machines. During the 1950s most industrial photography concentrated on the machine itself (a fact that also tells us something about the period) but the J & L staff preserved an essential humanism. Man, the worker, was always in the picture or not far out of it. Because of this the pictures take on a documentary value at a new level. Man's relation to his industrial environment can now be compared across time. A clear contrast exists between the images in the J & L photo library and the photographs taken by the nineteenth- and early twentieth-century photographers. Man, the hero dominating his environment, has clearly been replaced by man, the servant of the machine, who may still be heroic but only in relationship to his machine, and who may even be threatened by his machine. A basic change had taken place by the mid-1950s. Large labor-saving machines were replacing workers in heavy industry at a rapid rate. As the machines grew larger, the crews who serviced them grew smaller, and the shift was not only statistical but visual as well. The J & L photographers were honest enough and sensitive enough to record this change.

Creative industrial photographers of the 1950s worked in a period when a number of factors over which they had no control were operating to their advantage. Technologically photographers were far better off than their predecessors. Cameras, lenses and films were quite advanced. In fact, a good photographer suffered very few technical limitations by the end of the decade. In addition, most heavy industry such as steel manufacturing, heavy construction, mining and the petroleum-related industries (all bread-and-butter clients of professional industrial photographers) were enjoying a period of expansion during most of these years. These industries all contained many visually exciting elements that were fairly accessible to the photographer. Industrial management was generally enthusiastic about good visual imagery and was not yet on the defensive concerning ecological and consumer issues. Public opinion was generally supportive of industry, too, for industry produced things and this was a materialistic age in the nation's life. As a result, industrial photographers were seldom called upon to play the lonely and difficult role of critic in the postwar years. They were seldom forced to deal with serious ambiguities in their own feelings or in the perceptions of their viewers. Postwar industrial photographers were blessed with the luxury of being able to believe wholeheartedly in what they were doing.

The positive atmosphere of the 1940s and 1950s meant that every photograph did not have to undergo the scrutiny of a nervous public-relations official before release to the public. A good photographic director like Stryker could send his people out on a general assignment knowing that they would have cooperation and a reasonable amount of freedom of movement, and that a fairly high percentage of their production would be deemed usable by management. Finally, good outlets existed for industrial photographs. Many companies followed the lead of Standard Oil of New Jersey and established their own house organs or other staff-produced publications. Several of these were and continue to be excellent. Corporate annual reports made more and better use of photographs and even began to use dramatic color on occasion. As a goal to shoot for, there was always *Fortune,* and many of the best photographers had the pleasure of seeing their work in that magazine's prestigious pages. Given all these factors, it is hardly surprising that the number of photographers who specialized in industrial subjects increased and that the quality of their work was often quite high. All in all, the postwar decades must have been a pleasant time to be an industrial photographer in America.

ABOUT THE PHOTOGRAPHS

XXII. Standard Oil of New Jersey (Photos 104–119 and Frontispiece)

When Standard Oil of New Jersey hired Roy Stryker in 1943 to build a major file of photographs of the oil industry, the oil executives may not have had a very clear idea of just what they were starting, but they knew Stryker was the best director of still photographers available and they wanted the best. Over the following eight years, Stryker and the men and women who worked for him compiled the first great company-sponsored record of a major industry at work. The Standard Oil Collection (now chiefly housed in the Photographic Archive of the University of Louisville) contains a broad and massive record of the oil industry in the 1940s, the people who worked in the industry and the impact of the industry on the nation as a whole. The Stryker team was capable of highly formal images, such as Sheeler or Bourke-White might have taken, but they were also interested in the less formal documentary approach. Within the technical limits of the 1940s, they produced as complete a visual representation of an industry as could possibly have been expected.

XXIII. Pittsburgh—Steel City (Photos 120–126)

Since the days of Alvin Langdon Coburn, Pittsburgh has fascinated photographers as the archetypal American industrial city. During the early 1950s, the city was undergoing an important cultural awakening and face-lift and some of the best young photographers in the country were there to record and comment visually on the change. In 1951 the University of Pittsburgh began to build a major Photographic Library showing both the historic development of the city (by collecting early photographs) and by utilizing the talents of rising young photographers like Clyde Hare. The man who directed and developed the project was, again, Roy Stryker. In 1953 Stryker began to develop another major file, this time for the Jones & Laughlin Steel Corporation, and again the general subject was Pittsburgh and steel.

XXIV. Color Arrives (Color Photos A & B)

One of the most exciting developments of the 1940s and '50s was the arrival of color photography as a practical medium. The Eastman Kodak Company introduced Kodachrome transparency film in all the popular film sizes in 1938, and within a few years most professionals were beginning to experiment with the new material. With color a whole new element was added to the visual language of industrial photography; it took photographers a decade or so to begin to understand how to utilize this new factor

fully. The new medium was so totally different from anything that these people had dealt with before that they were thrown off stride. Like their earliest predecessors in the nineteenth century, they were content if they could just get a good picture. In this case, if the colors were all nice and bright the image was generally considered successful. The stylistic rhetoric that had been so carefully developed over the years was, for a time, almost forgotten while photographers painfully relearned the color awareness that painters had known for centuries. Gradually, by the late 1940s, a few photographers were learning to make color work for them as an integral part of the picture and as a way of adding impact to the message. By 1950 and the years after, photographers were becoming comfortable with the medium and industrial photography was becoming more and more a strong field for the person who could see and utilize color well.

XXV. A Fenno Jacobs Portfolio—"A Landscape of Industry's Leavings" (Color Photos C & D)

Reproduced here with their original captions from *Fortune* magazine (March 1950), Fenno Jacobs' photographs of the industrial backwaters of New Jersey retain a freshness and excellence that set them apart from the average color industrial photography of the time. Jacobs had clearly solved the basic visual problems of using color film. He was moving beyond the "picture postcard" effect and using color to establish mood and draw the eye to certain elements of the picture. Jacobs' ideas were not only visually fresh but also ahead of their time ideologically. To suggest in 1950 that industry bore a responsibility to the land, water and air required a certain amount of courage (both for Jacobs and for the editors of *Fortune*).

XXVI. A Clyde Hare and Ivan Massar Portfolio—"Steel: A Fresh Focus" (Color Photos E & F)

Young, fresh from college and totally unknown, Clyde "Red" Hare and Ivan Massar had the heady pleasure of seeing their work in the most prestigious magazine in the field of industrial imagery. Their portfolio was accepted for publication by *Fortune* (April 1955) for the simple reason that it was very good. Color was not only used well, it was an integral part of their compositions. Unlike the other photographers of the day, Hare and Massar had realized that every color photograph does not have to contain every color. They dared to use monochromatic effects and they dared to use abstractions. Most of all, their youthful enthusiasm came through in every image. They thoroughly enjoyed the work they were doing and it showed.

104. Crude-oil pipe still No. 7, Baton Rouge, Louisiana; no date; photo by Esther Bubley.

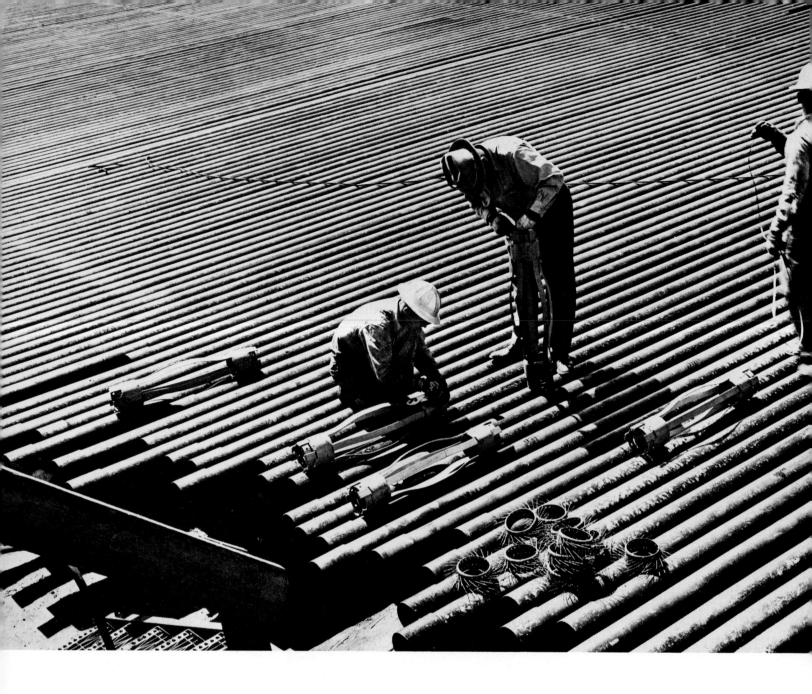

105. Workmen adjusting casing centralizers, Hobbs, New Mexico; no date; photo by Esther Bubley.

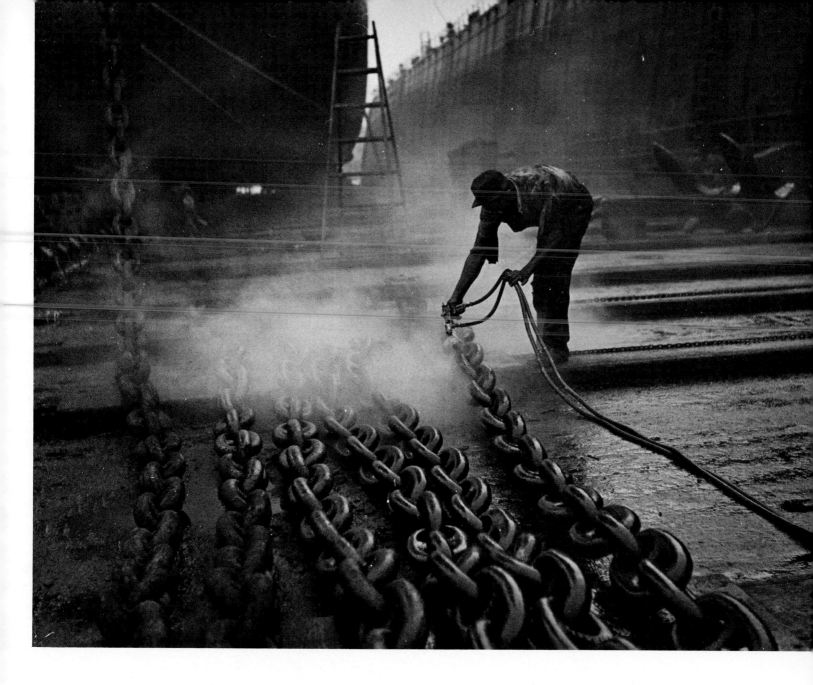

106. Cleaning hawser chains on a dock, New Jersey, ca. 1945; photo by Esther Bubley.

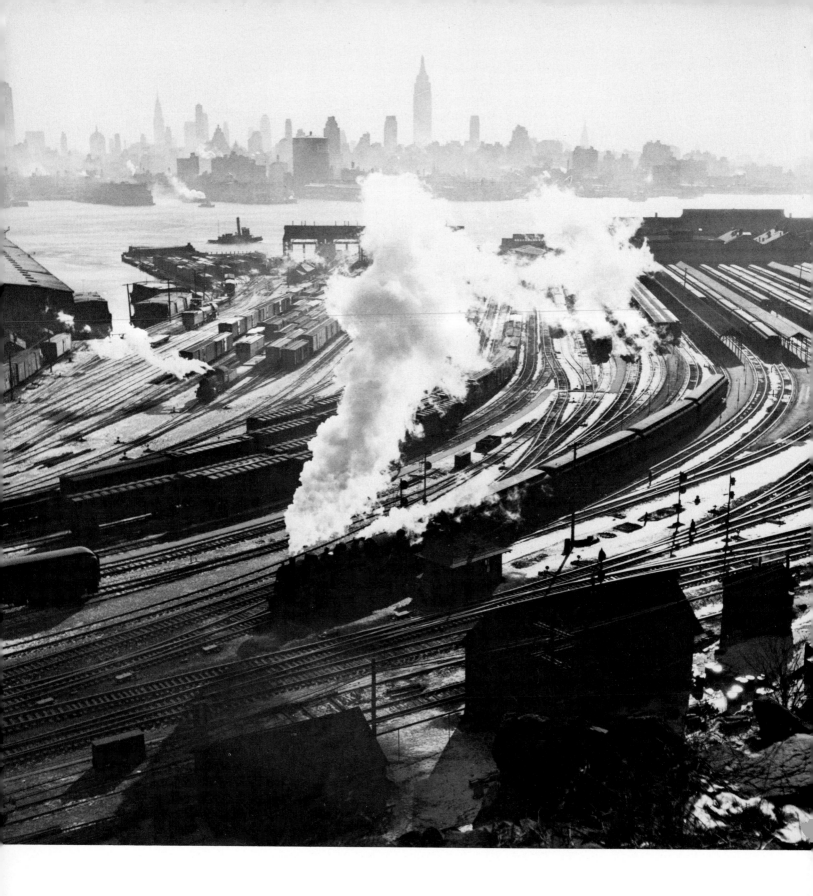

107. View across the New York Central Railroad yards toward Manhattan; no date; photo by Esther Bubley.

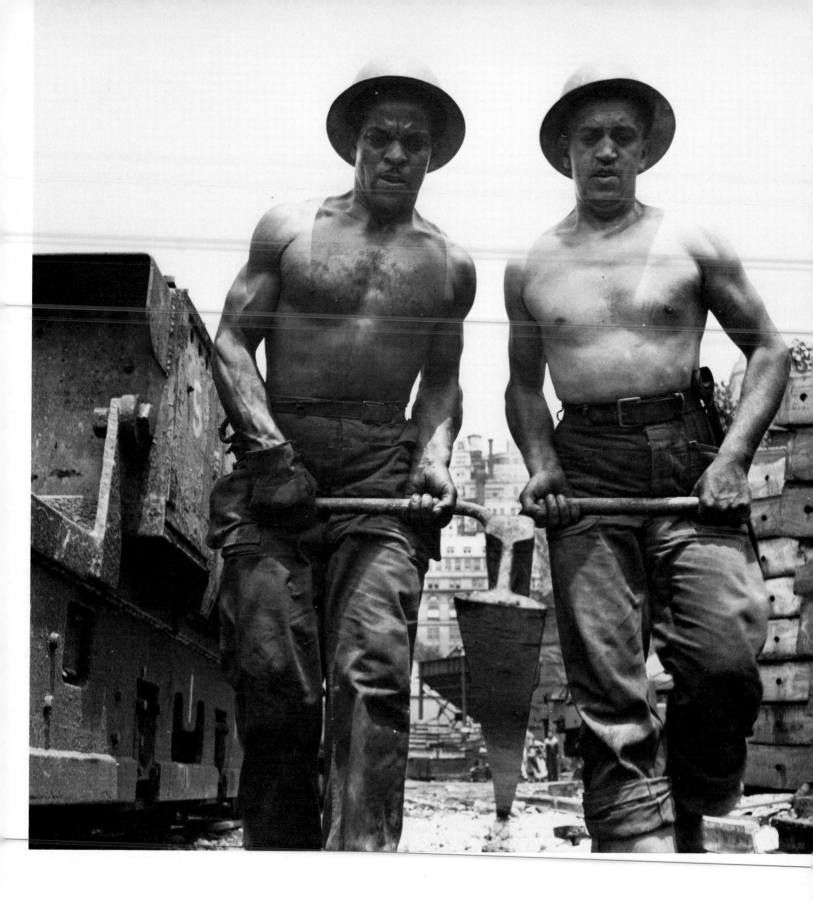

108. Installing a narrow-gauge railroad for a supply yard during the construction of the Brooklyn-Battery Tunnel, New York City, July 1947; photo by John Vachon.

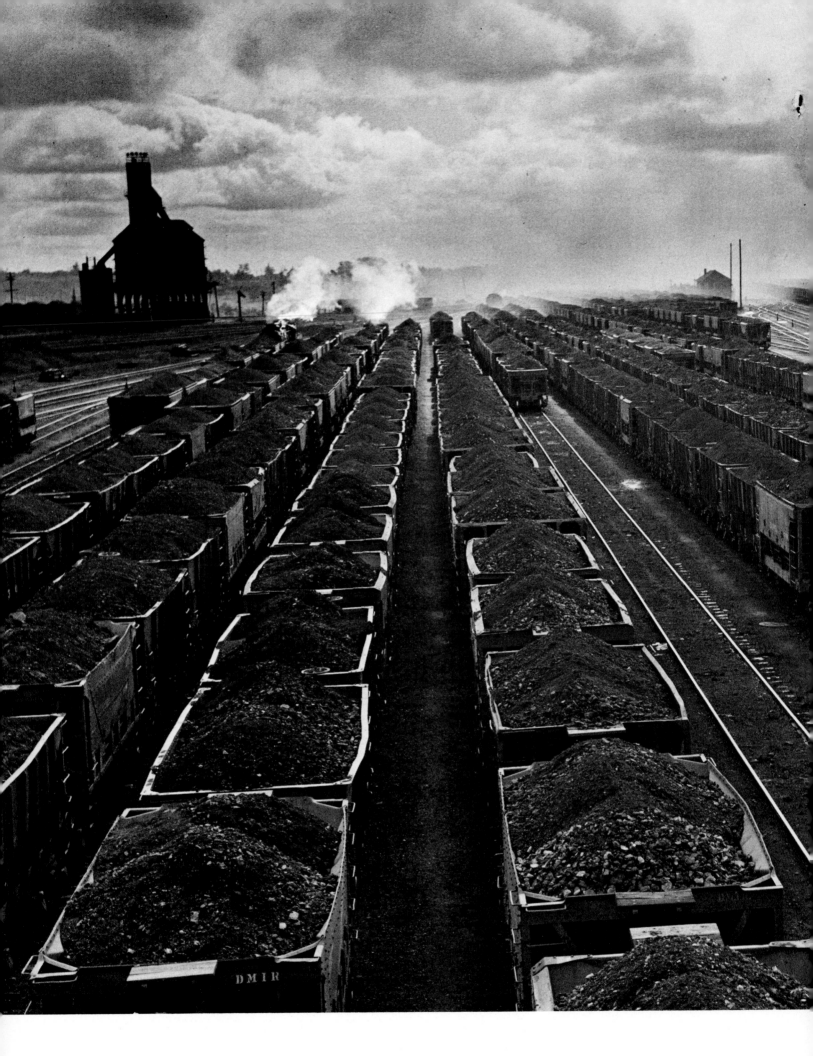

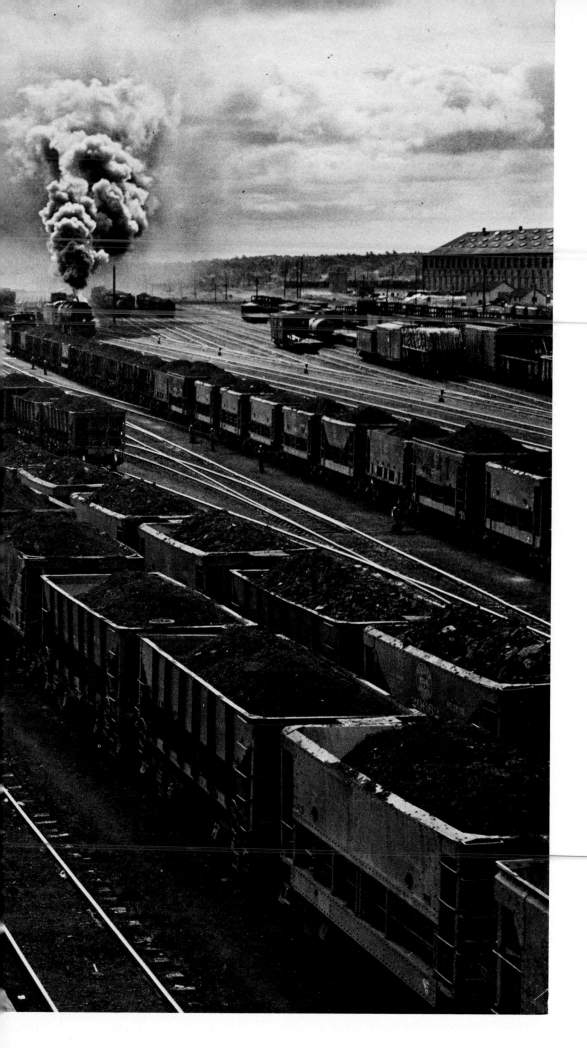

109. Railroad yard, Superior, Wisconsin, ca. 1945; photo by Esther Bubley.

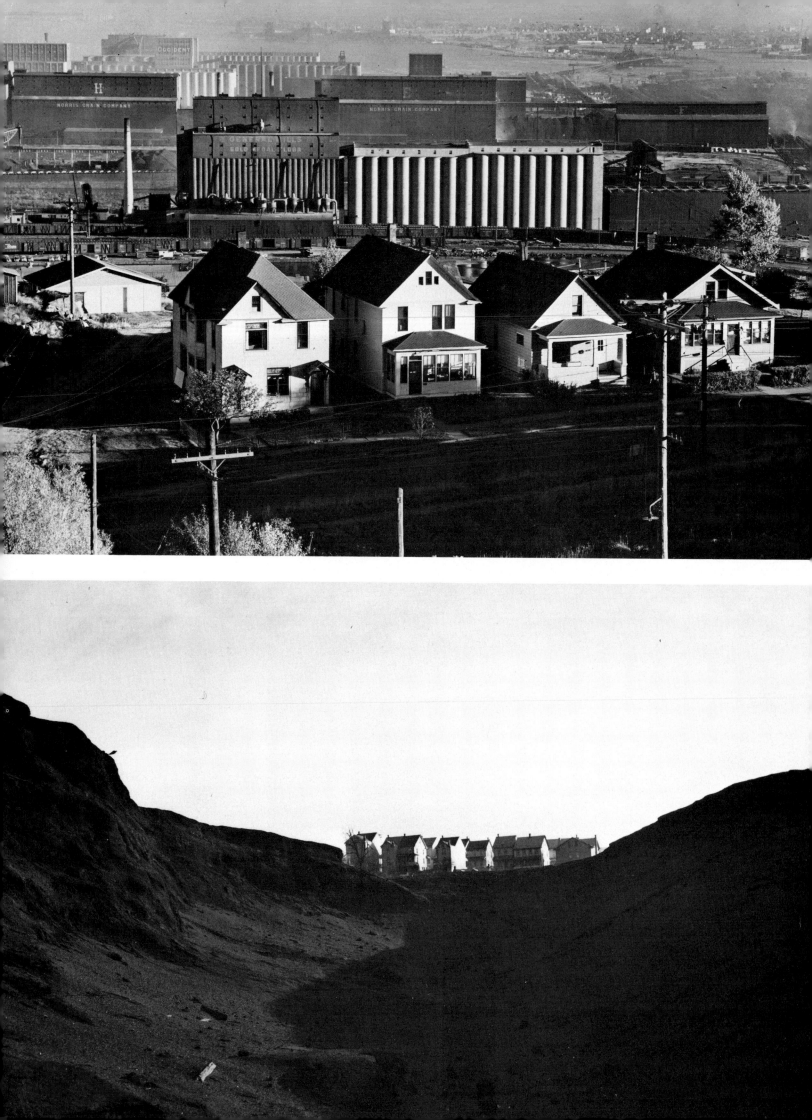

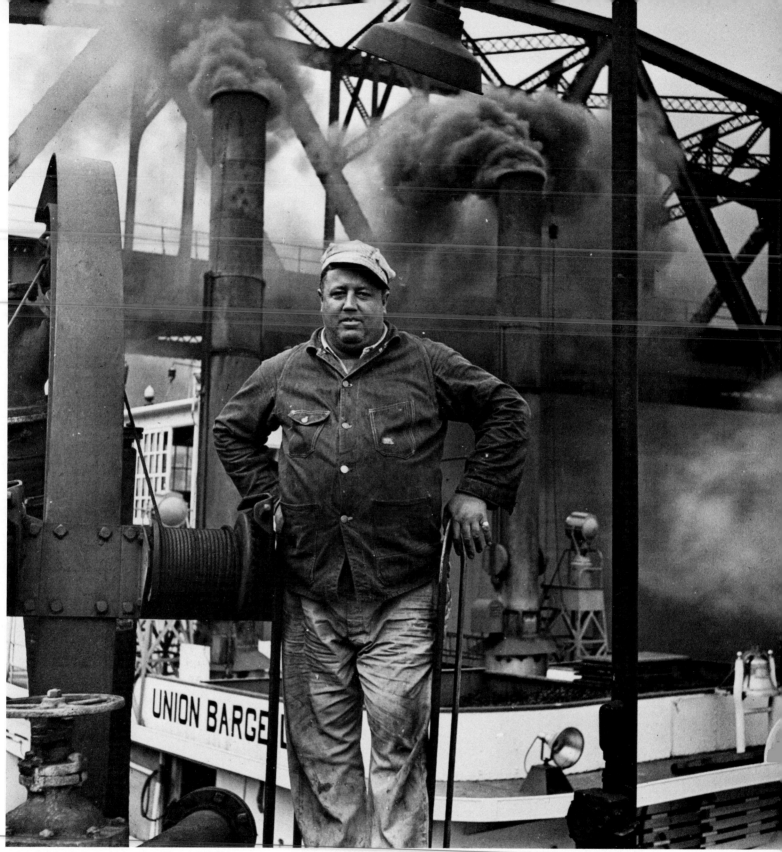

112

110. Houses and grain elevators, Duluth, Minnesota, ca. 1945; photo by Esther Bubley.
111. Miners' houses and slack pile, Shamokin, Pennsylvania, December 1947; photo by John Vachon. 112. Charles P. Wright, mate of the steamer *Sam Craig* on the Ohio River near Pittsburgh, May 1945; photo by Edwin Rosskam.
Overleaf: 113. Looking toward Pittsburgh from a hill near Westinghouse Bridge, ca. 1948; photo by Todd Webb.

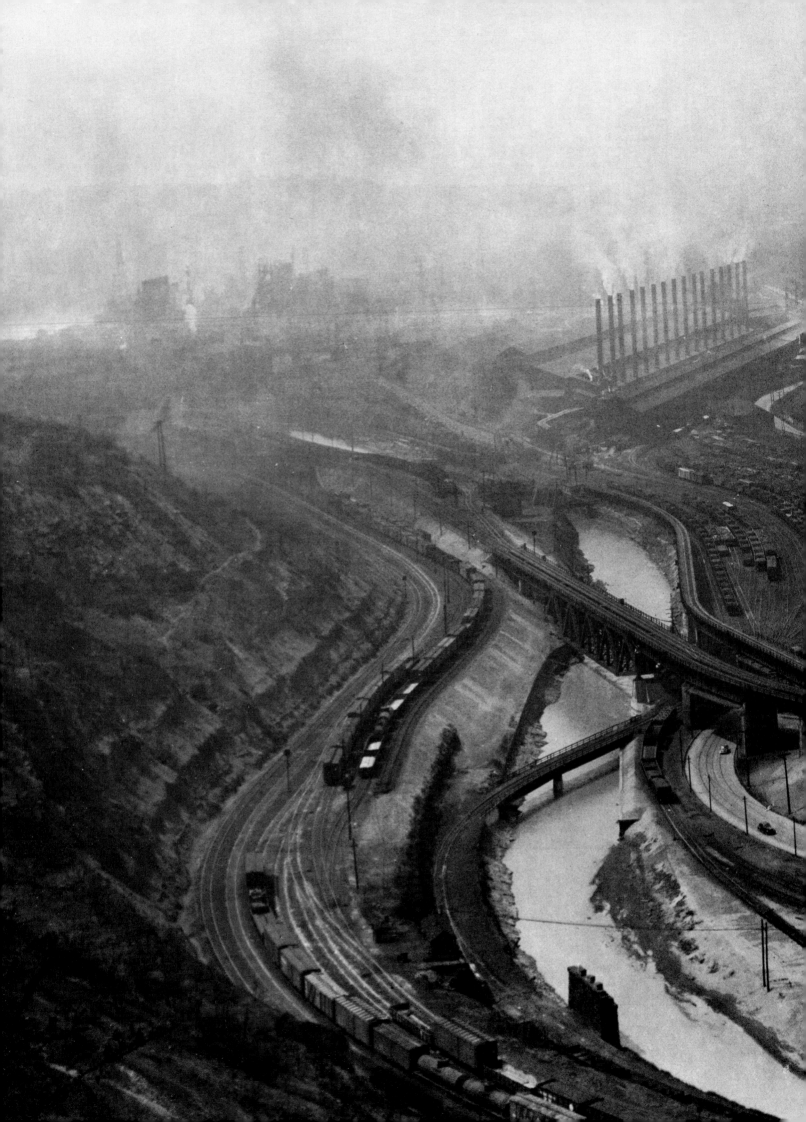

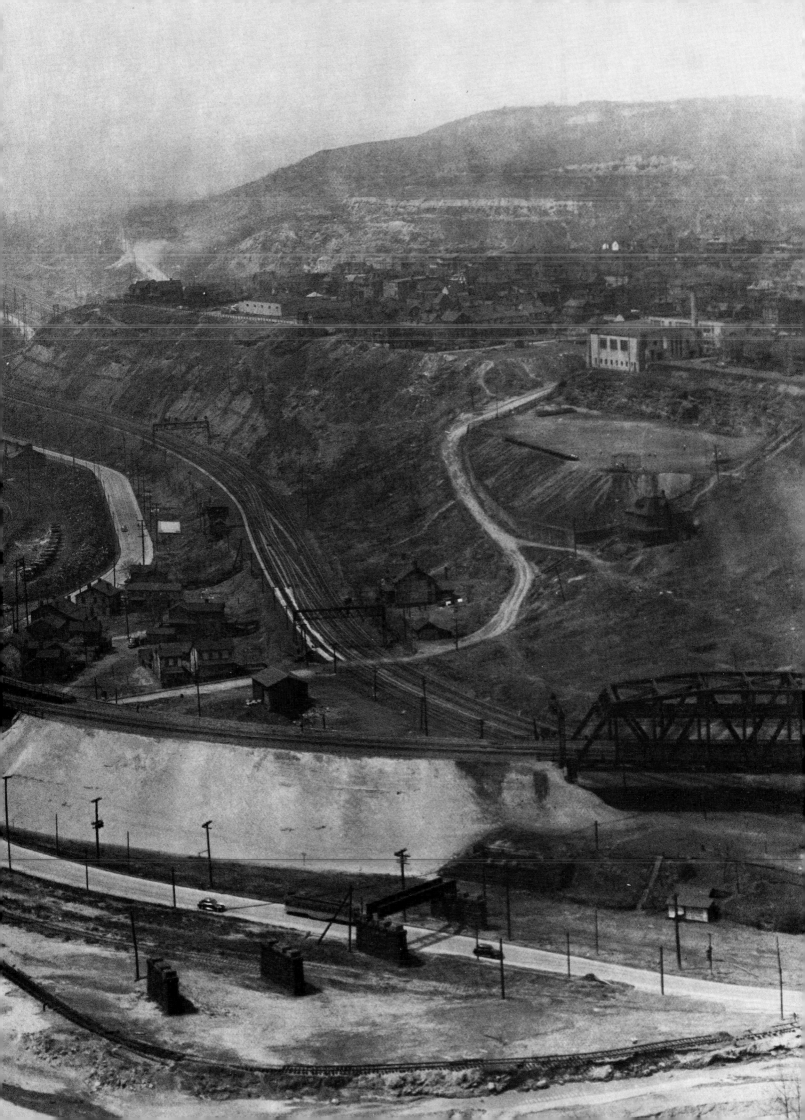

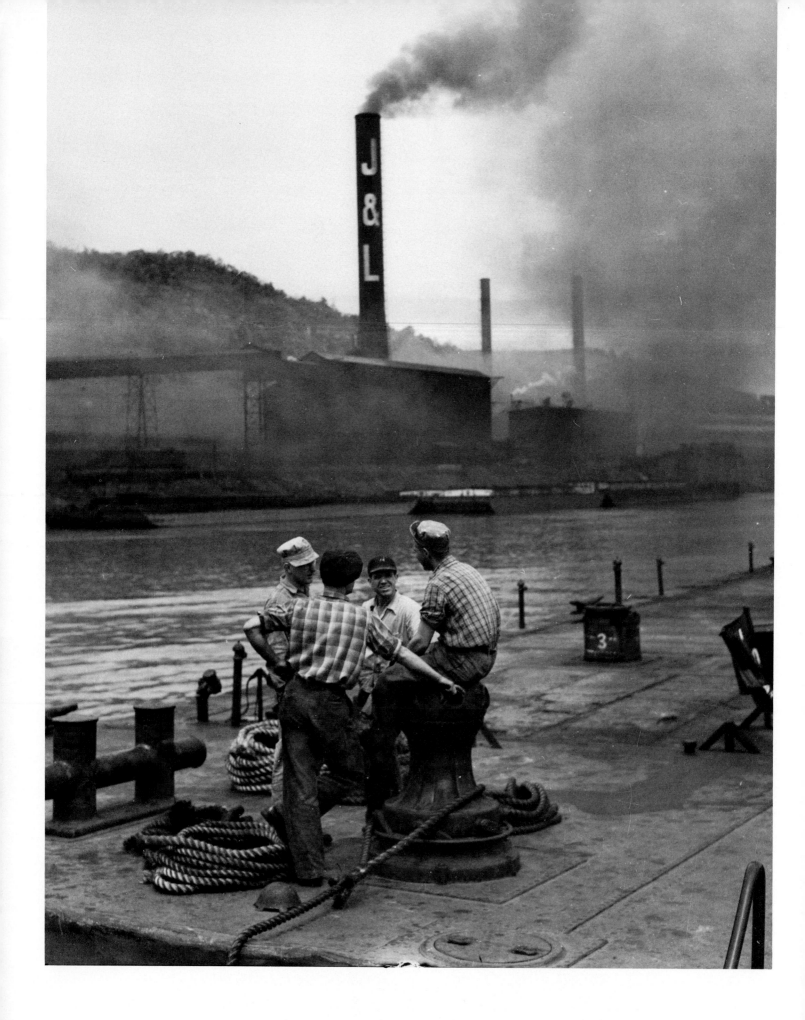

114. On the Ohio River towboat *Peace*, May 1945; photo by Edwin Rosskam.

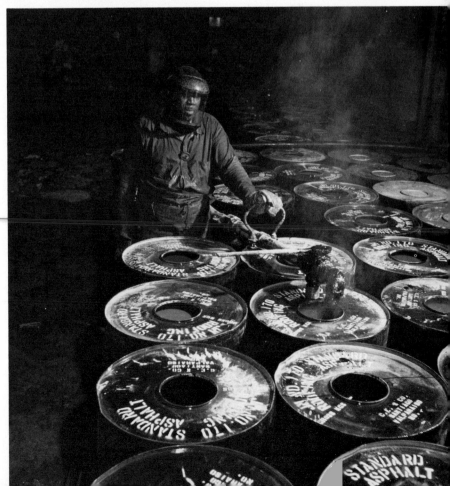

115. Mate, engineer and pilot in the mess room of a Mississippi and Ohio River towboat, 1945; photo by Edwin Rosskam. **116.** Thomas Owen pouring hot pitch, Bayonne, New Jersey, July 1945; photo by Gordon Parks.

115

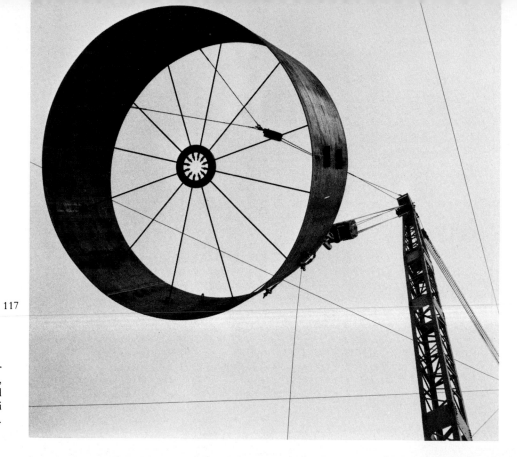

117

117. An ironworker's view during construction of a fluid catalytic cracking plant, Bayway, New Jersey; no date; photo by Sol Libsohn. 118. Small tow on the Mississippi River, November 1948; photo by Charles E. Rotkin.

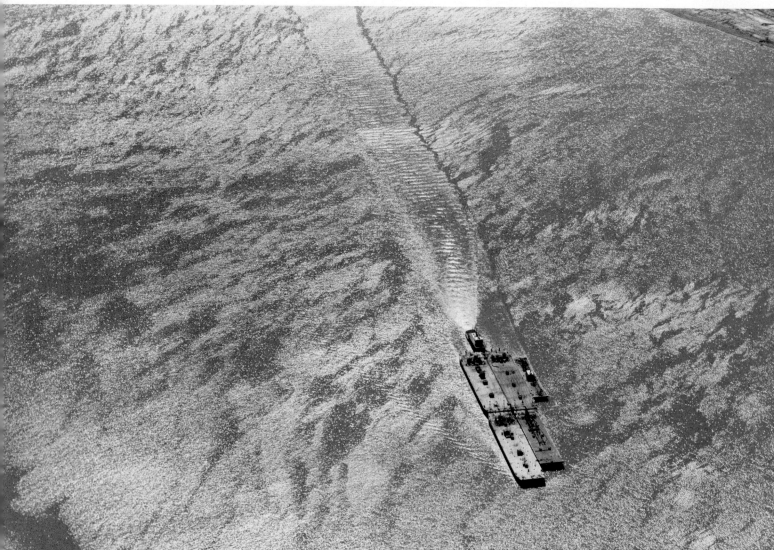

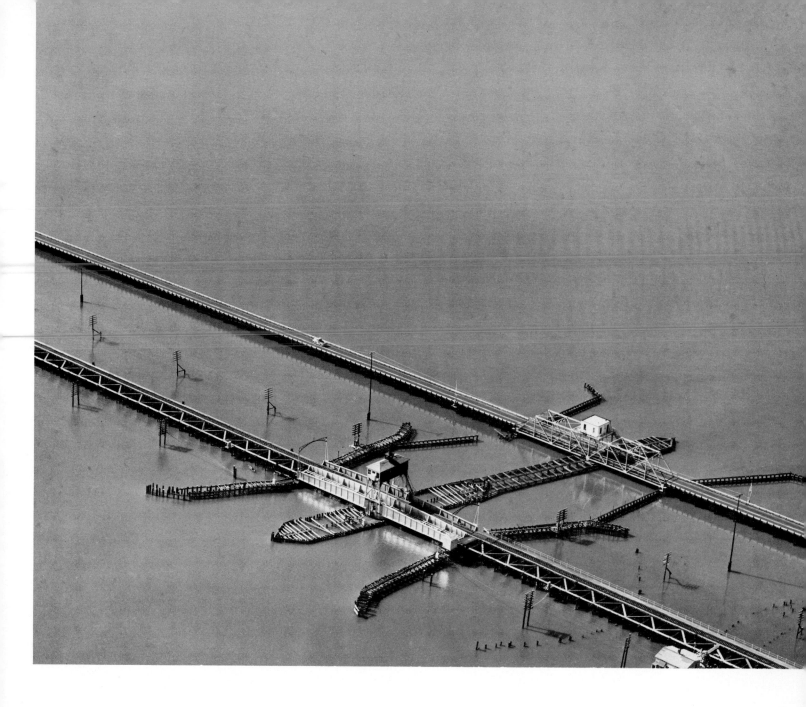

119. Rail and auto causeways, Lake Maurepas, Louisiana, ca. 1948; photo by Charles E. Rotkin.

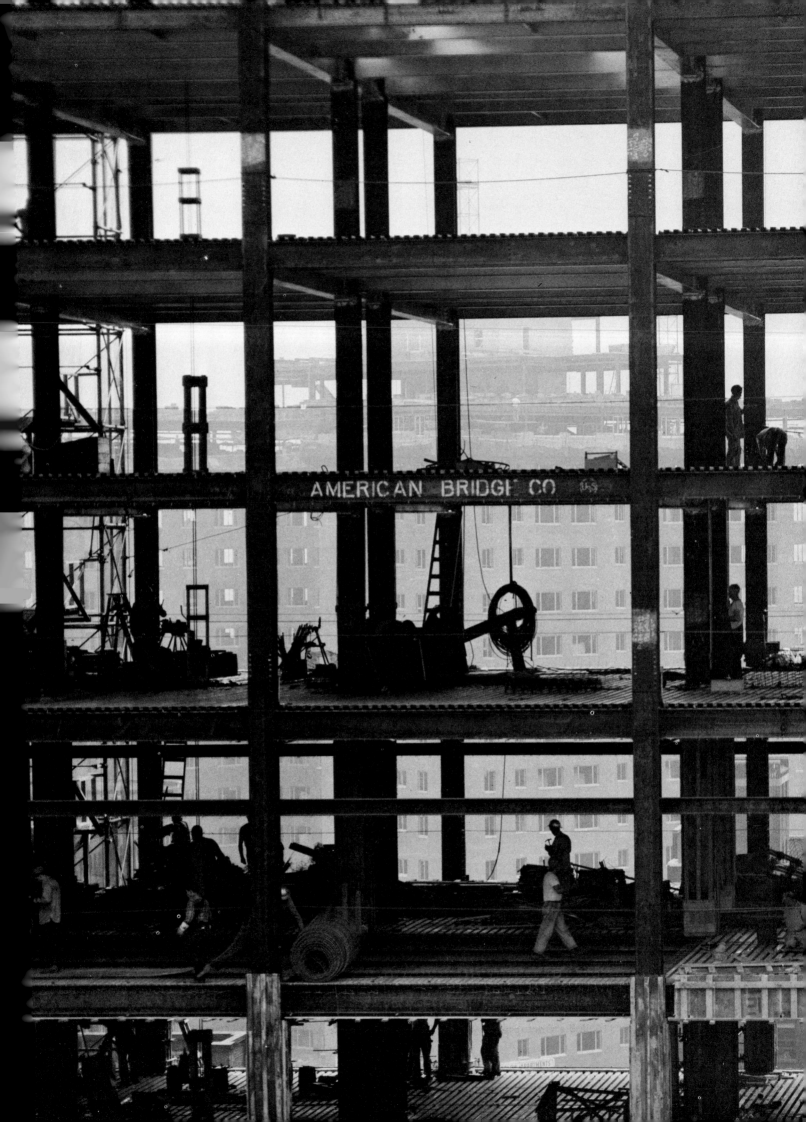

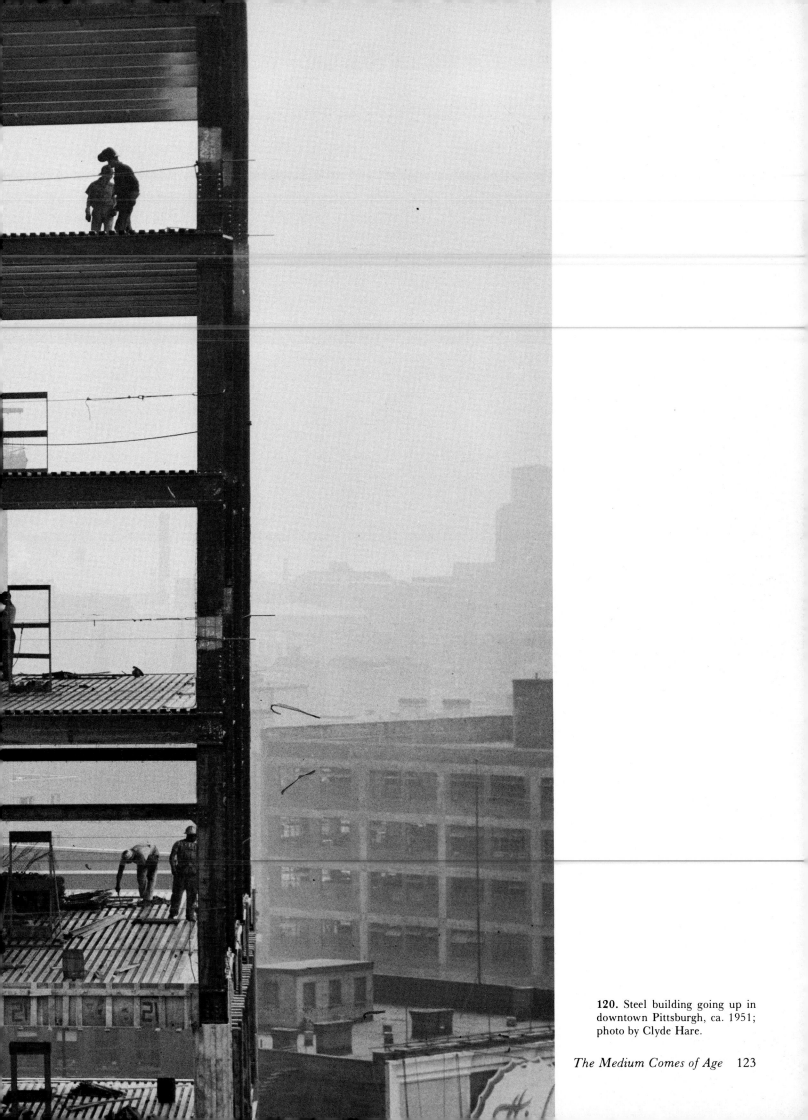

120. Steel building going up in downtown Pittsburgh, ca. 1951; photo by Clyde Hare.

The Medium Comes of Age 123

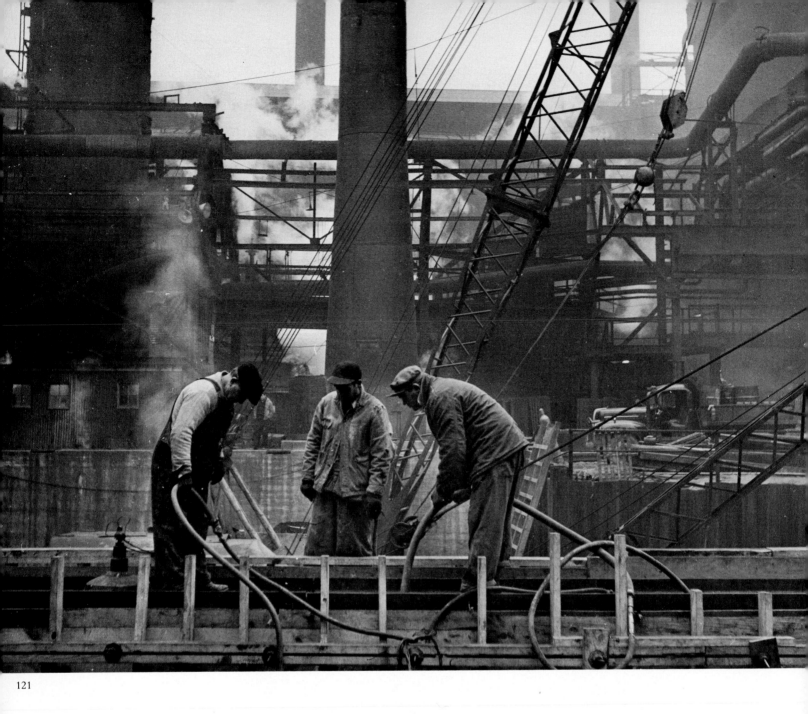

121

121. Workmen at a construction site in Pittsburgh, ca. 1951; photo by Clyde Hare. 122. Houses, Pittsburgh, ca. 1951; photo by Clyde Hare. 123. Smoke from a Pennsylvania Central engine in the valley, houses on the ridge, Pittsburgh, ca. 1951; photo by Clyde Hare.

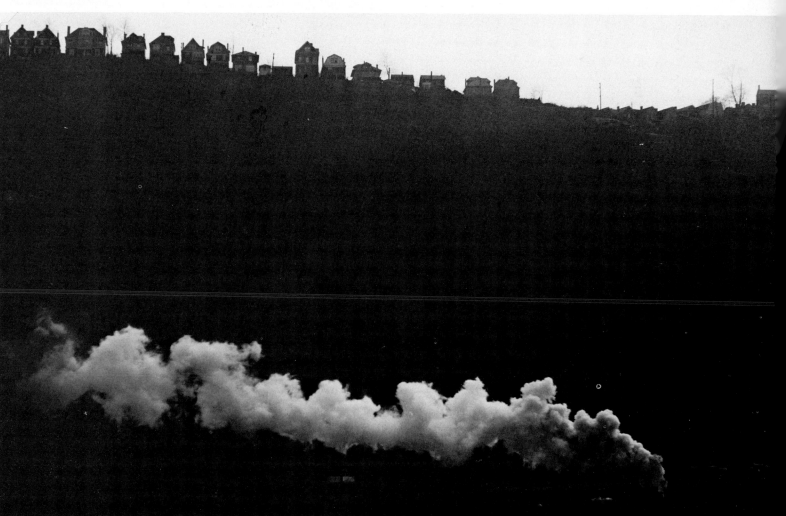

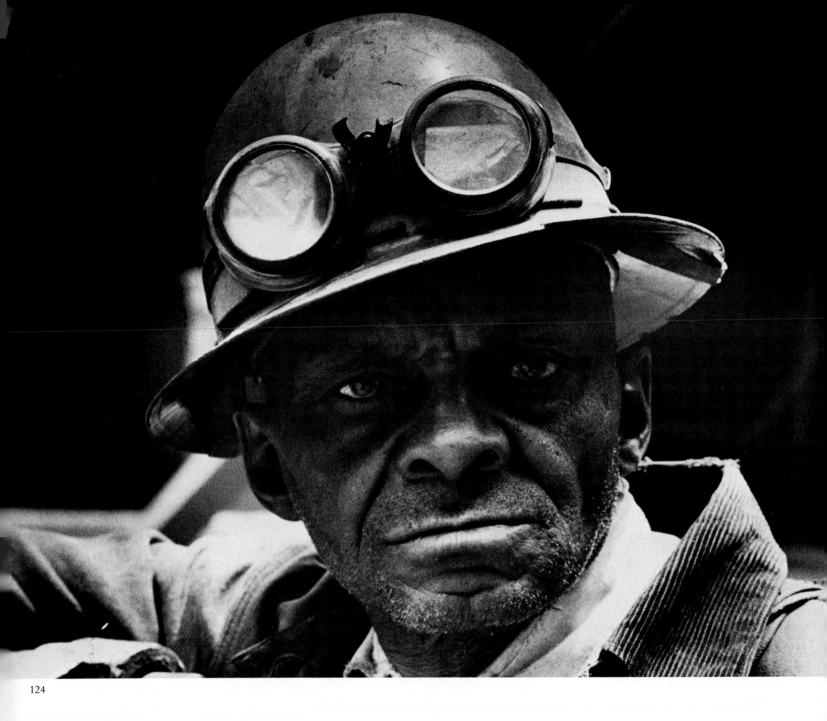

124

124. Steelworker, J & L Steel, Pittsburgh, ca. 1955; photo probably by Ivan Massar.
125. Steelworker in a hot suit with an oxygen lance, J & L Steel, Pittsburgh; no date; photo by Ivan Massar.

126 *The Medium Comes of Age*

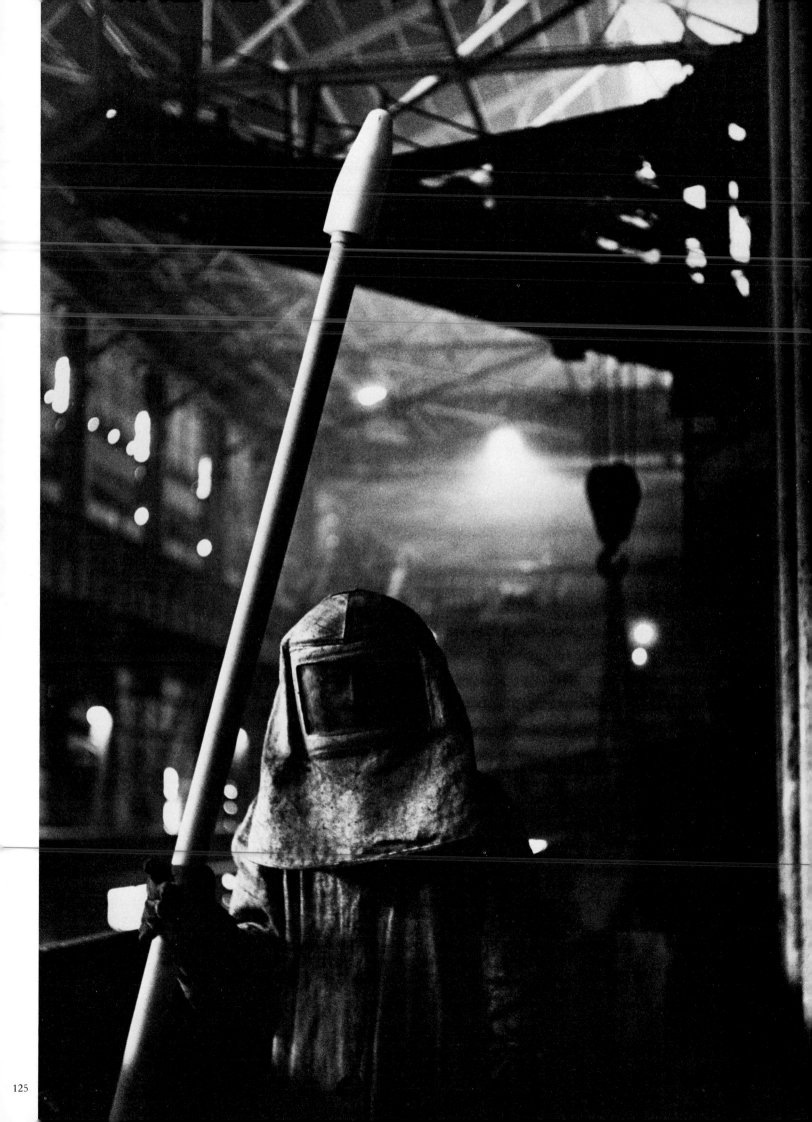

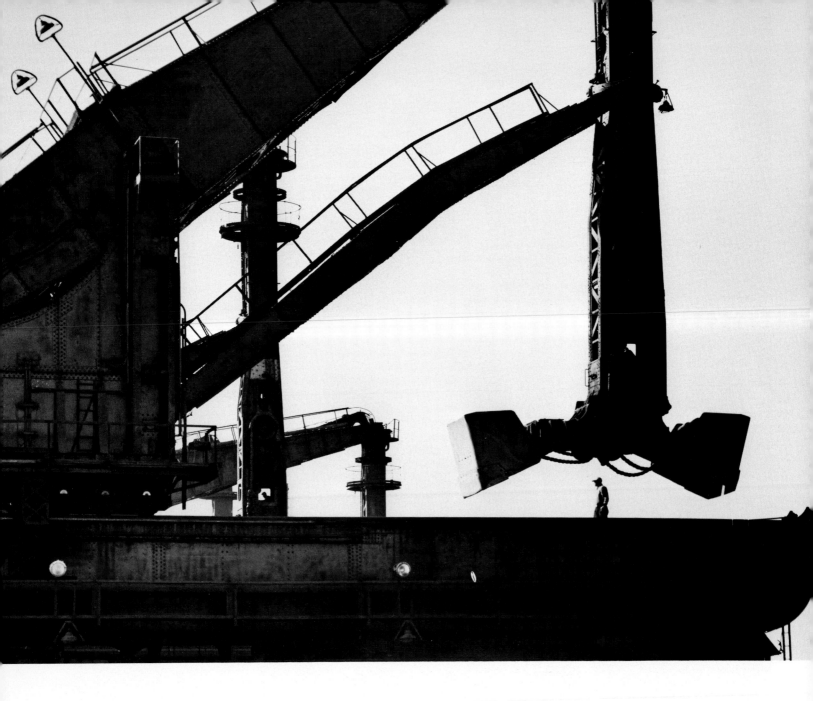

126. Hulett ore-unloading machines at the Union Dock Co., Pittsburgh, September 1956; photographer unknown.

CONFLICT AND AMBIGUITY: INDUSTRIAL PHOTOGRAPHY IN AN AGE OF QUESTIONS

In recent years the relationship between photography and industry has grown more complex. This is a natural development since national attitudes toward business in general have become more ambiguous. Twenty years ago, in the midst of the affluent 1950s, President Dwight Eisenhower's Secretary of War announced the proposition, "What is good for our country is good for General Motors and vice versa," and the vast majority of Americans applauded the statement. The generation that has grown up and begun to inherit the reins of power since that time has not been granted the luxury of such certitude.

The nature of industrial activity has changed. More and more of our national energies have shifted from heavy industry to service and light industries such as electronics and computer technology. A far smaller percentage of Americans depended on the classic heavy industries for their livelihood by the early 1960s than had twenty years earlier. Between 1947 and 1963 the percentage of workers in blue-collar jobs declined from 40.7 percent to 36.4 percent, and the decline in most of the large-scale heavy industries was even greater. This did not mean that national production was falling; indeed it was rising during most of the years cited. Fewer men and women were needed to run the machines. For example, more automobiles were built in this country in 1961 than had been in 1956, yet the industry accomplished this with 17 percent fewer production-line workers. This was done by the introduction of more and more automatic machinery.

Economists and sociologists like to argue about the effects of automation on workers but one thing seems clear. The worker who pushes a button to operate a giant piece of machinery is not as *involved* with the industrial process as was his predecessor who actually carried out the process himself. That is to say, the new worker does not commit as much of his own skill, judgment and experience to the process. In the new case, the worker may or may not be happier, he most probably is safer, but he is not as involved. With a smaller proportion of the population engaged in heavy industry, and with those who were so engaged feeling less committed to their work than before, it was only natural that by the mid-1960s a feeling should start to grow that perhaps heavy industry was not so important after all, and that perhaps the costs of activities like strip mining, steelmaking, dam construction and chemical manufacturing were at least as great as the gains. Add to these economic and social realities a growing national sophistication about the environment and the awareness of the finiteness of our resources, and the groundwork is laid for a major period of questioning of practically everything having to do with basic heavy industries.

The growing climate of criticism of industry in the 1960s affected the work of many photographers who found themselves and their clients or employers faced with a whole new group of perplexities. National magazines such as *Life, Look* and even *Fortune* began to debate issues such as the ecological impact of industrial activities, consumption of national resources and consumer rights. By the latter part of the decade, hardly any industrial photographer, either in-house or free-lance, could have entirely escaped the debate. The questions raised by consumer and ecology groups were real and, as a result, a degree of ambiguity entered the work of photographers who were attempting to grapple honestly with the image of industry.

Visual criticism of industry became fairly common by the late 1960s. Interestingly enough, the majority of those photographers who trained their cameras on industrial pollution and other specific sins were men who had made their livings in industrial photography. Charles E. Rotkin, for example, had worked for Roy Stryker during the early days of the Standard Oil of New Jersey project and had done hundreds of major industrial assignments during the 1950s and early 1960s. His last major story for *Life* magazine (accepted but never printed because the magazine ceased publication) was a bitter attack on strip mining which he titled "The Machine That is Eating Ohio." Rotkin still does a great deal of industrial work, such as annual reports and advertisements, but he does not hesitate to attack specific problems in industry when he feels the situation warrants it.

Some who have taken a visually anti-industrial stance have done so on the basis of more pessimistic and less traditional grounds. In his fine book *The Hand of Man on America*, photographer David Plowden has written: "Our habitat is basically self-made but, tragically, we are destroying it as we destroy most things we touch. Perhaps we are not meant to survive as a species, for we certainly are making our environment less and less livable. We are polluting the landscape as well as the air and water, not just with the effluence of society but with architectural sewage as well" (p. 23).

This represents new ground. Plowden and many others among the new breed of photographers in America are worried about the industrial environment that has been created in this country under the rubric of "progress." Plowden's photographs in *The Hand of Man* seem to find great dignity and even heroism in man's industrial artifacts but there is a sense of tragedy underlying everything, a sense that we are seeing the physical remains of a once-great culture. In this context, the idea of progress

seems almost beside the point. Progress, these pictures are saying, has led us to sterility.

The theme of industrial sterility has been developed by several of the younger photographers who have recently come into prominence. Louis Baltz, for example, has done excellent work in his portfolio on California tract houses and his book on industrial architecture. Consistent with their general pessimism, these photographers do not feel the need to suggest alternatives. Their role is purely to record their perceptions of America's industrial landscape and iconography. "Here man has worked," their images seem to say. "He has worked on an heroic scale, leaving behind the fascinating evidence of his vigor and his total lack of sensitivity to the earth around him."

The majority of those who make their livings in industrial photography see both good and bad in the visual images around them. Many still feel the magic surge of enthusiasm for a great industrial landscape. Heavy construction, the theme of tiny men putting together great buildings and bridges, still continues to draw from photographers their best efforts. In-house photographers such as Arthur Lavine at Chase Manhattan Bank in New York find a great deal of industrial activity to fascinate them. The sheer diversity of a major corporation's efforts provides an almost endless parade of visual images for those who love to capture them. As Henry Luce suggested in the first issue of *Fortune* some thirty-five years ago, industry is interesting because it is, essentially, people doing things.

The ancient Greeks understood that heroic enterprise was often tragically flawed. The maturing vision of industrial photographers of the 1970s had to face up to the same realization. We know now that there has been a powerful element of overweening pride in doing things bigger, better and faster in the United States, and that this pride has cost us heavily. Photographers cannot ignore this. In fact, the end result of this realization has been to make the visual language of industrial photography richer and far more subtle. At long last, photographers have had to learn to deal with ambiguity.

The story of American industrialization continues to attract great photographers for the simple reason that it is one of the most important stories being played out around us. All fine artists, whether they are writers, painters, musicians or photographers, realize sooner or later that their work can be no better than the themes that they choose to work with. A great essay cannot be produced on an insignificant subject. A great painter is recognized because he consistently breaks new ground or finds new ways of working with important visual themes. A great photographer must seek out images that speak eloquently of man and reality, for photography is by its very nature more concerned with specific reality than other visual arts. In a nation such as the United States, where for the last century and a half so much human effort has been devoted to industrial enterprise, it is only natural that a new and exciting visual language such as industrial photography should evolve. Gradually, as the nature of industrial activity has changed and the technical capabilities of cameras and films have improved, photographers have learned to express the broadest possible range of images and emotions concerning industry. Undoubtedly this process will go on as photographers continue to observe and record the image of industry.

ABOUT THE PHOTOGRAPHS

XXVII. Charles E. Rotkin—Industrial Photographer and Critic (Color Photo G)

A veteran of the Standard Oil project, in the course of which he made bold experiments with aerial photography, Rotkin has since taken critical looks at industry, as in his attack on strip mining in Ohio, intended for publication in *Life* magazine.

XXVIII. The New School of Industrial Photography (Photos 127–134)

During the late 1960s and early 1970s a small but influential group of photographers began to look upon industry as a remarkable trip to nowhere. Without praise or condemnation, they focused on the monuments to industry which they saw around them, like tourists at Stonehenge recording the past accomplishments of a culture they could not personally recall. Pessimistic about man and the impact of man's activities on the fragile environment of the earth, these Calvinists with cameras seemed to be trying to capture the essence of a civilization that they regarded as passing, rather than to document an on-going process. Whether history shows them to be right or wrong is unimportant. What is important is the clear irony of their intellect and the monumental quality that pervades their work.

XXIX. Arthur Lavine—The In-House Photographer (Color Photos H–J)

Arthur Lavine is the head of the photographic studio of the Chase Manhattan Bank of New York. His company is involved in businesses all over the world, covering a wide variety of human activities. Some involve the depletion of natural resources but many others involve the recycling of materials. In the portfolio represented here, Lavine has visited an auto junkyard and captured a certain grim beauty among the rusting hulks and the heavy machinery. This sort of assignment is fairly typical of the modern in-house photographer's work. The next trip might take Lavine to the docks or to a bridge under construction. From the quality of his work it is clear that Lavine still finds the theme of industrial activity exciting. It also seems clear that he does perceive ambiguities. His work is not as simply pro-industry as that of earlier industrial photographers such as Bourke-White or D'Arazien, yet it remains essentially positive. For Lavine and many others, "man at work" remains an exciting and vital visual theme.

XXX. The Making of a Skyscraper (Photos 135–141)

The construction of the Chase Manhattan Bank and Plaza in downtown Manhattan was an undertaking of awesome proportions. The theme of tiny men putting up huge buildings has always fascinated photographers, and Robert Mottar followed the progress with great interest. Mottar's work seems to relate to the humanistic tradition of Lewis Hine and his "skyboys" on the Empire State Building in the early 1930s. Mottar had the advantage of lighter, less obtrusive, 35-mm cameras, and his work never seems to fall into the staginess that Hine sometimes had to employ. Yet taken as a whole, the two series are remarkably similar.

XXXI. And Still They Build (Photo 142)

Raymond Juschkus, a photographer on the staff of the Chase Manhattan Bank, captured the image that seems most fitting to close this study of photographic style in American industrial photography: the worker, seemingly pulling a great building up behind him.

127. Doremus Avenue, Newark, New Jersey; no date; photo by David Plowden.

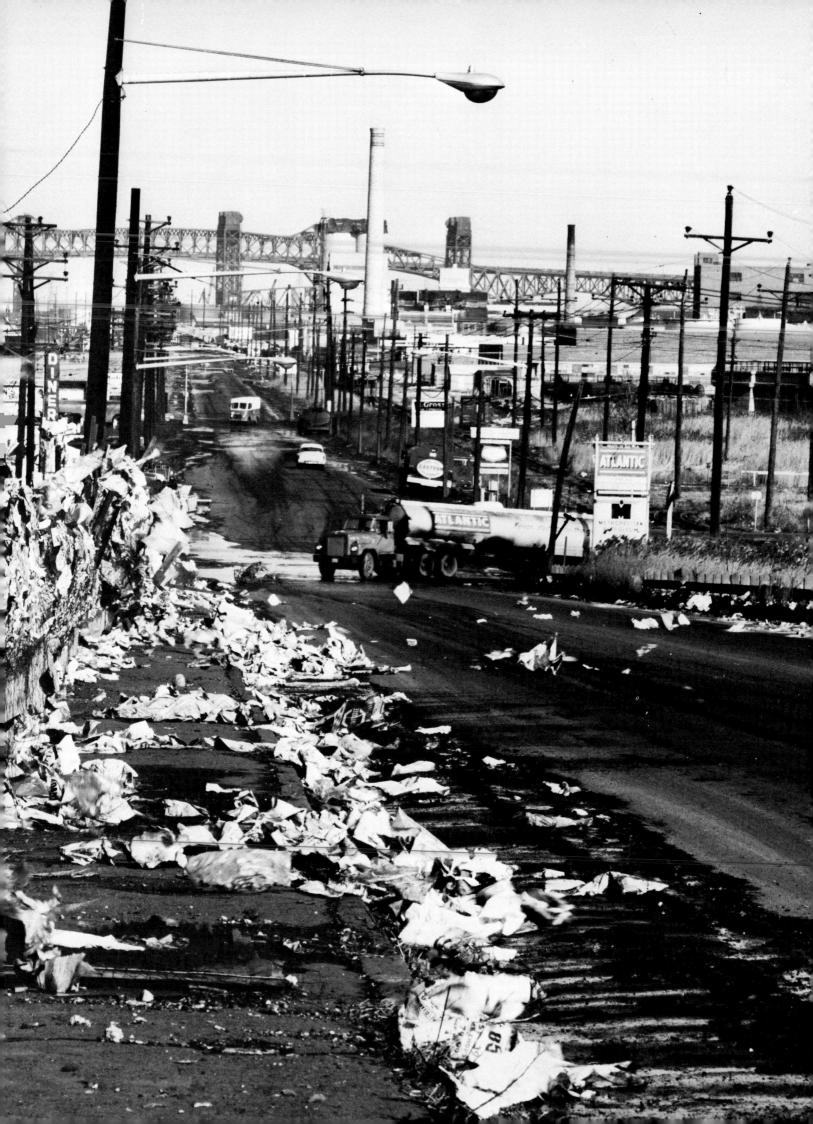

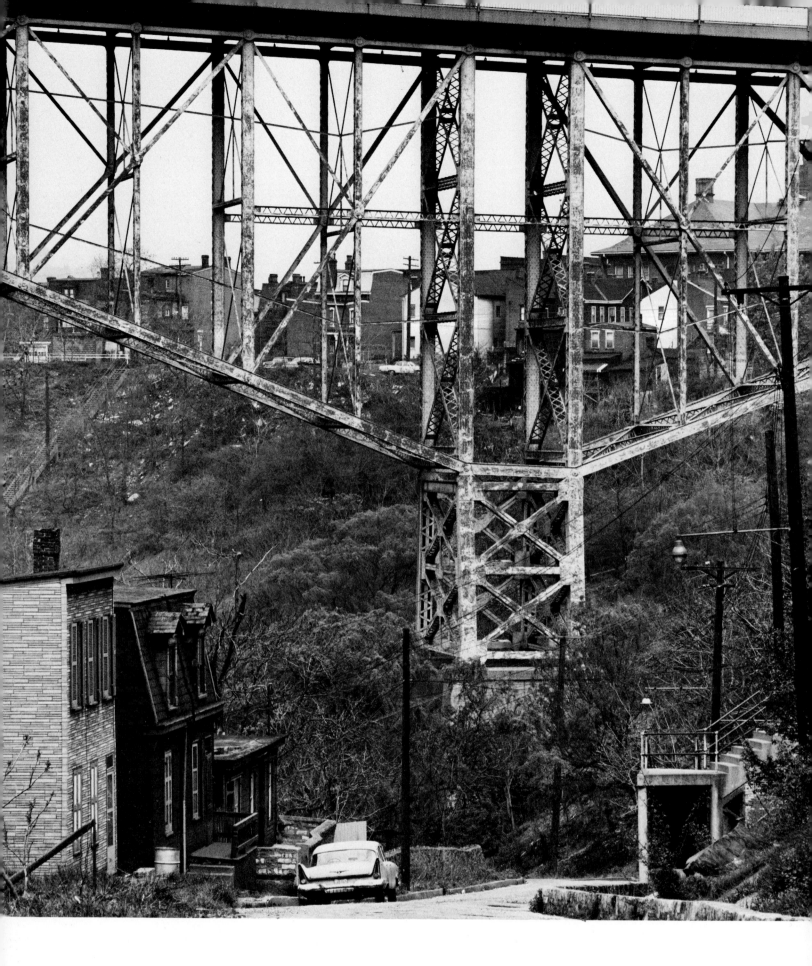

128. Beneath the Bloomfield Bridge, Pittsburgh; no date; photo by David Plowden.

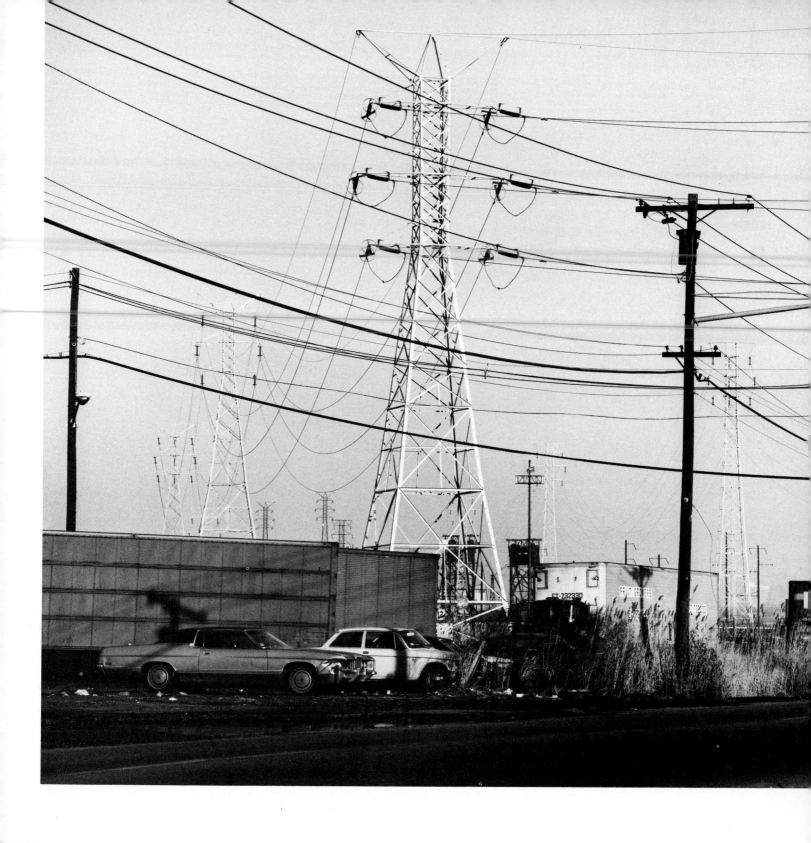

129. Kearny, New Jersey; no date; photo by David Plowden.

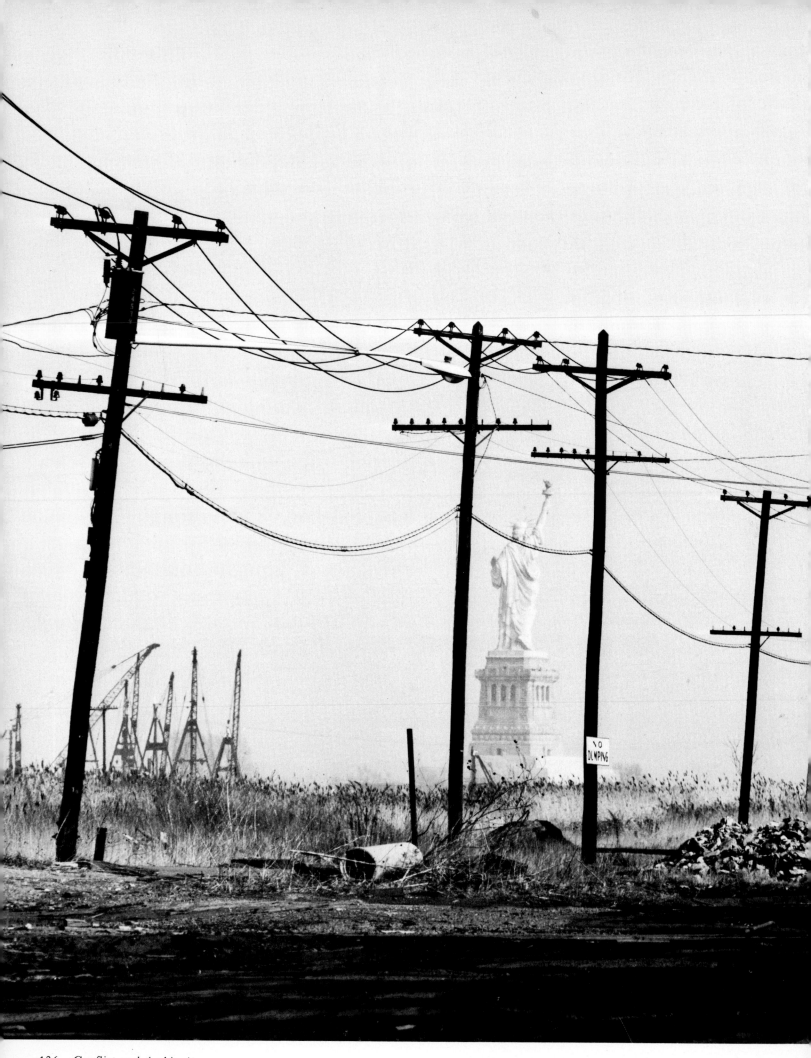

130. View from Black Tom, Jersey
City, New Jersey, 1971; photo by
David Plowden.
Overleaf: 131. Tract house, California,
1971; photo by Louis Baltz.
132. Construction detail, east wall,
Xerox, Santa Ana, California; no date;
photo by Louis Baltz. 133. East wall,
Energy Products Division, Royal In-
dustries, Santa Ana; no date; photo by
Louis Baltz. 134. South wall, PlastX,
Costa Mesa, California; no date; photo
by Louis Baltz.

133

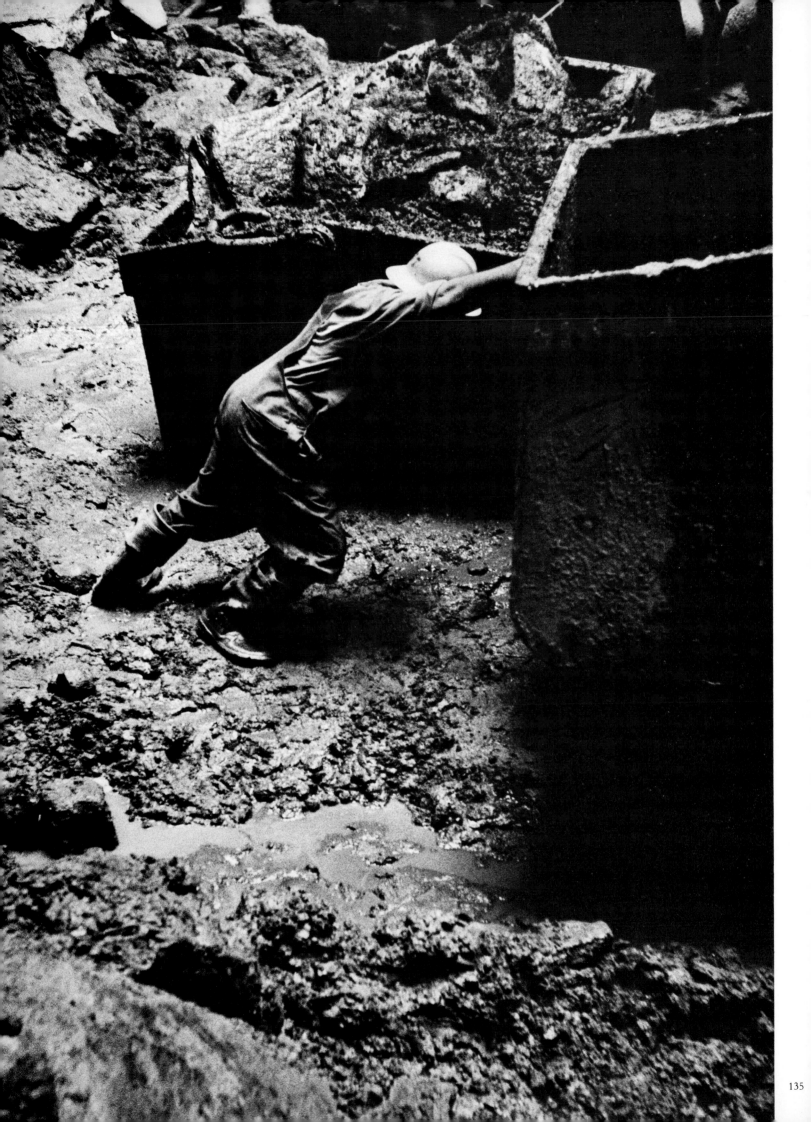

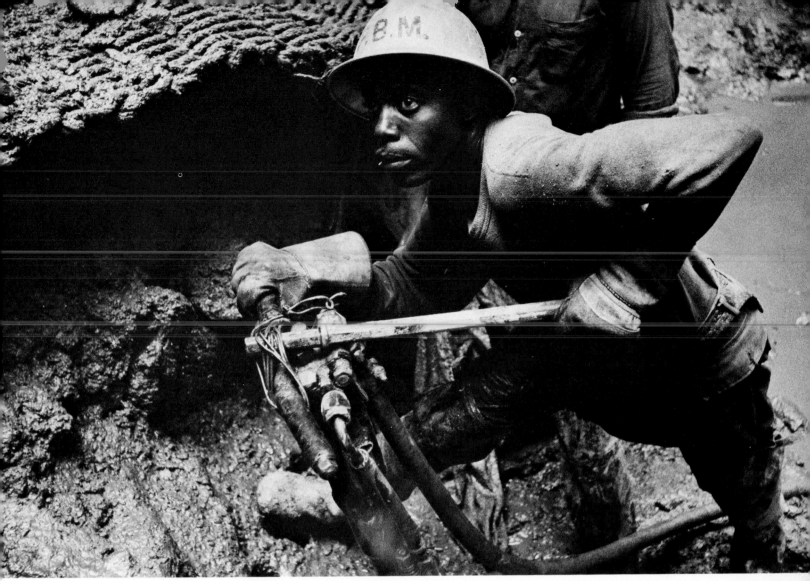

136

135. Basement excavation, Chase Manhattan Bank and Plaza, New York City (building completed 1960); photo by Robert Mottar. **136.** Drilling in mud, Chase Manhattan; photo by Robert Mottar.

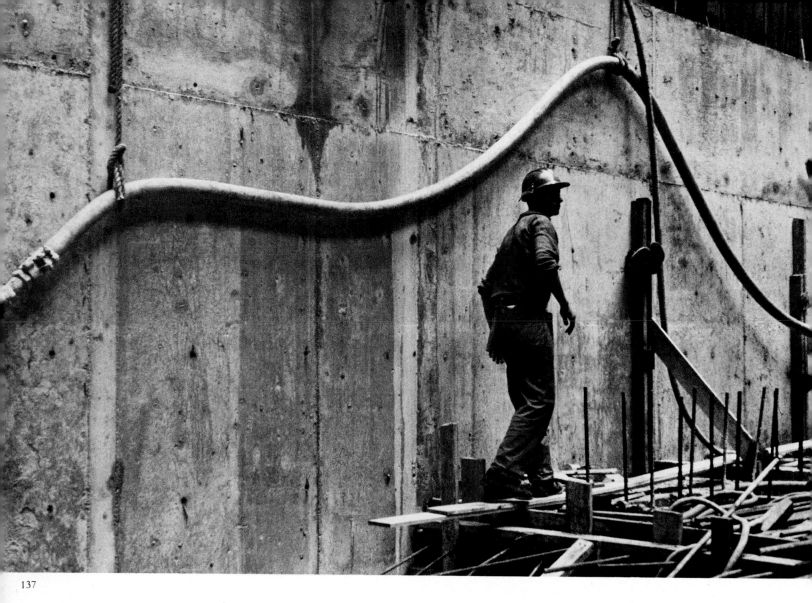

137

137. Worker near the wall, Chase Manhattan; photo by Robert Mottar. 138. Steel goes up, Chase Manhattan; photo by Robert Mottar.
Overleaf: 139. Steelworker on a high beam, Chase Manhattan (with a view of the since demolished Singer Building); photo by Robert Mottar. 140. Worker looking down at the city, Chase Manhattan; photo by Robert Mottar.

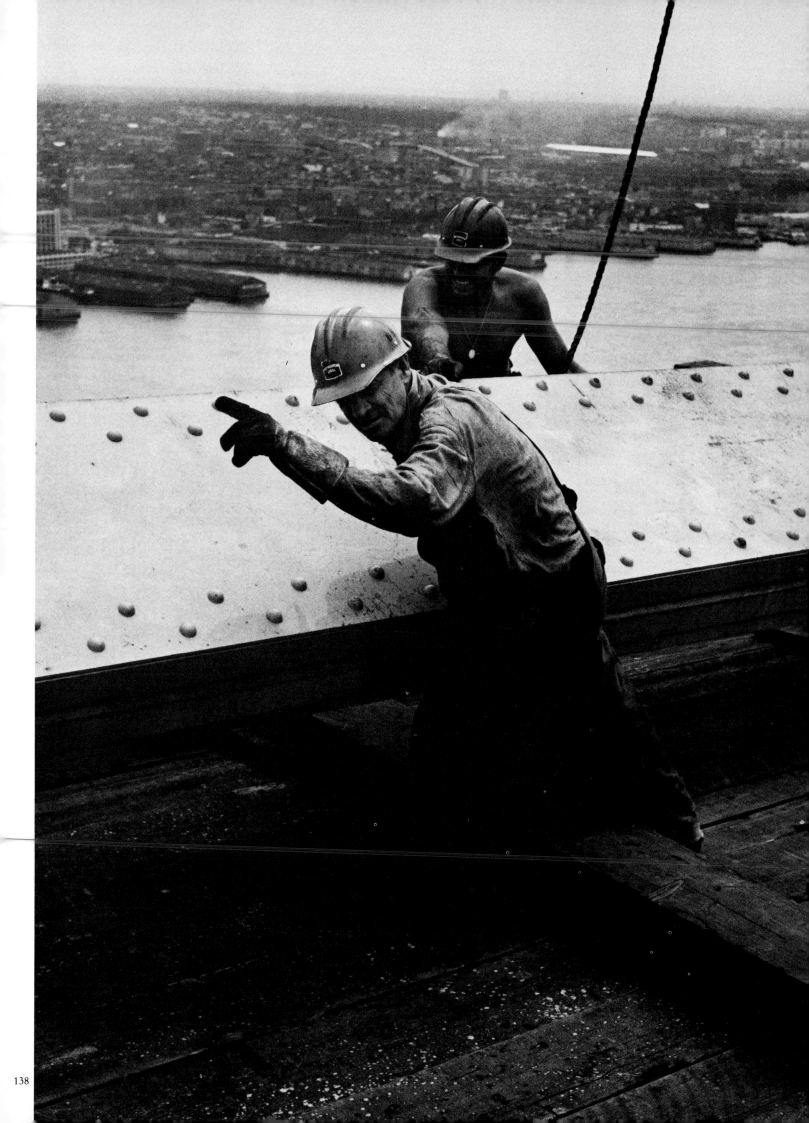

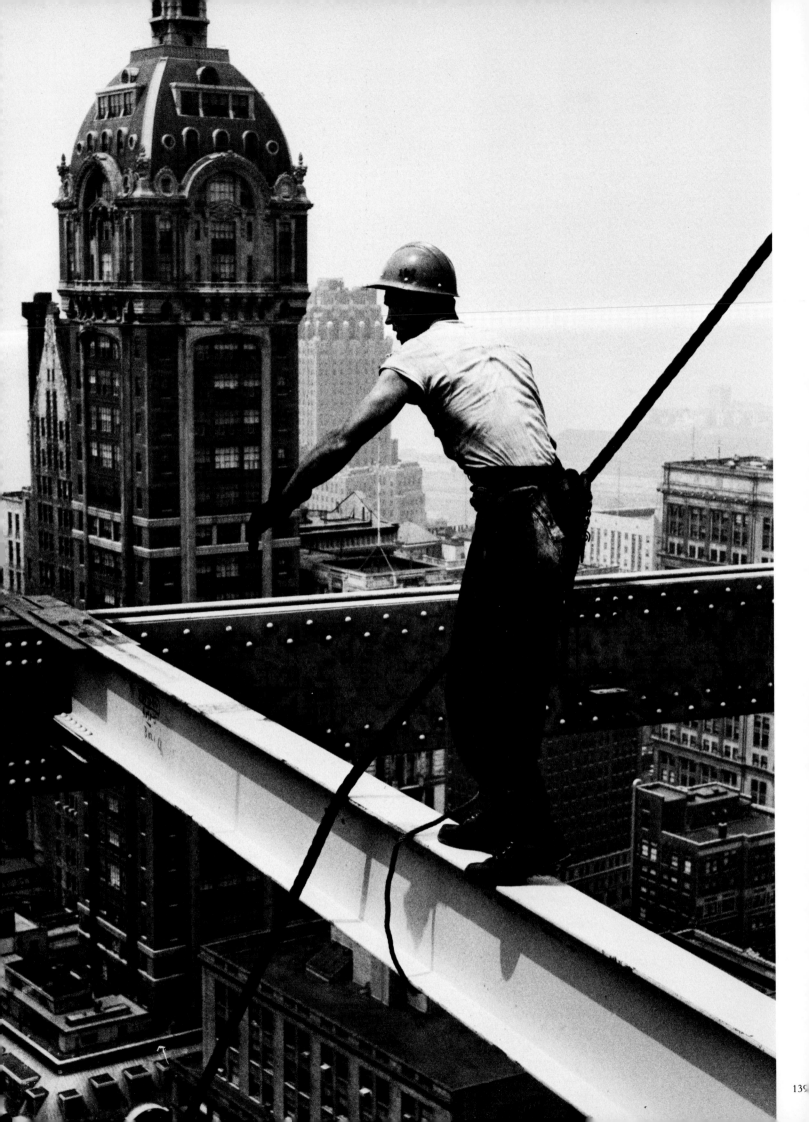

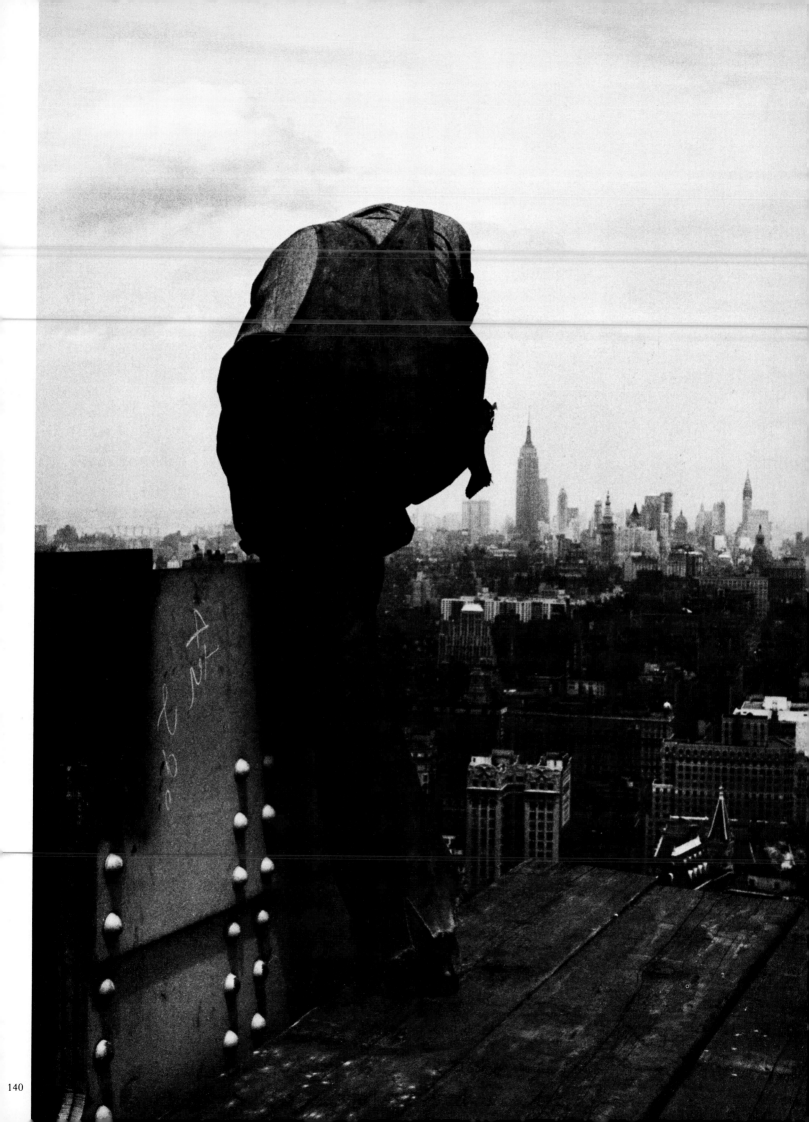

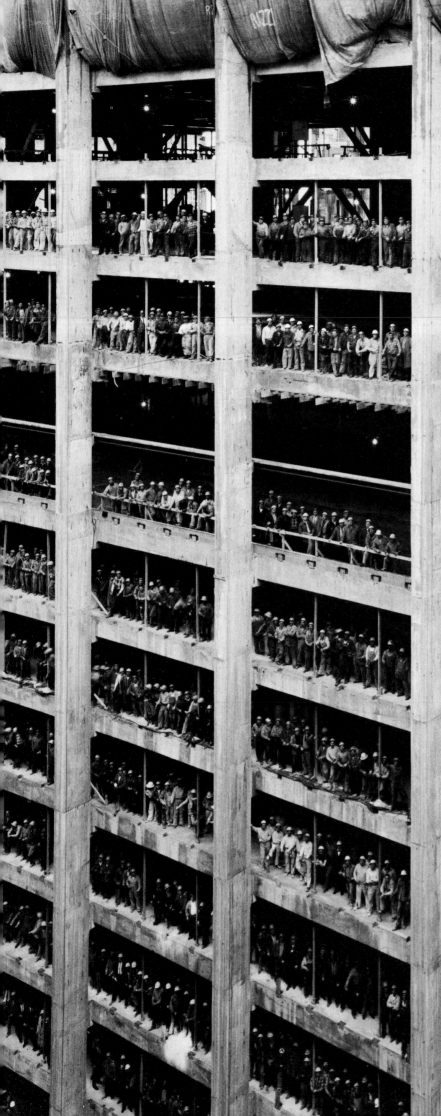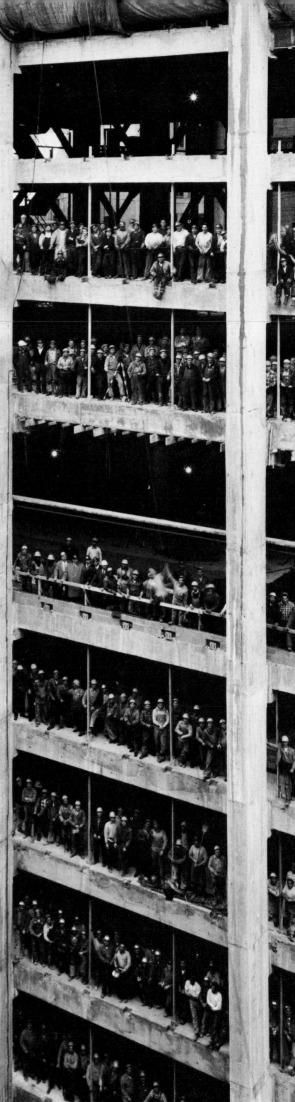

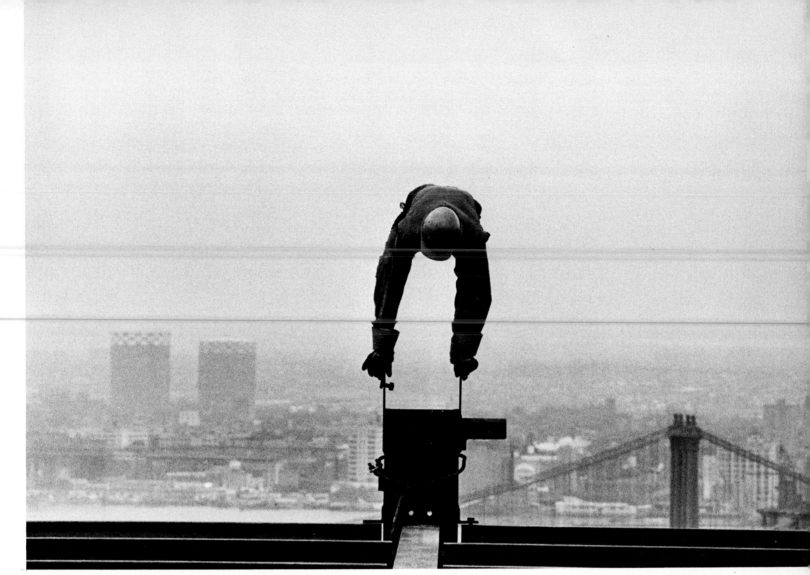

142

141. Thousands of workers on the Chase Manhattan Bank building; photo by Robert Mottar.
142. Steelworker, Chase Manhattan Bank; photo by Raymond Juschkus.

PICTURE CREDITS

Author and publisher are grateful to the following lenders (named in order of illustration numbers):

76: University of Louisville Photographic Archive; Caufield and Shook Collection 67376.
77: University of Louisville Photographic Archive; Caufield and Shook Collection 34576.
78: University of Louisville Photographic Archive; Caufield and Shook Collection 33412.
79: University of Louisville Photographic Archive; Caufield and Shook Collection 39159.
80: University of Louisville Photographic Archive; Caufield and Shook Collection 109089.
81: University of Louisville Photographic Archive; Caufield and Shook Collection 90943.
82: George Eastman House; 72:159:3941.
83: George Eastman House; 72:159:121.
84: George Eastman House; 72:159:4082.
85: George Eastman House.
86: George Eastman House; 72:159:5633.
87: George Eastman House; 72:159:5631.
88: George Eastman House; 70:341:6661.
89: George Eastman House; 70:086.
90: University of Syracuse, George Arents Research Library; negative OS 44.
91: University of Syracuse, George Arents Research Library; negative Port of New York Authority 3.
92: University of Syracuse, George Arents Research Library; negative NFP 2.
93: University of Syracuse, George Arents Research Library; negative Amoskeag 9.
94: Minnesota Historical Society; HD 9 p 87.3.
95: Minnesota Historical Society; HD 9 p 90.
96: Minnesota Historical Society; HD 9 p 89.
97: Archives of Labor History and Urban Affairs, Wayne State University, Detroit; 6.86/13612/9-5-73, No. 4.
98: Archives of Labor History and Urban Affairs; 6.86/13612/9-5-73, No. 7.
99: Archives of Labor History and Urban Affairs; 6.86/13612/9-5-73, No. 3.
100: Wide World Photos; 10902.
101: Wide World Photos; 15291.
102: Wide World Photos; 15972.
103: Wide World Photos; 16963.
104: George Eastman House; 1276-36, SONJ 865.

105: Esther Bubley, N.Y.C.; SONJ 27117.
106: Esther Bubley; SONJ. Loaned by Esther Bubley.
107: University of Louisville Photographic Archive; SONJ 49112.
108: University of Louisville Photographic Archive; SONJ 49133.
109: Esther Bubley; SONJ 54077.
110: Esther Bubley; SONJ 52721.
111: University of Louisville Photographic Archive; SONJ 53999.
112: University of Louisville Photographic Archive; SONJ 23521.
113: George Eastman House; 1276-3, SONJ 59469.
114: University of Louisville Photographic Archive; SONJ 24676.
115: University of Louisville Photographic Archive; SONJ 1528.
116: University of Louisville Photographic Archive; SONJ 25579.
117: University of Louisville Photographic Archive; SONJ 60091.
118: University of Louisville Photographic Archive; SONJ 62178.
119: George Eastman House; 1276-22, SONJ 62311.
120: Carnegie Library, Pittsburgh; 5425.
121: Carnegie Library; 7893.
122: Carnegie Library; 3915.
123: Carnegie Library; 8170.
124: Jones & Laughlin Steel Corporation, Pittsburgh; 3593 M22.
125: Jones & Laughlin Steel Corporation; 2735 M28.
126: Jones & Laughlin Steel Corporation; 3913.
127–130: David Plowden, N.Y.
131: George Eastman House; 72:015:13.
132–134: George Eastman House.
135: Chase Manhattan Bank Collection, N.Y.C.; 645-7-26.
136: Chase Manhattan Bank Collection; 645-3-13.
137: Chase Manhattan Bank Collection; 645-12-21.
138: Chase Manhattan Bank Collection; 685-19-27.
139: Chase Manhattan Bank Collection; 685-12-37.
140: Chase Manhattan Bank Collection; 685-14-23.
141: Chase Manhattan Bank Collection; 645-2.
142: Chase Manhattan Bank Collection; 2058-95-29A.